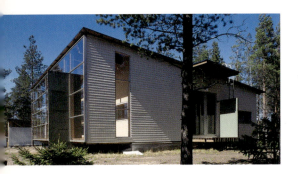

pre-text, the collection, hip, hop, house, the assemblage texts by **Roger Connah**
other texts compiled by **Roger Connah**
graphic design **Antti Ahlava** inside cover photos **Juha Nenonen**
translations **Roger Connah**
publisher **Building Information Ltd (Rakennustieto Oy), Helsinki, Finland, www.rakennustieto.fi**
paper **Arctic Volume 130g**
printers **Karisto Oy, Hämeenlinna**
© Roger Connah, the authors and Building Information Ltd, 2002 **ISBN 951-682-646-6**

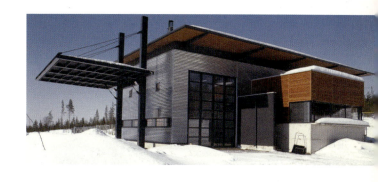

YOUNG
ARCHITECTS FROM FINLAND
COMPILED BY ROGER CONNAH RAKENNUSTIETO®

contents

6	preface (Gunnel Adlercreutz)
8	pretext (Roger Connah)
12	the collection (Roger Connah)

hip projects

20	hip (Roger Connah)
24	Minna Lukander
28	Tuomas Silvennoinen
32	Sopanen & Svärd
36	Hannunkari & Mäkipaja
38	HKR Architects
42	Jenni Reuter
46	Sarlin+Sopanen
50	Jari Tirkkonen
52	Saara & Janne Repo
56	B&M Architects
60	JKMM Architects
66	Keskikastari & Mustonen
70	Petri Rouhiainen
72	APRT Architects

hop projects

80	hop (Roger Connah)
84	Mikko Mannberg
90	Anni Vartola
94	Marco Steinberg
98	Ria Ruokonen
100	Anders Adlercreutz

106	m3 Architects
110	POOK
114	Heikki Viiri
118	Meskanen & Pursiainen
124	Karola Sahi
128	Jesse Anttila
132	Eeva Pelkonen
136	Sanaksenaho Architects

house projects

142	house (Roger Connah)
146	QUAD
150	Narjus Siikala
156	Berger+Parkkinen
164	Kirsti Rantanen Mauri Korkka
168	a.men
174	Harri Hautajärvi
178	Päivi Jääskeläinen
182	Kaisa Soini
186	Antti Ahlava
192	Reflex Design
198	Livady
202	Valvomo
210	OCEAN North
218	the assemblage (Roger Connah)
225	biographies
238	acknowledgements and photo credits

preface

Finland is young as an independent nation. Throughout its history, including the time before independence, Finland has valued the arts and in particular architecture, design and music. They have formed the frame for a national cultural identity that has been born partly, of course, by chance but also with deliberate intent. This tradition is still alive today. People in general are aware of and recognize the importance of the arts as elements adding value to everyday life. What we build today forms the built heritage of tomorrow and thus shows future generations where our values lay. Buildings and environments do not become well known or loved because they have been cheap to accomplish or because they represent extremely practical solutions, but rather because of their beauty, of the way they give value to life, environments and people.

To continue to accomplish this we need artists and we need architects. It has long been obvious that there is a need for publications that deal with the younger, not yet known Finnish architects that, however, will be the well-known names of the future. Already famous architects are easy to find in publications all over the world, but there is also an obvious need for books about the younger ones, too.

In today's Europe, the identity and the importance of the built environment of any one member of the European Union is increasing. Architecture and its quality is a formal goal for many countries, Finland included. In 1998 the Finnish government accepted and approved an Architectural Policy, a guideline and framework for the decisions taken by government, public bodies and municipalities regarding architecture.

The Building Information Foundation and Building Information Ltd support good building practice in both theory and practise, through guidelines and tools for both the users and building branch professionals. Architecture has always been central to this: all construction starts with design, and no building is better than the design that precedes it. Therefore, it felt natural for us to decide to publish this book and through it add another element to the current discussion about architecture, about the built environment, and about quality and what leads to it.

The Finnish architectural tradition has always emphasized quality through open and anonymous competitions, a heritage that we need to maintain and foster. Why? Because it is a system that lets talent emerge on its own merit, without the hindrance caused by lack of fame, trust or experience. The competition tradition has presumed that a person capable of winning an open competition that is professionally and carefully judged, is also capable

of organizing and carrying out the project itself. Finnish architectural competitions almost always lead to commissions and finally to built buildings. Over the years most of the well-known names in Finnish architecture first came to light through competitions – it is the accepted way to proceed. This was the fact a hundred years ago, and it still is today. It has been and still is a pride of the profession that this system has continued to work well, producing good results.

So why did we decide to make this particular book? In fact, the choices have been those of Roger Connah. He looks at Finnish architecture both from within and from afar, as an "inside outsider". As publishers we find this a relevant and interesting angle – an angle we would not be able to produce with a Finn making the choices and selections.

When this book was first born as an idea, the working title was *40 under 40*. The title has been modified, but then one can say that youth in an architect is a relative quality. Architects in Finland often work as couples – this is also reflected in the list of names. It is an everyday truth in the architect society that architecture is more than a profession – it is a way of life.

After having decided on the group he wanted to be represented in the book, Roger Connah then made the next decision – that of giving them a free hand in how they wanted to present themselves. The final book contains theoretical ideas and unbuilt schemes as well as finished projects and competition entries. They all reflect the different ways architects develop ideas, strategies and stylistic elements.

Young Finnish architects probably do not differ from young architects elsewhere – at least not in any significant way. Should they differ, however, then there is an interest in seeing how they differ; but should they not, then youth is an interesting quality in itself.

We hope that this book will find its forum and its readers, that it will add to the current discussion about architecture, and that it will help to explain some of the background that the Finnish world names in architecture stand for and come from.

Architects in Finland often work as couples – this is also reflected in the list of names. It is an everyday truth in the architect society that architecture is more than a profession – it is a way of life.

I want to thank Roger Connah for making this book and all those presented here for their own input and enthusiasm – hoping that they got something out of the process, a chance to test their own ideas and put the right questions to themselves about why and when and where.

gunnel adlercreutz
professor, director general /the building information foundation RTS

> –long enough and just so long
> tomorrow will not be too late
> **e.e.cummings**

pre-text

This collection on new architecture from Finland began life as 'the young ones' in discussion with Heimo Salo at Building Information Ltd. We planned a book about younger architects which, of course, implied neither young nor immature thinking. The catch phrase – *forty under forty* – arrived later and, we acknowledge, is not new. Philip Johnson and Robert Stern used it in the 1980s, as did a French show a decade later, as have the German publishers Taschen recently. This is no drawback. After all, in what other profession do practitioners approach forty years of age still to be considered young? In this collection this also signals another concern. A condition peculiar to architecture, it might be even more specific in Finland where the acknowledged strength of the apprenticeship system still exists.

To aid this selection of architectural work, a cut off point had to be used: those born on or after 1960. However, not wishing to be unreasonably strict and given the contemporary emphasis put on 'fusion' and 'collaboration', some work of younger architects who collaborate with 'older' partners has also been included.

Intended as a contemporary mapping, a 'sampling' of architectural projects and ideas produced by young Finnish architects and painters, the collection set out to illuminate the differences within shared, blended concerns, whilst at the same time hinting at something peculiarly talented about the young architects of this part of the world, and their uncanny habit of releasing new energies. The collection suggests a wider, identifying talent for affinity, synthesis and amalgamation.

pre-text

Some of these young practices are of course already known for their successful competition career, some are yet to establish themselves, whilst others persist in working in the margins of architecture itself. It has been equally important to identify younger practices, those in partnership in Vienna, Paris, Boston or New Haven, who may or may not have come through the Finnish education system. Who knows when and how architecture ceases being an impossible project and becomes process, pattern, metaphor and reality? And where are those ideas that are not yet quite formed? Are we to ignore them until they reach 'maturity', or win a competition? And how do we select some architects and not others, include the work of one young practice and discard another? 'Sampling' here implies a responsible selection process. It acknowledges the subjectivity of choice, whilst at the same time brings attention to work left out. Where, for example, are those architects who prefer to work in the liminal zone between architecture and painting, between architecture and landscape, between architecture and industrial design, between fashion and commerce? We have tried to identify those who desire to explore the metaphor of 'architecture' for as long as archi-tecture cannot and does not remain a built project only. Must we be afraid of an indeterminacy that is as yet not fused into 'architecture'? An architecture as we know it, or an architecture as we shall come to know it?

To organise the collection yet allow diversity to be expressed, the works have been categorised for an operative convenience not a critical convenience. *Hip, Hop* and *House* were used as useful subdivisions for the purpose of collecting and ordering the work. This is not a critical imposition, though of course the very fragmentation of *hip, hop* and *house* is not arbitrary but has contemporary nuance.[1] 'Hip' exists on its own. It means of the moment, topical, possibly synthetic, even at times 'cool', as used in the colloquial sense of 'now'. 'Hop' is a jump, the transition from one place to another, suggesting the way ideas might pass, develop and fuse into something else.

Only by looking at the looping and spiralling, the synthetic and formative work, the creative stuttering, the innovative and strong collaborative work of younger architects might we approach and understand the implications of this 'fusion' for for the future.

'House', of course, is the place we end up in: ultimately architecture as home, as shelter. In this case, in whatever form or envelope its architecture chooses. Besides its musical nuance, 'house' is the destination for architecture often, at present, only partially defined; a place, like infinity, where things happen that don't!

All practices, individuals or groups, were given the opportunity to make a statement which reflects their current concern and position in the production of architecture. No coercion was applied, no pleading. In a country often reluctant to take up the pen, this wasn't easy, but it was always a rewarding experience. Some of these texts have been edited slightly, others abridged. None of these texts or statements have, however, been doctored for any increased style and effect. And though clearly all these practices negotiate architecture in their own way, no other agenda has been imposed, nor has there been an attempt to provide a running commentary or evaluation of the individual practices. In text and layout these works, though expressions of a variety of contemporary skills, are not used as an illustration of any prescriptive theory for architecture in the future. Instead we offer a digital compendium.

We do not speak here of an eclecticism, but attempt rather to map this fusion, this series of 'attitudes'.

The three small texts at the head of each section – *hip, hop* an*d house* – reinforce this contemporary 'sampling'. Though detached from any deeper analysis of individual projects, the words try to put the works in touch with other ideas. The texts merely open up trajectories of thought in order to help us discover more about the position of architecture in the contemporary world. They allow us to consider the imagination and skill of these practices in relation to the rapid pace of architectural issue, and the trend which currently over-emphasises contemporary architecture as an image-making process.

Architecture as a choreography of culture and society, reflecting its own glass ceiling; architecture as an innovative re-treading of the past; architecture as participation; architecture as retreat? Or architecture as delay, intervention, accumulation, disruption, even protest? How are ideas turned into a talent in architecture? How do they become talented architecture and what does this

mean in the current re-definitions of the actual term 'architecture'? We do not speak here of an eclecticism, but attempt rather to map this fusion, this series of 'attitudes'. Why is Finnish architecture so prominent? What is its secret, if indeed it has one? Only by looking at the looping and spiralling, the synthetic and formative work, the creative stuttering, the innovative and strong collaborative work of younger architects might we approach and understand the implications of this 'fusion' for the future.

There is naturally some linearity in any book like this, in any sampling process, as it isolates particular examples in relation to a suggested, more generalised 'whole'. And though the book moves toward architectural ideas that may reveal a more experimental approach, some even loosening and widening the site of architecture and its production, these do not necessarily indicate more avant garde practices. 'Hip' might be cool, 'hop' might be a transition, and 'house' might be the destination of new architecture enveloping us with its future. But today, just as in jazz improvisation, just as in fusion, looping is essential. Ideas can be seen to go back and forth, spiral, testing the very critical subdivisions we sometimes feel so comfortable with. This is as it should be. The fusion so common everywhere today in our multicultural cities reminds us of a jazz response to architecture, its history, its presence, its software. We are at a new frontier! Which makes sometimes for known, but more often for unknown, architectural thrill. Of this, here, unplugged or not, there is plenty!

roger connah
university of texas at arlington

1 For more invention around these ideas see Craig I. Wilkins (W)rapped Space: The Architecture of Hip Hop. Theorising the Africentric Diasporian project of identity embedded in rap music, Wilkins attempts to identify and extend to architecture four spatial principles produced by the hip hop revolution: palimpsestic, anthropomorphic, performative and adaptive. Journal of Architectural Education, 54/1, pp.7-19, September 2000. ACSA.Inc.

–It's a good thing I don't allow myself to be influenced!
Ludwig Wittgenstein

the collection

In 1943 Eliel Saarinen expressed what seems to have been an unstated aim for most Finnish architects: "Style in architecture must not be understood as a fashion of the day, but as an expression of the age. Even if many style-varieties might appear, mirroring the shiftings of life, nevertheless these varieties must be based on such fundamental form-characteristics as are ultimately going to shape the coming style of that respective culture in the making."

We can now appreciate what Saarinen pre-empted. The brief history in Finland within which architects operate implies – in 'modern' terms – about 100 years. In Finland the 'past' is neither negative nor suspect, it is a repertoire. And despite the fragile, politicised 1960s, the 'past' is not, necessarily, something to rebel against. This has significant implications. A past so much 'present' in the contemporary moment may be the perfect condition for a synthesising energy, a 'continuum'.

In Finland the 'past' is neither negative nor suspect, it is a repertoire.

During the last century, especially the 1950s and 1960s, Finland was the place to be for 'modern architecture'. This *golden age* of Finnish architecture embedded a lasting professional strength within the culture. An apprenticeship at a Finnish architect's greater family studio became a passport to the passion of Modernism. Various studios generated strong loyalties and clear ideologies. There existed a solidarity within the profession only mildly shaken by the rivalry and differences in office methods and results. If Alvar Aalto's office was one in demand, a small office

nothing but egg-shells

such as Keijo Petäjä's extended and taught architecture with as much passion, rigour and clarity as any other office. Such loyalty to studio or office doubtlessly helped Finland survive the playful years of Postmodernism. Today, where other countries struggle for a wider acceptance of the role of architecture and design within their societies, Finland continues to build modern buildings some would die for. Offices and studios, though diminished in size somewhat, still operate on the familial, asking for and receiving loyalty. This solidarity within the profession has seen Finland once again emerge in this, the first decade of the new millennium, to be once more identified as a strong architectural culture. What is its secret if not the secret promise of modern architecture itself?

> **Such loyalty to studio or office doubtlessly helped Finland survive the playful years of Postmodernism.**

Just as it was for much of the 20th Century, architecture in Finland is taught as much in the studio as in the university. Within the small, centralised society with a collegial professional body, the strength of the office studio system has thus not only defined the 'continuum' within Finnish architecture, but it has supported a legacy for the promise of 'modern architecture'. Interpreted as a 'continuum', this is the legacy any young architect in the 21st century must negotiate. It is also this 'continuum' which, recently, has been linked specifically with the re-appraisal and immense critical respect now given Alvar Aalto.

The 'continuum' in Finnish architecture relies on an architecture being matched by progress, tectonic finesse, the subtlety of site management, the relations between nature and landscape, and – possibly a more ambiguous factor – the 'authentic' soul within the work. Readily indexed, promoted and catalogued, the 'continuum' in Finnish architecture has also become part of the heritage factor within the society allowing it, toward the end of the 20th Century, to take on mythic proportions. Whilst respecting both tradition and the new, the scale of this myth must involve us in the notion of 'Finnishness'.

> **Just as it was for much of 20th Century, architecture in Finland is taught as much in the studio as in the university.**

To many outside Finland, 'Finnishness' represents – albeit

loosely – something pure, honest, direct, and, possibly, ascetic. Siegfried Giedion was not the first to celebrate an architecture that was natural, human, and Finnish. Finnish architecture in the last century not only began to celebrate this 'reading' but the more strength it gained, the more it was able to feedback on itself and mediate this very 'finnishness'. By its very nature and ambiguity, *finnishness* could then stand in – metonymically – for notions about the whole culture. Toward the end of the 20th century, encouraged by the rise in the media role within architecture, the Finnish culture learnt to judge itself by how well it performed to these notions of finnishness. The width of talent and range of architecture appeared once more to bring deserved attention to such a small culture. Though it could perform for what were at times estranged, even secondary notions about its own image, this careful solidarity produced an architecture, encouraged by tectonic finesse and the ubiquitous steel and glass, that has currently become strangely spectacular, international and seductively poetic.

We might consider that the 'soul' of the work has passed through figures like Lars Sonck and Eliel Saarinen, onto Alvar Aalto and Reima Pietilä, and more currently been continued by the works of Juha Leiviskä and the duo, Heikkinen and Komonen. More recently, and significantly for the 'continuum', this 'soul' has been lifted once more into the forefront by the award of The World Architecture prize to the young, though disbanded practice, *Viiva*, for their Finnish Embassy building in Berlin. An architectural commentator on the BBC recently described it as a building with 'obvious Scandi-

nothing but egg-shells

navian references'! Is this accurate? Does a continuum suggest a succession such that adjacent parts, in this case different buildings, become indistinguishable one from the other? How useful has it been to create opportune syntheses, at the crossroad of other architecture?

Three specific characteristics will help us understand this 'continuum' in Finnish architecture: the specific education of architects within Finland, the office-apprenticeship system and the professional competition structure. They have ensured a vibrant tradition and sustained a strength in the profession which may have all but disappeared in other countries.

Due to the often lengthy education process, architects in many countries have to work at the same time as they study. This type of apprenticeship works both ways. It initiates students into the professional world whilst it also delays graduation. The harsh ordinariness of constant practice is often avoided, as are the loans which eventually have to be paid back. In Finland this apprenticeship is both unique and well-established. It feeds itself back into the schools of architecture where professors are usually established practitioners rather than pedagogues. Appointment of professional architects as professors in the three schools of architecture in Finland grounds this apprenticeship system into one resembling the 'meister class' system from central Europe.

Most professors and assistants in the schools of architecture also run their own offices. Students follow their education almost seamlessly, from institution to office and back again. From the late 1950s to the 1970s, the well-known offices such as Aalto, Revell, Ervi, Siren, Pietilä, Petäjä, Blomstedt and Ruusuvuori all acted as an apprenticeship system for both Finnish and foreign architects and students. And though today collaboration amongst architects has loosened the professional bonds within partnerships, though moving from one office to another is now more common, this type of apprenticeship is still prevalent within Finland. The loyalty, legacy and achievements of the past interweave constantly with the present. The continuum in architecture be-

comes a sequence of subtle, not always minor, gradations between extremes.

Passing on knowledge and ideas about architecture through education and office apprenticeship has also gone hand in hand with the unique competition structure set up by the Finnish architectural profession. Established for over 100 years, most of the well known Finnish architects from the past and the present have established offices on the strength of winning designs in competitions. The list of successful competition architects is vast and the current system of open competitions within Finland and the Nordic countries, or Finland and the European Union, still provides a rare gift for each participant.

> **Established for over 100 years, most of the well known Finnish architects from the past and the present have established offices on the strength of winning designs in competitions.**

A vibrant competition programme means that students not only participate alike with other architects, Finnish or foreign, but they clearly have a chance of upsetting the 'apple cart'.. The system of project evaluation whereby each successful project receives assessment from the professionally appointed Jury is also unique. And though various sources have hinted at the professional control that can exist within any competition structure, Finland's achievement in competitions, through its governing body SAFA (the Finnish Association of Architects) remains healthily unique. It is also, naturally, the envy of many architectural bodies throughout the world.

Do we not remember how five young 23 year old students won first prize in the Seville Expo 92 Finnish Pavilion competition and set up an office to carry out the commission? Calling themselves Monark, they all had long and unpronounceable names.[1] These *five young Hannibals* talked, laughed and smoked their way through what must have seemed to them, a never-ending architectural nightmare. They managed famously to set up an office and complete a remarkable building. And, post-Seville, it looked as if youth might once more be given a chance in developing Finnish architecture. This was, though, not the first time youth broke through. In 1898, three young Finns were designing the Finnish Pavilion for the 1900 Paris World Fair. Eliel Saarinen was 25.

nothing but egg-shells

Armas Lindgren and Herman Gesellius were both 24. And is it not also worth recalling that by the age of thirty, Alvar Aalto had won and lost his share of competitions. By then too he had completed the Turun Sanomat building and Paimio Sanatorium. He had also designed a range of other Neo-Classical buildings only recently re-assessed and critically retrieved as part of his oeuvre.

In 1995 the same five young Finns that had succeeded in Seville returned to the Expo 92 site. Forced into an accelerated adulthood, they were speaking to each other again, though working separately. Upon arrival the scene was stark. As they walked around, a time warp hit them. Since their triumph, graduation and unemployment plus one or two more prize-winning schemes had followed. They felt – and they expressed it forcibly – it was important to show architecture to others as they felt it to exist. Not as someone else felt it to exist. Not as any critic felt it should exist. And certainly not according to any critical text that prescribed how it should exist. But as they felt it to exist!

Despite the success of many young practices during the 1990s, despite the strong continuing apprenticeship system and the competition structure within the profession, there is no doubt however that some ideas of the younger architects can remain on the drawing board or then, lost in the margins of other disciplines, they remain ill-defined, unable to receive any response. But difficult as it is to gain commissions, young architects always shape future architecture by searching for new ways to express even impossible ideas. Today ideas, diagramming, game strategies, looping, sampling and prototyping are all used to explore an architectural process in many ways previously unimaginable. Fused and fusing together, newer practises are starting to seek other means to extend architecture's own site, de-limiting architecture by extending its own brief and contract with itself as a profession.

A vibrant competition programme means that students not only participate alike with other architects, Finnish or foreign, but they clearly have a chance of upsetting the 'apple cart'.

Along with many types of inter-disciplinary experiments, digitalisation and new science, architecture is itself extending its reach.

Some of these younger students and architects also seek newer outlets for their work, acknowledging that competitions do

Some of these younger students and architects also seek newer outlets for their work, acknowledging that competitions do not always widen the design or the operative and productive base of architecture.

not always widen the design or the operative and productive base of architecture. Is it possible to capture a thinking 'in' and 'about' architecture before these architects themselves become involved in that all too familiar second-order exercise, the obligatory task of pitching and advertising themselves and their work? An obligation that can, as we well know, take them away from the very architectural courage and difference they began with.

In a globalizing, satellitizing world, in a world functioning on immediacy and image, the local stamina must produce fresh intelligence and return something back. Whilst the theories move some architects to imitate themselves, the young look as if they are beginning to turn their own architecture into a new fusion, a looping with and beyond the past. This suggests a new talent, a fresh poetics. They begin to speak of taste, history, ecology, nature, Alvar Aalto and architectural metaphors, terminal games, parametrics and inconspicuous architecture, empathetic affinities and electronic spaces. Foam, formica, straw, fibre and sponge can become new building materials. Cities become metaphors for the building interior as they too become seamless, holes are voids, gaps are new networks, data flows visualised architecture and set theory re-applied. Everything is on the move. And as the new architects de-mystify and re-mystify, replying with their own talented invention, there is a question we must pose: what architectural invention and thinking does their intelligence demonstrate?

Whilst the theories move some architects to imitate themselves, the young look as if they are beginning to turn their own architecture into a new fusion, a looping with and beyond the past.

As the new works, new strategies and diagrams speak for themselves, let us remember how Alvar Aalto was once young, how he too changed his mind, imitated others only to discover through in-

nothing but egg-shells

fluence, assimilation, synthesis and collaboration, a remarkable innovation all his own. His work still signals an invention key to the past and the future for many of these young architects. Aalto is the 'continuum' or a major part. But Aalto also expressed ideas like this: "In modern society it is at least theoretically possible for the father to be a mason, the mother a university professor, the daughter a film star, and the son something even worse. Obviously these people have their special demands to be allowed to think and work undisturbed. The modern home must be built to meet these demands."

And the son something even worse! An architect?

"Every artist has been influenced by others," Wittgenstein states, "and shows traces of that influence in his works; but his significance for us is nothing but his personality. What he inherits from others can be nothing but egg-shells."[2]

Nothing but egg-shells?

They begin to speak of taste, history, ecology, nature, Alvar Aalto and architectural metaphors, terminal games, inconspicuous architecture, empathetic affinities, electronic spaces.

1 The five were Matti Sanaksenaho, Jari Tirkkonen, Juha Kaakko, Petri Rouhiainen & Juha Jääskeläinen.
2 For this and an interesting new appraisal to Modern Finnish Architecture see Kari Jormakka's 'Modern Finnish Architecture and Austria since 1900.'

hip

—Architecture is the art of subordination.... Is the right angle the octave phenomenon of the visual world?
Aulis Blomstedt

—I freely confess that my architectural ambitions considerably influenced my social contacts. Artists, writers and actors or Bohemians of any sort mighty indeed be more interesting and often much more fun than the country families and city magnates with elegant houses in Mayfair or Belgravia, but it was the latter and never the former who had jobs to hand out.
Clough Williams-Ellis

It is no accident that we begin our sampling of contemporary architecture in Finland with the word 'hip' and the black house, Villa Sälteskär in Inkoo by Minna Lukander, and end it with the word 'house' and the digital creations and fusion of the group Ocean North. Nor is it any accident that Lukander worked recently (with Pia Ilonen) on the careful and skilful renovation of one of the most important functionalist icons of the 1930s in Finnish architecture, Viljo Revell's Glass Palace (1936).

It is the vast range of new work, the relationship to architectural history and the understanding of the 'continuum' legacy that begins here, as both departure and, as we pass through to the second section called 'hop', transformation. A 'legacy' can, of course, indicate a programmatic hold on the present by the past. But is it not too simple to assert these young practices are only altering an accepted and refined 'continuum' in Finnish architecture? The concept of re-treading, in tires as in architecture, may not be quite as simple as it seems. Whilst there are new practices that affirm an identifiable signature, there are others sampling wider source, fusing new disciplines and varying architectural experience itself. The combined aim of these works is 'difference'. Most of them experiment

within the limitations of the profession and though their works may not be clouded with critical theory, their architecture is still *thought through* differently.

In many ways the works in this first section – Hip – allow us also to demonstrate the strength and the potential misunderstandings that have gone unchallenged within the notion of 'Finnishness'.. For many years this notion has been a critical paradigm with which to appraise the work of very many different architects. Natural, human and Finnish! Perhaps this notion still allows us to identify works that not only appear to signal a relationship to the past, a legacy to previous work, but seek that promised 'timeless' solution to architecture which Petri Rouhiainen describes as 'unplugged': "I've always thought of my work as an example of Unplugged Architecture. Like music that real people play with real instruments. Think of Crosby Stills Nash & Young and "My house". Or Neil Young and "Old Man". And listen to the harmony of voices and the somewhat ragged guitar sounds and the contrast between the two. These appeal to me!"

Rouhiainen speaks for others in the respect given previous architecture whilst expressing a desire to avoid facile national myths. He helps us understand why it would be a mistake to read these projects only as a development in relation to increased technique and material technology, or as a new answer to old issues. This would deflect critical enquiry away from the innovations, the serious planning ideas and the genuine desire to attack issues thought already irrelevant in more urban, media-rapid societies. Issues like rural planning, ecology, sustainability.

Of course in these works there are echoes to Aalto's vast legacy. But the works also demonstrate an ongoing, even ambiguous, debate with one of the most influential thinkers and teachers in Finnish architecture, Aulis Blomstedt. To debate the merits of Blomstedt is to take on the classical modern spirit in Finnish architecture and suggest new ways of finessing architecture's constant mission; to shelter those wishing to dwell, to house architecture. Blomstedt's echoes are still heard in many of the young; to house more naturally is to understand the nature of place itself! In relation to an understanding of the history of modern architecture, this is a synthetic process, a series of re-mappings which of course never can, and never will, quite close on any original.

That said, many of the works shown here also demonstrate an interest in not only understanding Alvar Aalto in a more contemporary way but allowing the past in the form of Saarinen and Lindgren, Aalto and Blomstedt, Pietilä, Revell and Petäjä and others, to become part of the sequence. The check to a strict binary thinking in the 1990s allowed younger architects to look again at Aalto's alleged softer line. Following the sensitive work of Sopanen and Sarlin, or Saara and Janne Repo, to the housing of Mäkipaja and Hannunkari (seeking the ordinary in everyday life minus any gimmicks), the sensitivity of Mustonen and Keskikastari, the ecological programme for HKR onto the larger, significant works of Bruun & Murole, JKMM architects and APRT, culminating in the latter's acclaimed Sibelius Hall in Lahti (Tikka & Lintula) we can see how the rational line of Aulis Blomstedt and Aarno Ruusuvuori has been fused with a tempered, even playful tectonics. The strong use of wood amidst steel and glass, the careful, even excessive detailing and rhythmic elegance, indicates a return to accepted Finnish values; something natural, human and, of course, those 'Scandinavian references' critics will identify. The difference here is the extent to which these works extend that spirit beyond the present.

To balance the classical 'modernist' line of some of the larger civic projects shown here, it is rewarding to scrutinise the apparently more modest works, those of Tuomas Silvennoinen in his approach to the Orthodox Centre for Religion and Culture, Jenni Reuter for her Straw Bale Cabin in West Finland and her collaborative women's work in Senegal, and Jari Tirkkonen for his Architect's Nest. Here one senses the subtext within the Blomstedt programme for Finnish architecture; that desire for an uninflected, modest, utilitarian architecture which proves as economic and as attractive as some of the larger projects. As Aulis Blomstedt was fond of narrating, he saw an image on the beach after the more fashionable modernists had left. There, alone, he would be picking up the flotsam and jetsam from the past and making once more significant architecture.

The idea of practices fusing and transforming as they do in Finland, in size and idea, is of common interest. The group Hunga Hunga formed and then de-formed (or trans-formed). It is a pattern than we see repeat itself as young architects seek new ways to work and collaborate. In such institutionally provisional structures, new architecture is created. Currently Hunga Hunga now go

under the name HKR Architects' Cooperative. Their working methods reflect the debate mentioned above. Fusing 'discussion, argumentation, mutual rivalry, independent decision making and collective responsibility' is, they admit, sometimes laborious, often painstaking but mostly energetic and beneficial. Like many of the earlier known modernists in Finland, it is a method which requires an office small enough - metaphorically and literally – to be able to continue working around one big drawing desk. In this way, the young repeat the ambitions of the 20th Century Finnish architects as they attack issues that vary in scale from urban planning to miniature design projects, whilst at the same time many if not all – in some way – seem to be involved in teaching and research.

The strengths and loyalties continue. Architectural competitions have been important for the 'hip' architects, many having been awarded prizes. As diversity encourages innovation, as the past is continually negotiated, the lack of universal rules and fundamental truths proves irresistible. HKR are worth citing: "Ecological thinking is – however – a uniting theme in all our work. Instead of being post-modern, we think of our work as post-humanist. This means that we want to challenge anthropocentric thinking and promote a bio-centric approach instead. We want to emphasize a shared human responsibility over environment and solidarity with nature. Furthermore we think architecture is not simply an activity restricted to the architect. It is as much an activity for those who enter, use and experience the built environment."

Whether these architects attempt private houses, housing design schemes or civic projects, whether they opt for experiments in mobile dwelling, open building and sustainable development, there is also a mutual interest in the integration of working and living. Time and again we notice here a serious echo to the natural and the debate on a contemporary loss of spirit. Perhaps Tuomas Silvennoinen's words might be more generally applied, for he seems also to speak for others:

"Though I have never felt an affinity to natural forms as direct models for architecture, I do regard the logic and genius of living organisms as a suitable model for man's imperfect construction skills. Although I have spent my life in the city, the peasant building tradition has become the most important model for me. In the peasant tradition, buildings were always parts of a whole moulded by man and nature. They lacked sculptural heroism and uncontrolled outbursts of emotion."

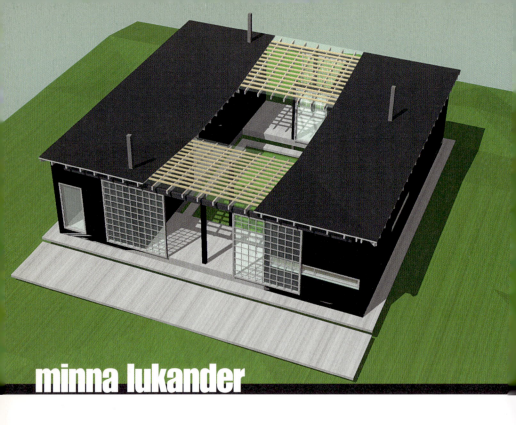

minna lukander

The common dominator of these projects is their adaptation to the existing landscape. The road project, Eliel Saarisen tie, is being constructed amidst the 1950s milieu of the Haaga district of Helsinki. The local inhabitants vigorously opposed the idea of a new street for many decades until the city eventually commissioned an 'ideas scheme' which involved covering and landscaping the street. We proposed planting the covered area of the tunnel with greenery as a compensation for the loss of the formerly wooded area, the intention being that the tunnel roof is a visual, landscape feature rather than merely being functional.

The location of the Savotta Day Care Centre on a rather small site was one of the reasons for the two-storey solution. In order that the building would not deviate in height from the surroundings, we designed a sloping grass roof, the higher end of which meets the woods behind the building. The Villa Sälteskär is situated on a narrow neck of land in the windy outer Finnish western archipelago. The atrium courtyard is a sheltered place maintaining visual connection to both the northern and southern seascape.

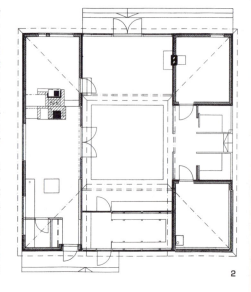

2

minna lukander

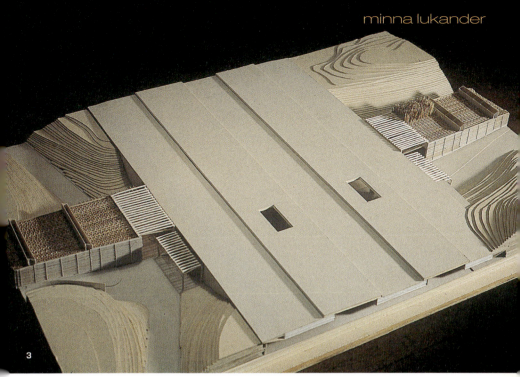

1–2 Villa Sälteskär @ Inkoo, Finland, commission 2001 > **1** computer perspective / **2** plan / 3–4 Eliel Saarisen tie traffic tunnel @ Haaga, Helsinki, Finland, realised 2001 > **3** scale model exterior / **4** scale model interior.

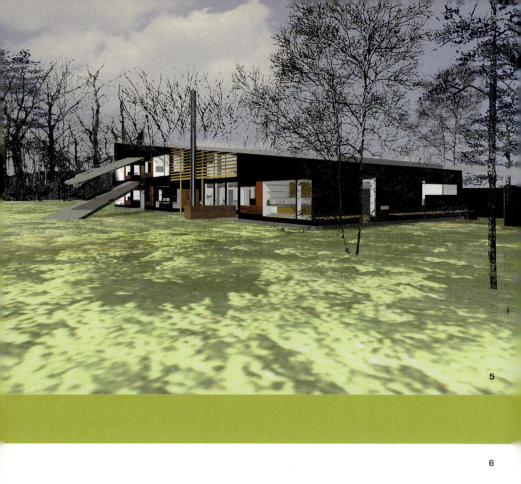

5

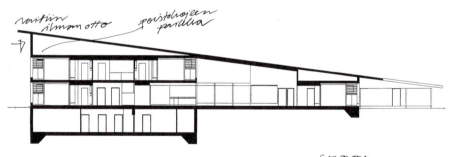

6

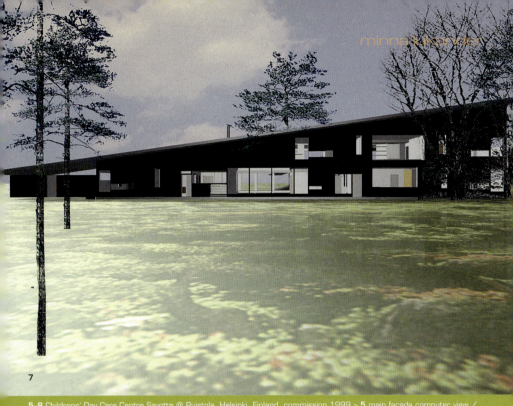

7

5–8 Childrens' Day Care Centre Savotta @ Puistola, Helsinki, Finland, commission 1999 > **5** main facade computer view / **6** section (sketch) / **7** backside computer view / **8** first floor plan.

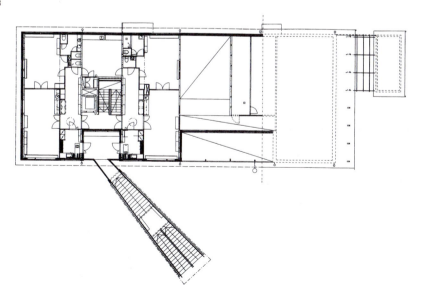

8

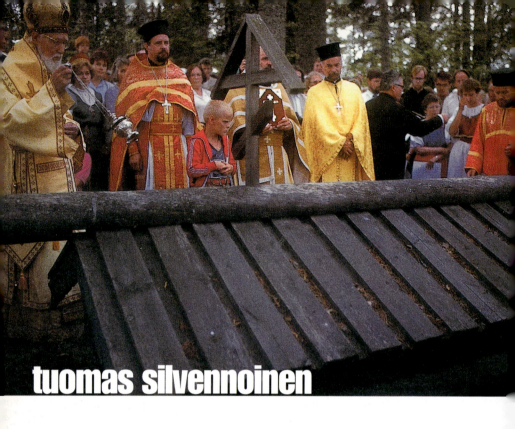

tuomas silvennoinen

Architecture is often compared to music. It could equally well be compared to poetry. We speak of poetic landscapes and city spaces. Good poems are also real spaces which we enter when reading. The spatial experience built of words is very similar to the tangible architectonic space created out of scents and aural worlds. Though I have never felt an affinity to natural forms as direct models for architecture, I do regard the logic and genius of living organisms as a suitable model for man's imperfect construction skills. And though I have spent my life in the city, the peasant building tradition has become the most important model for me; buildings always parts of a whole moulded by man and nature, lacking sculptural heroism and uncontrolled outbursts of emotion. I do not believe that there is a right or wrong architecture, but there is good and bad architecture. The architect's profession is, above all, a social mission and art form and the architect must be able to identify and solve problems. Technical or functional challenges often bring tension to the design, helping to create strong architecture. Perfect freedom is not, in my opinion, fertile ground for the architect's work.

CENTRE FOR ORTHODOXY & NATURE

The roots of Finnish Orthodoxy go back 2000 years. The active Orthodox Parish of Ilomantsi, a small municipality in Eastern Finland, is 500 years old and represents the oldest unbroken Christian tradition in Finland. The Parish Church, dedicated to Prophet Elijah, was completed in 1892. The Centre for Orthodoxy and Nature offered opportunities to study both Orthodox culture and its potential architecture. Nostalgia and a longing for the areas lost in the wars too often colour images of the Orthodox Church in Finland. The new Centre will provide information and experiences at the intersection of different periods and cultural spheres of the Orthodox world, whilst also expressing the rugged nature of North Karelia.

With the help of modern technology, real-time connections are created to neighbouring villages and others around the world, for example, to the monastery mountain of Athos in Greece.

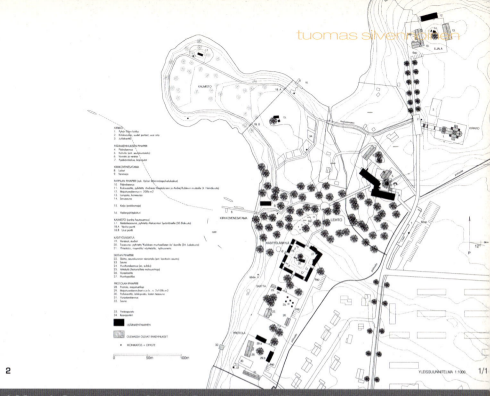

1–6 Centre for Orthodoxy and Nature @ Ilomantsi, Finland, commission 2000 > **1** orthodox ritual / **2** general plan / **3** south facade. The project includes dwellings, an artisan village and two chapels (tsasouna) in a modern style. The new buildings are of wood, as is the existing building stock, including the valuable old vicarage milieu.

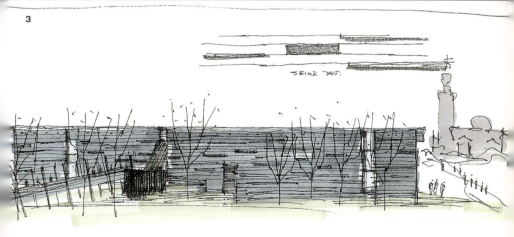

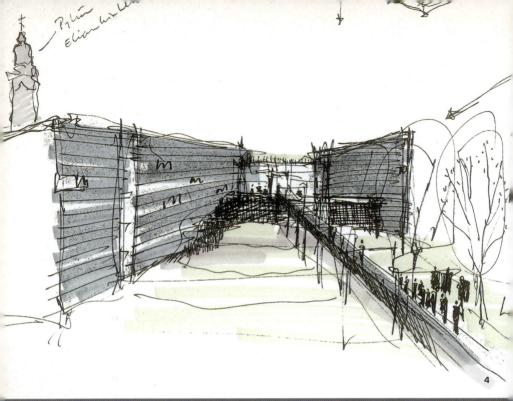

4 the main building of the centre, exhibition and assembly spaces: two simple wooden masses, "halves of old Karelian houses connected by a glass pavilion. One continues along tarred wooden ramps into the grove that splits the area. At its heart is a temple, a glass church. / **5** forest tsasouna / **6** church

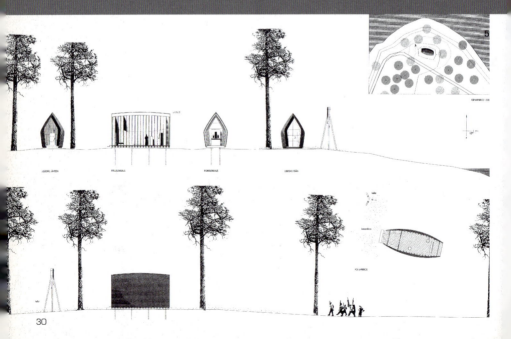

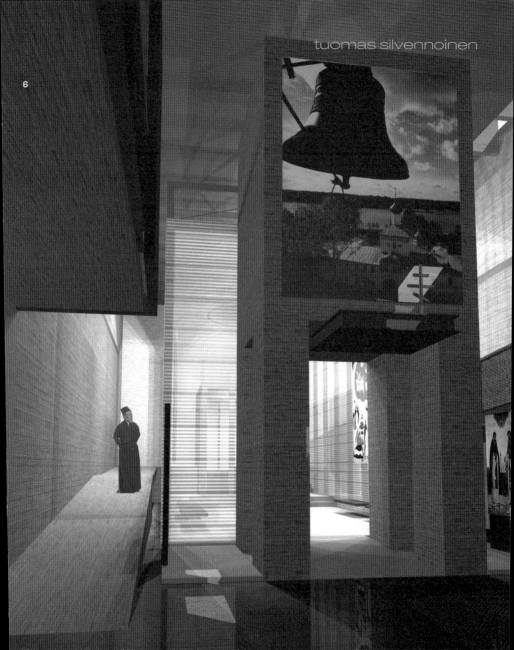

Visitors descend to the exhibition spaces in the forecourt of the church along a ramp that circles the glass church. The ritualistic descent alludes to the services of the original church in the catacombs and to the Orthodox tradition of processions with a cross. Excerpts from the texts of the original Greek New Testament have been sand-blasted into the walls of the glass church.

The church is the main source of light in the space, a gigantic light fixture. Natural light from the south, filtered by foliage, spills into the space with the help of light-catchers in the eaves. The relationship to light is probably the biggest architectonic difference between Lutheran and Orthodox churches. In Orthodox churches, light from candles and, to some extent, also electric light is used to highlight the different stages of the service. The light in the churches is an internal light, also referred to as "quiet light".

sopanen & svärd

Pia Sopanen Ilkka Svärd

Since 1983 whilst working together we have also been team members in different architectural and design projects. We share common beliefs. Our working methods have been unified by working on several architectural and design competitions. In our own work there is also a clear correlation with painting and sculpture. Our designs are a result of interaction and an intense self-criticism.

THE HOTEL KOLI AND HERITAGE CENTRE

The Hotel Koli and Heritage Centre is situated in Koli National Park, a nationally significant environment, geography and landscape. The two separate buildings and the courtyard connecting them simply use natural materials and a modern timeless architecture.

The design improves the existing built environment whilst respecting the spirit of the unique site and its ecological values

The partly newbuilt and totally renovated hotel, The Heritage Centre UKKO, is a independent functional unit with its own strong character.

1–4 The Hotel Koli and Heritage Centre @ Koli, Finland, open competition, 1st prize 1997, commission, realised 2000 > **1** Heritage Centre Ukko, south elevation / **2** model / **3** autumn mist / **4** first floor lobby.

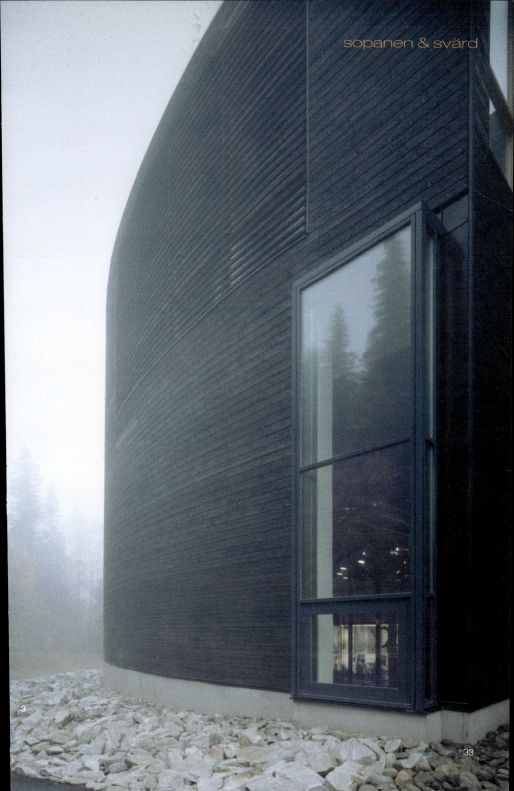

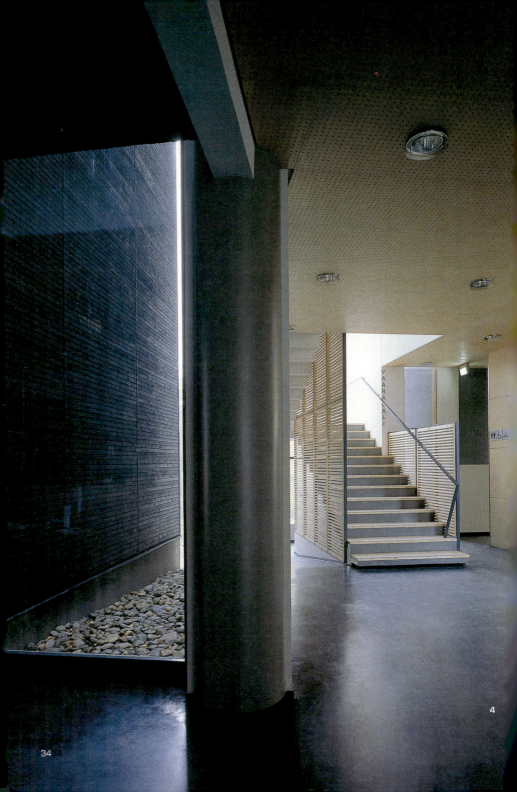

sopanen & svärd

5–7 Järvenpää Pajala area competition, Finland, 2nd prize 2002.

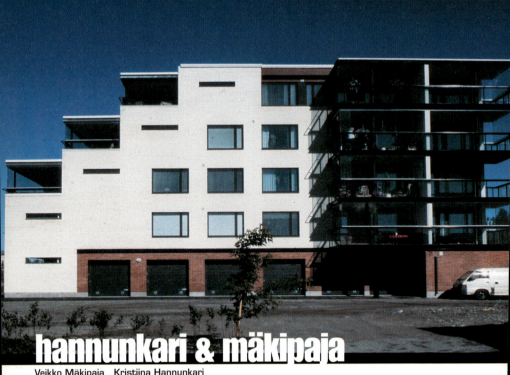

hannunkari & mäkipaja

Veikko Mäkipaja Kristiina Hannunkari

Contemporary living in a media and market oriented metropolitan network is usually hectic. Shuttling from one activity to another, people have specialized needs, trends come and go…

City life and also buildings have become spectacles and happenings, not a natural part of everyday life. We meet either very large monsters or uninteresting small scale projects in suburbia. Financing and planning mechanisms control projects in a mediocre way.

Our work deals most with the everyday life of people. To create places that users of the environment can adapt to and make themselves at home.

Too often home or work is connected to the rest of the city only by a parking lot. The dialogue between houses and their surroundings is crucial.

Basic town-elements, the street and square (dynamic/static space) create neighbourhood unity.

Environments on the other hand should offer relaxing private places, possibilities for different lifestyles. Mixing different house-types offers a natural diversity. Public space should not be oversized. Only the essential that can be designed with a high quality.

Our buildings are usually quite simple with solid volumes. In our climate this is ecologically a natural solution. Around the basic body of the house there are lightweight structures for living to expand in short summer periods and to identify one's private space. We like to emphasize entrances, passages from outside to a more intimate world. The interplay between different elements create richness in the environment, more important to us than one individual building.

It is a game of order and variation. Different programs, materials and building techniques respond to this game in a different way. Every milieu has its effects on the image of the building; we try to find a different story for the different surroundings.

hannunkari & mäkipaja

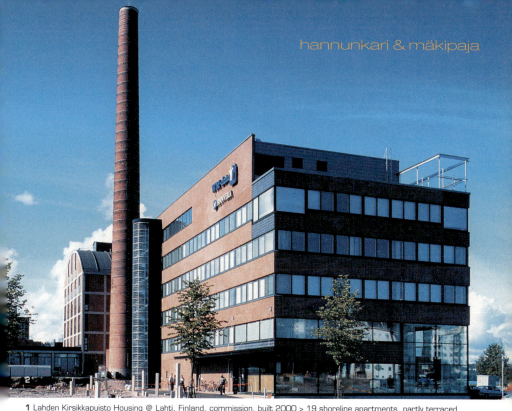

1 Lahden Kirsikkapuisto Housing @ Lahti, Finland, commission, built 2000 > 19 shoreline apartments, partly terraced.
2 WM Data IT office building @ Lahti, Finland, commission, built 2000 / **3** Sorsavuorenkatu Housing @ Helsinki, Finland, commission, built 1999.

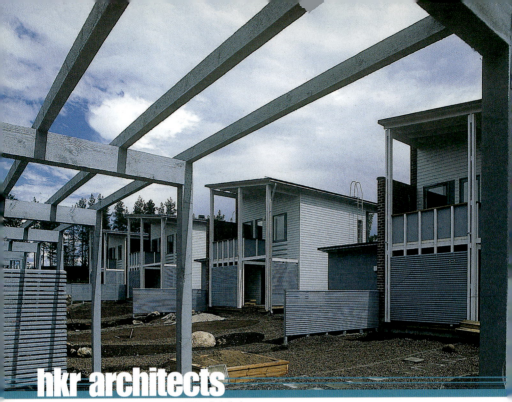

hkr architects
Markku Hedman Timo Karhu Mikko Reinikainen

HKR's working methods are based on an ambiguous mixture of discussion, argumentation, mutual rivalry, independent decision making and collective responsibility. It is laborious, sometimes painstaking but mostly energetic and beneficial. It is a method which requires us to keep the office small enough to be able to continue working around one big drawing desk.

During the last five years our activities have varied from large scale urban planning to miniature design projects, including also teaching and research. Architectural competitions are also an important part of our work (present members of the cooperative have been awarded prizes in 13 competitions). We respect diversity and cherish innovation. For us there are no universal rules neither fundamental truths in architecture. Ecological thinking is – however – a uniting theme in all our work. Instead of being post-modern, we think of our work as post-humanist. This means that we want to challenge anthropocentric thinking and promote a biocentric approach instead. We want to emphasize a shared human responsibility over environment and solidarity with nature. Furthermore we think architecture is not simply an activity restricted to the architect. It is as much an activity for those who enter, use and experience the built environment; something we attempt in our recent housing designs using ideas of mobile dwelling, open building, sustainable development and integration of media, working and living.

1–3 Kissankäpälä Housing @ Tuusula, Finland, commission, built 2000.

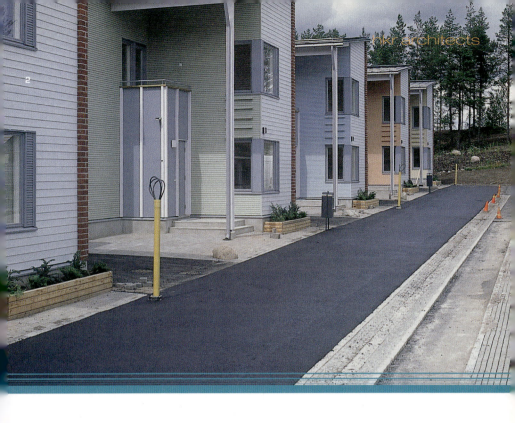

2

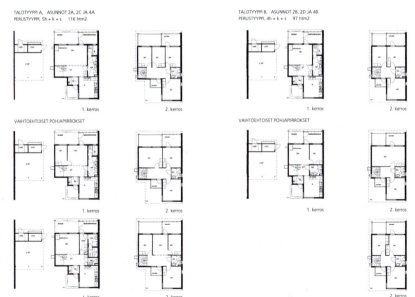

TALOTYYPPI A, ASUNNOT 2A, 2C JA 4A
PERUSTYYPPI, 5h + k + s 116 htm2

TALOTYYPPI B, ASUNNOT 2B, 2D JA 4B
PERUSTYYPPI, 4h + k + s 97 htm2

1. kerros 2. kerros

VAIHTOEHTOISET POHJAPIIRROKSET

VAIHTOEHTOISET POHJAPIIRROKSET

1. kerros 2. kerros

3

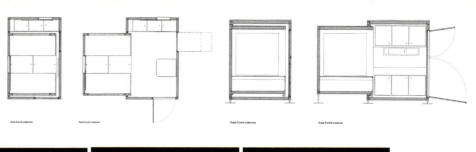
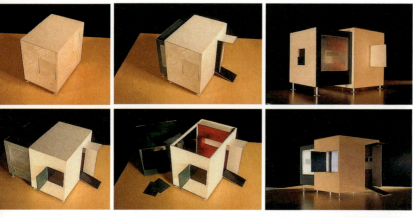
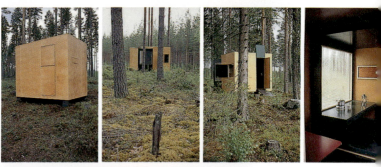
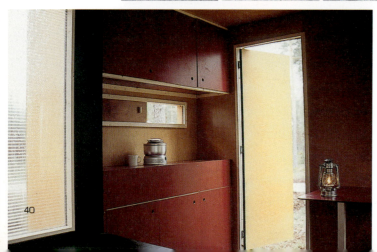

4 Kesä-Kontti Portable Holiday Residence, commission, built 2000.
5 Raisio Library and Auditorium @ Raisio, Finland, competition entry 3rd prize 1996.

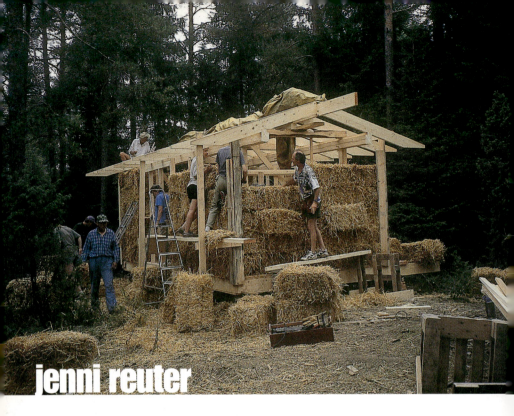

jenni reuter

STRAW-BALE CABINS

The old croft of Sattmark stands at the intersection of two important routes: the Saaristotie (Archipelago) road and a boat route leading from Parainen to Airisto near Turku. Rented cabins in connection with the existing cafe at the site will provide a subsidiary livelihood for the Lofsdal estate. The cabins were built by amateurs participating in courses on straw-bale and clay-straw construction.

The first straw-bale cabin of 14 m² was based on straw bales (ca. 75 x 45 x 35 cm) and recycled windows (68 x 98 cm), sleeping space for four, and the possibility for simple cooking. A natural aspect of straw-bale construction is to minimize openings in the walls. The windows and doors of the house were placed between the straw-bale walls which had no fenestration or openings. Two entrances, both leading to the well-lit central part of the house which contains a cooking range, heating stove and a dining table. Flanking the central part are bunk beds and beds that can be combined into a double bed.

In order to minimize transport local materials were used as much as possible. The straw-bales were made in the fields of the Lofsdal estate and dried during the winter in a nearby barn. The timber for the bearing wooden frame comes from the local forest, the foundations are of unworked stone, and the recycled windows are from the old Littoinen broadcloth mill. The tar was made in a small tar-burning pit a kilometre from the site, and the plaster was made of local clay, sand, straw and cow dung.

1-2 Straw-bale Cabins @ Sattmark, Parainen, Finland, commission 1997-99 > **1** cabin under construction / **2** interior.

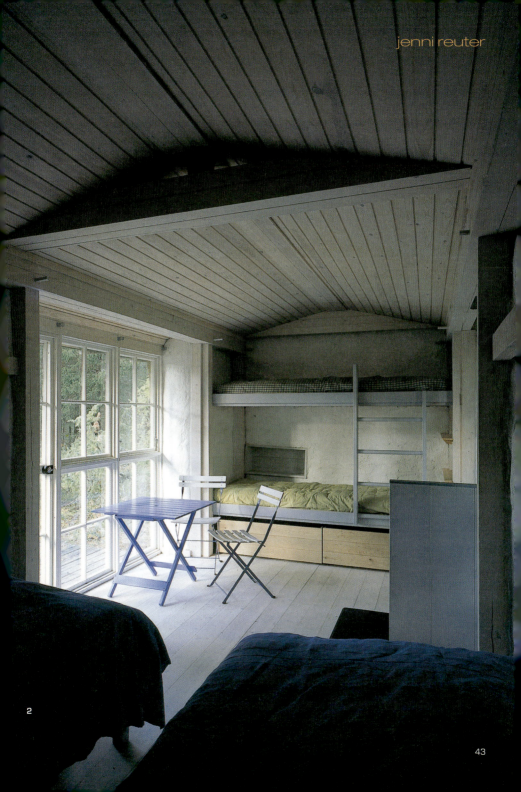

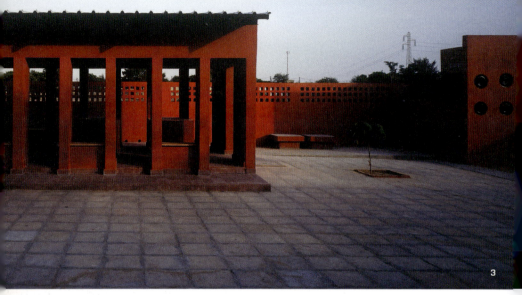

3-4 Women's Centre@Rufisque, Senegal, project, realised 1995– > **3** courtyard / **4** streetside.

WOMEN'S CENTRE

Women in Senegal follow the general African custom of organizing into bodies ranging in size from a few dozen members to hundreds of women. Groups of active and strong women seek to make the lives of their members easier amidst conditions of everyday poverty and to ensure a tolerable level of social security. They are also involved in improving their standard of education through voluntary literacy courses, maintaining traditional handicrafts customs and methods, and helping women moving into the cities from the countryside to adapt to their new conditions. This work is organized and arranged from within the groups, which signifies a step forward from traditional social networks of relatives and friends.

This plan for a women's centre in the suburbs of Rufisque in Senegal is a project fostered by a civic organization upon the initiative of three architects, Saija Hollmen, Jenni Reuter and Helena Sandman. The project began in 1995 as part of the Helsinki University of Technology Architecture Department course "Interplay of Cultures". It seeks to facilitate the work of women's organization.

In keeping with local custom, the building is arranged around an internal courtyard, with a distinct boundary between the private and the public sphere. The simple design of the street front makes the building conform to its setting; a corner opened at the intersection forms a small public square opening onto space reserved for shops and trading.

Ecology and local considerations are emphasized in the choice of material; for example timber is used only where it cannot be replaced by any other material. Employed in the various details are materials such as recycled wheel rims for vents and old glass bottles for fenestration. The design of the roof structure seeks to provide a cool internal climate without compromising durability. The centre was completed in October 2001. Hundreds participated in the opening festives and the atmosphere was happy and relaxed.

(In collaboration with Saija Hollmén and Helena Sandman.)

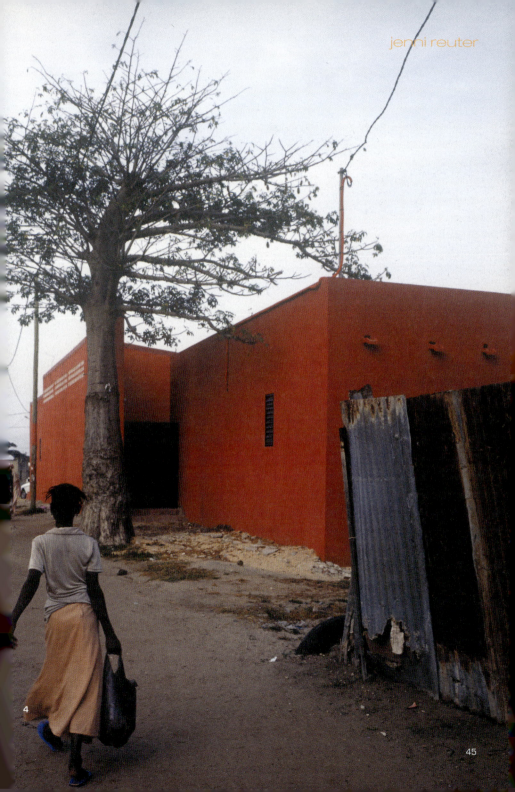

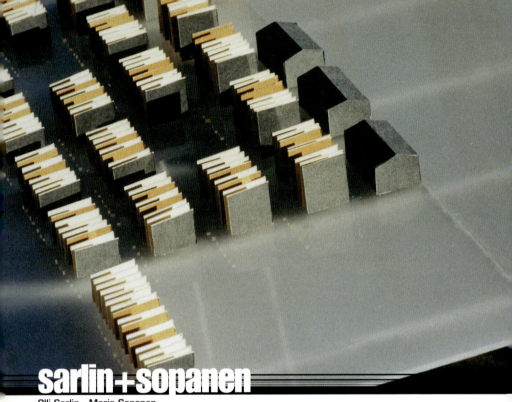

sarlin+sopanen
Olli Sarlin Marja Sopanen

The architect's task has traditionally been to create a good and pleasant environment. For us the role of the architect must be wider than merely resolving function and giving form. The architectural context has become global, demanding a more holistic attitude, largely related to taking responsibility for the environment. Architects can now even act outside their traditional field by, for example, taking a stand on renewable energy sources in power production or energy saving strategies. Not unconnected with architecture, for example the consumption of energy is significant in both the construction and maintenance of buildings, especially in the Finnish climate. Considering ecological sustainability the most important decisions are made without exception at the beginning of the process. Through an active role it is possible for architects to use their authority on many different levels in planning and construction, allowing them to be more involved in public discussion and gathering and distributing information about sustainable developments in architecture.

When ecological aspects are taken into consideration in architecture, the architectural task becomes more interesting involving methods to combine ecology and aesthetics, sustainable architecture with contemporary design. Traditional architectural methods serve ecology on a local level by providing a favourable microclimate and using passive solar energy. Today, however, planning and design choices have increased global effects. Ecological evaluation begins with urban planning and reaches as far as any chosen materials. Preserving and reusing existing buildings is in most cases favourable – no other way utilises maximum energy input. Maintaining the history and strengthening the identity of place also makes it easier for users to adopt the project, something which then increases social sustainability. By using simple, environmentally friendly materials like wood or bricks, it is possible to create visually pleasant surroundings. The use of pure, homogeneous materials also makes recycling easier.

1–2 Europan 5 @ Tallinn, Estonia, competition entry 1st prize, 1999 (Tuomas Hakala, Olli Sarlin, Marja Sopanen, Katariina Vuorio).

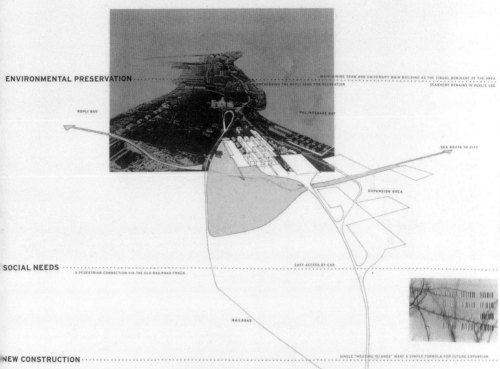

GOOD HEAVENS, CLEAR SKIES!

Our entry emphasized preserving the unique historical urban granularity of both the competition site and in a broader sense the whole Kopli area. At the same time we took into account the various social needs of the future residents. We came up with a theme where new structures gradually replace the old.

"Housing islands" presented in the competition entry make a simple pattern for the future expansion of the Kopli area. Automotive traffic is separated from pedestrian traffic and is rerouted, the tramline's dominance is preserved. The pedestrian route smoothly following the existing railroad expands the Kopli-park into a green axis running across the peninsula thus connecting the two bays.

The dense and low blocks provide a favourable microclimate on the otherwise windy seaside. Empty sites converted into public squares break the monotony of the urban structure. Buildings facing the squares have common and commercial spaces on the ground level. As a contrast to the semipublic ground level each apartment has it's private entrance, plenty of outdoor space on the roof terraces and a seaview to the Baltic. The new apartments are flexible. The simple structural system allows a wide range of dwelling sizes thus promoting social diversity.

(Tuomas Hakala, Olli Sarlin, Marja Sopanen and Katariina Vuorio.)

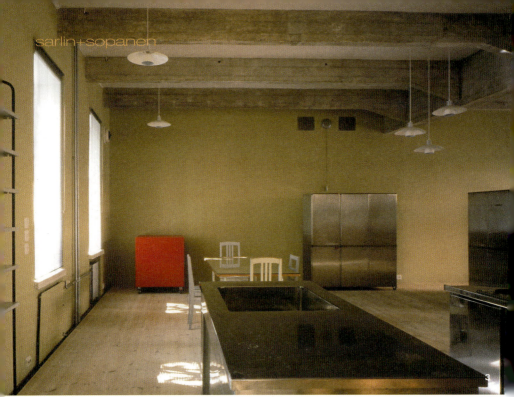

3 Knitting Mill Silmu (Sopanen & Sarlin loft), apartment renovation in former industrial building @ Helsinki, Finland, built 1996–1997 (Olli Sarlin, Marja Sopanen) / 4 Satumaa 'Dreamland'@Tikkurila, Vantaa, Finland, open competition, tied second prize (first prize not awarded), 2000.

KNITTING MILL SILMU

The loft apartment is located on the ground floor of a former textile factory, a red-brick building in central Helsinki (1928). The upper floors of the three-storey building were converted to apartments a few years ago whilst the ground floor, originally the office, was turned to other commercial uses. The aim of the project was to uncover the original volume and structure of the factory and convert the space into a large open-plan apartment. Partition walls were removed and suspended ceilings stripped away. The shuttered concrete beams underneath cleaned and concrete and exposed red-brick walls sealed with a mixture of beer and wallpaper paste. The timber joists from the ceiling were reused as studs for the floor and a new bleached and oiled pine floor laid on top.

The L-shaped apartment is arranged with the bathroom and kitchen occupying the shorter end of the plan and a 60 square-metre open plan living and sleeping area running across the full width of the building. The bathroom occupies a new structure covered with plywood and also forms a housing for the oven and kitchen cupboards. The bathroom enclosure stops short of the ceiling to indicate its newness and provide storage space above. Almost every other element in the apartment is mobile. The living and sleeping area can be divided with pieces of old hospital furniture. Recycled materials have been widely used.

SATUMAA 'DREAMLAND'

The project is named after the well-known Finnish tango Satumaa meaning Dreamland. Over the years, several plans have been drawn for the centre of Tikkurila (the administrative capital of Vantaa, a neighbouring town of Helsinki) without putting them into practice.

Task: to develop the large central block of Tikkurila bound by the railway into an attractive centre and a place for the townspeople to gather. To be achieved by adding to the area new buildings for commercial, administrative and also residential use plus the introduction of a large urban park and a market square.

Our proposal tried to strengthen the identity of the area by maintaining recognizable fragments of the existing city structure, and emphasizing the historical importance of the railway station. The density of the area has been increased and the spatial quality defined by additional buildings.

A street leading through the area westbound from the railway station is converted into a pedestrian route whilst another important connection is the north-south axis, which is enhanced rhythmically by a series of squares.

The market square is located at the intersection of these pedestrian routes. North from the square stands a new church surrounded by the park. Residential buildings are placed next to the railway with patios opening onto the urban park which flows through the area offering additional pedestrian routes.

(Tikkurila Area 2000, Open Competition – tied second prize: first prize not given – design team: Sari Lehtonen, Olli Sarlin, Marja Sopanen and Heikki Viiri.)

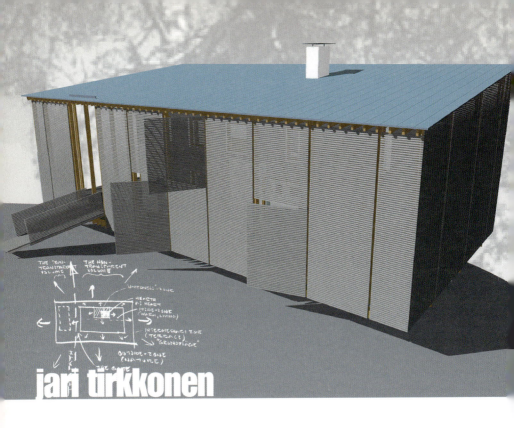

jari tirkkonen

AN ARCHITECT'S NEST

The master plan consists of three buildings: the main house, the store and sauna by the lake. Each building has two volumes creating gates through which a path meanders, ending on a jetty.

Each building also has a terrace that forms a distinct level, a Grundfläche above the ground.

A kind of a "natural courtyard" is enclosed by two rocky hills, the storage and the main house.

The spatial idea of the actual Nest, the main house, is very simple: an empty space into which a block containing Finnish bathroom facilities and a hearth have been placed. All living functions radiate around that block.

The house consists of the hearth and three concentric zones: the bathroom ("nakedness") zone, the living zone and the intermediary zone (terrace); maybe the nature surrounding the building can be called the fourth zone, the outside zone.

The more intimacy is required, the inner the zone, applying the same sort of principle as with phenomena like transparency, natural light and temperature.

The first floor is half the size of the ground floor. The opening between the floors serves a visual and audial bond between the floors and a reservoir space for future extensions.

As a second stage of the terrace design, the whole building may be covered with a wooden grille – or one made from cloth – consisting of openable shutters.

In addition to its somewhat experimental architecture, the Architect's Nest is a study in creating an ecologically and economically sustainable building by using normal off-the-shelf materials and products.

Propellerhead-mentality has been avoided. Mostly.

jari tirkkonen

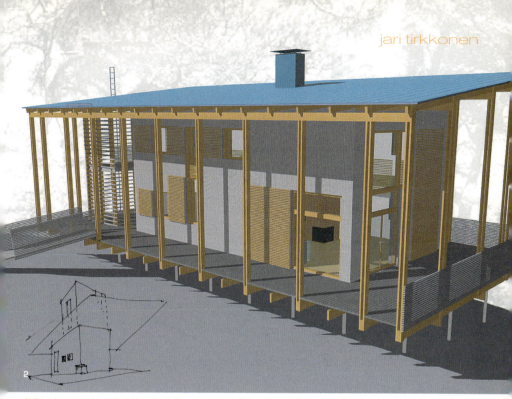

1–3 An Architects Nest @ Kirkkonummi, Finland, own experimental private house project 2002 > **1** perspective rendering, exterior stage 2 and explanatory sketch / **2** perspective rendering, exterior stage 1 / **3** interior sketch (lines) and axonometric sketch.

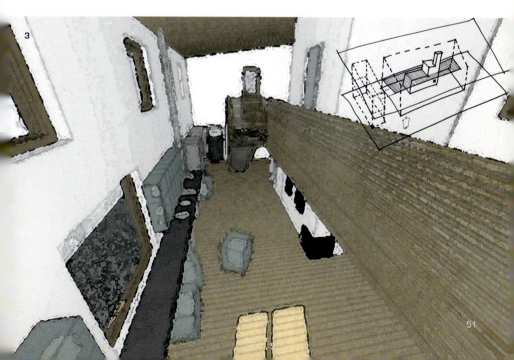

saara & janne repo

FIRST THOUGHTS

What does architecture mean to us? How do we approach the problem? What are the factors and variants? What is the equation? Avoiding the obvious – searching the obvious. What are buildings to us? What is the city to us? Ecology vs. economy? Change and permanence? Generic and unique?

In our practice we always try to find the underlying structure as an universal answer to specific problems. This structure is more like a scheme or strategy. It doesn't need to take any particular form or shape to make it physical. The approach is in some degree diagrammatic, with the exception that our diagrams don't wear clothes. They are open to different kinds of solutions and styles. They are open to changes in the actual design process, which makes them quite useful tools.

We began our studies with a touch of deconstruction – something like that was going on at the time. Nobody knew then exactly what it really meant. We just had to live (and learn) in confusion. To begin the study of architecture at this stage – to deconstruct something you haven't ever constructed before – city, buildings, meanings, everything was an interesting and a fruitfull starting point. So the concepts 'new' and 'modern' gained other meanings in our minds. It was a relief. We felt free to find the questions and search for the answers to them. It wasn't important whether they were right ones because sometimes there are no right questions or right answers either.

CITY, NATURE, ARCHITECTURE – these all get a new set of values every time we approach the task. For us there is no fixed equation to answer the question of what architecture is. The equation is formed from different factors and variants bonded to time and the occasion.

Modernity means to us the urge to sense the time and the occasion – to find suitable 'keys' to open the 'locks'. Modernity doesn't prevent us using those keys that have existed even for a century, as long as they work in the chosen occasion and solve the problems posed today. A found key can't be used with the same exact original meaning but we can use it as a mould to form a new key

saara & janne repo

2

1 'Multum' flexible housing unit @ Ylöjärvi, Finland, competition, 1st prize 1994 / **2** 'The Guide' sustainable development day care centre "by Nature" @ Helsinki, Finland, competition, honorary mention 1996 / **3** 'The Cycle' growing housing unit @ Eco Village in Tuusula, Finland, competition, honorary mention 1996.

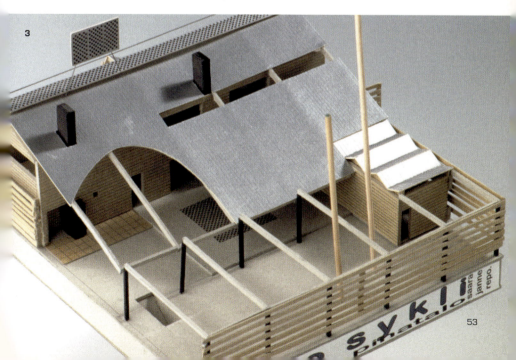

3

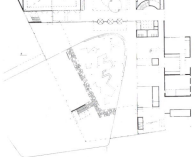

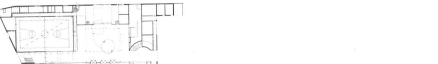

and use it in this time. We leave it to others to rediscover it and make a new mould out of it... and so on, over and over. Keys can be found everywhere. It is a totally subjective choice after all which key it is, and how it is going to be used to solve the problem in a given task, in just this particular occasion. Forms and 'metaforms' are individual interpretations of how the solved problem is spoken out.

There is a language and then there is an individual way to speak. In our projects we have kept the forms relatively simple so far.

In the future functions will be separated from architecture when technology is advanced enough to free space back to art and people. Functions will not be important any more – technology will do the dirty work – architecture can then evolve or go back to the caves where everything started – a digitalized cave!

saara & janne repo

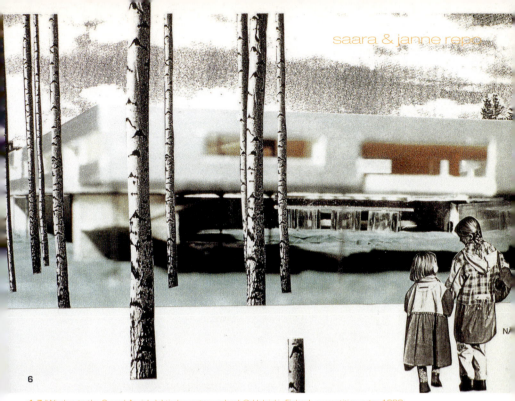

4–7 'Window to the Space' Aurinkolahti elementary school @ Helsinki, Finland, competition entry 1999.

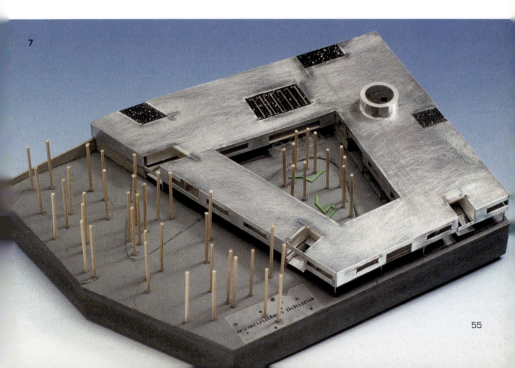

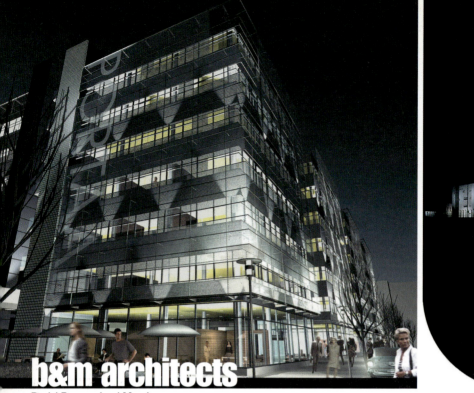

b&m architects

Daniel Bruun Jussi Murole

For a young architectural office we have been fortunate to have had the possibility in our work to cover the whole range of architecture, both in Finland and abroad. Our projects have varied from new cities to detail design, including administrative centres, housing areas, public and private buildings, apartments, traffic areas and urban landscapes. One of our main projects is the Al Jufrah Administration Centre and Congress Hall in North Africa; a commission which allowed us to design everything from the master plan down to the smallest detail.

"The new centre leaves its own trace on the landscape through very elementary geometric forms and alignments. It interacts with the old city and marks the desert through an intersecting combination of two orthogonal grids. The project is designed around the interaction between two building strategies; one aimed at defining territorial-urban form and the other working around the design of architectural forms."

Architectural style is not essential to us; buildings are always part of the environment. The city and buildings in the desert of Sahara or a small villa in the Finnish archipelago look different but they share common design philosophies: interaction between interior and exterior spaces and geometric forms often producing a circular system or plan in order to create a focal place for the site or space.

Sometimes we compare our projects to the thousand and one nights – there is a different story behind each project but one can still find connecting themes, connecting stories.

1 Portaali Office Buildings @ Arabianranta Virtual Village, Helsinki, Finland, commission 2000 > Two office buildings, 26.000 m². Arabianranta will become Helsinki's centre of art, design and new media. Arabianranta is a life-size prototype of the 21st century information society. The Portaali office buildings are like two slit cubes, the office spaces divided by a glass-covered void.

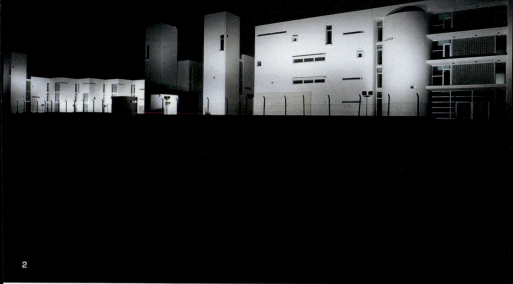

2–3 Al Jufrah Administrative Buildings @ Al Jufrah, Libya, commission, built 1992–2001. The project comprises the Congress Hall and a library, two main buildings and 14 office buildings.

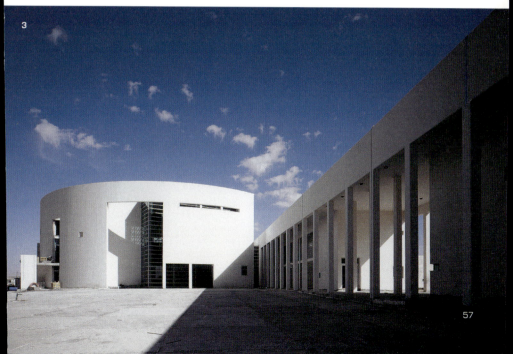

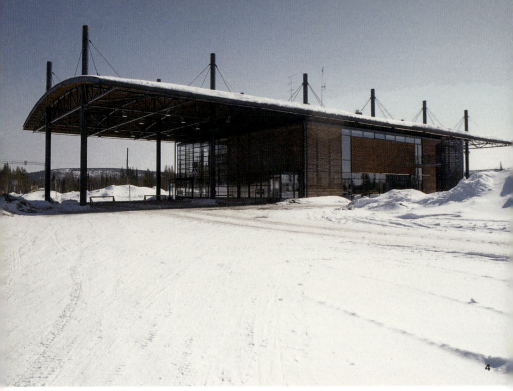

4 Salla Customs and Border Office @ Salla Finland, commission, built 1997 > The vigorous growth in border traffic between Finland and Russia, plus the fact that the border is now the outmost border of EU have meant new requirements for the Customs and Frontier Guard Sevices, necessitiatng the need for two new Customs and Border Stations. The station is a two-storey high glass-walled pavilion under the long canopy.

KAMPPI CITY CENTRE

The idea for the new Kamppi-city center block was to continue and complete the existing urban grid pattern, in order to save the long axial views through the site and to create clear scale classical urban spaces. The Coach terminal area is defined by two low wings, transparent pavilions. The alternative uses for terminal are presented as botanical park or cultural multipurpose square. Located in front of the renovated modernistic Tennis Palace is an entrance area that connects Aalto's Electric-house and the SAS-hotel to the west part of the block. Pedestrian squares form a clear backbone for various activities, cinemas etc. A huge electrical information and commercial wall defines the triangular entrance hall at Annankatu-street, the entrance continuing through to a glass covered passage.

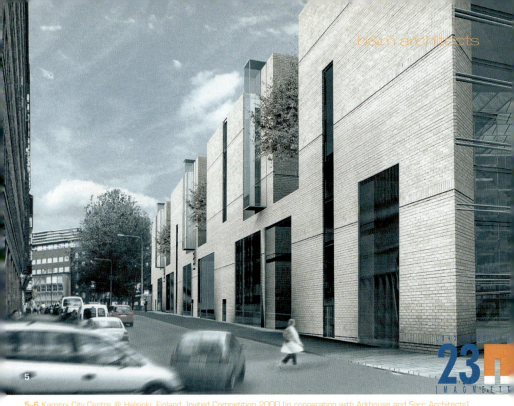

5-6 Kamppi City Centre @ Helsinki, Finland, Invited Competition 2000 (in cooperation with Arkhouse and Sarc Architects).

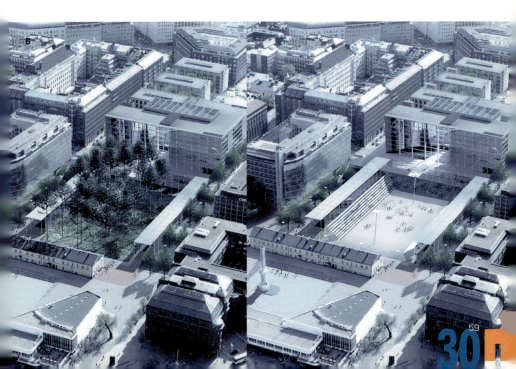

jkmm architects

Asmo Jaaksi Teemu Kurkela Samuli Miettinen Juha Mäki-Jyllilä

Architecture has to do with the context. Buildings start their life as simple, stubborn, black figures on paper. Architecture of a single building simultaneously creates the larger architectural context: new fragments of urban fabric or landscape emerge.

Architecture has to do with making sculptures. The guiding force behind the architectural concept is the logic of sculptures. The design process is a delicate affair of refining the balance between the contemporary and timelessness, between stereotypical beauty and odd discoveries.

Architecture has to do with craft. The finished building is what counts. The materials of a building are real: they have texture, weight and smell. The joints in a wooden boat possess beauty because they are simple, natural and fulfill their function.

In buildings, architectural beauty can be found in crafting things. Architects are craftsmen.

Architecture has to do with people. Spatial experience, scale and function are abstract things. But in buildings, they should be translated into a physical form.

Buildings begin their life when somebody walks in.

1-2 Houses Killi and Nalli @ Raisio, Finland, commission completed 1997.

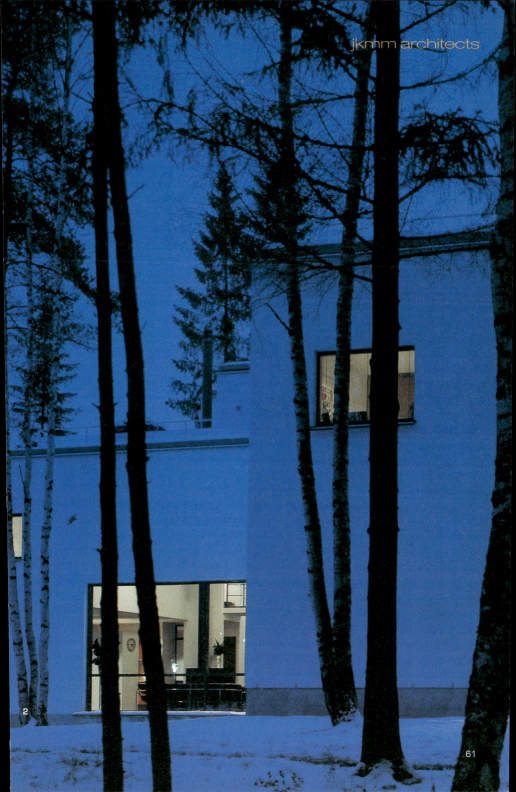

ikmm architects

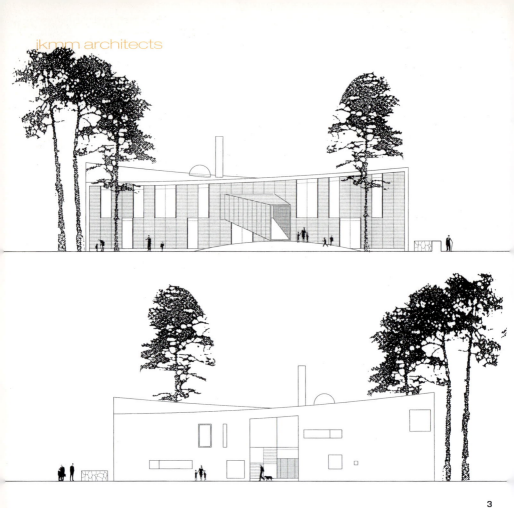

3

3–4 Nursery Leipuri @ Helsinki, Finland, competition 2000, construction 2002 > **3** facades / **4** perspective image / **5–7** Three single family houses > **5** House Santala&Nuorto @ Tampere, Finland, commission, construction 2001–2002, site plan, facades, plans / **6** House Horisontti @ Helsinki, Finland, commission, construction 2002: facade, plans / **7** House Jaakonsaari @ Mikkeli, Finland, commission, completed 2001: facades, plan, site plan.

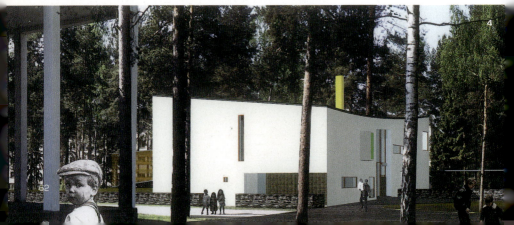

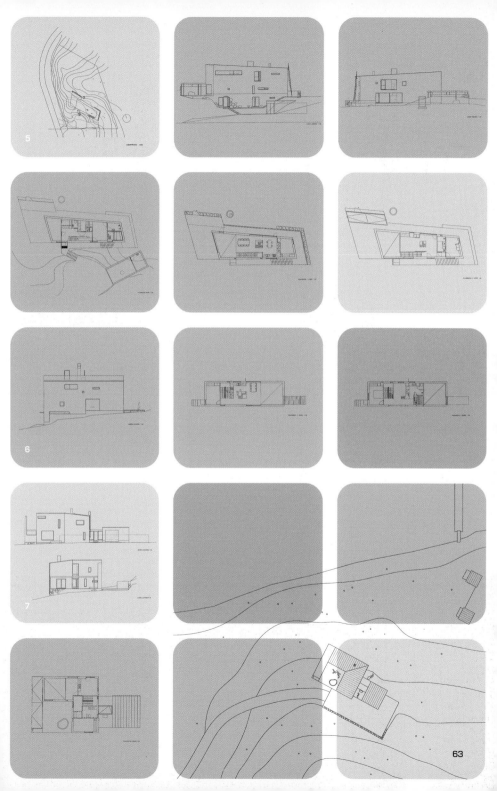

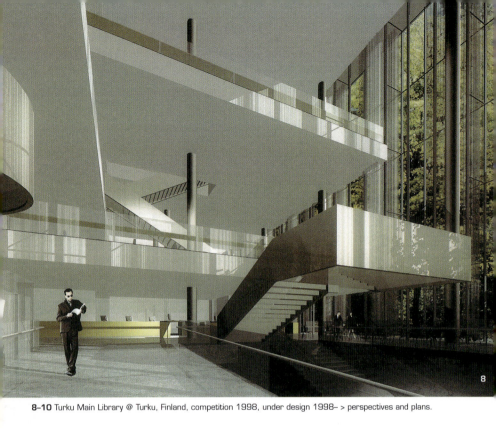

8–10 Turku Main Library @ Turku, Finland, competition 1998, under design 1998– > perspectives and plans.

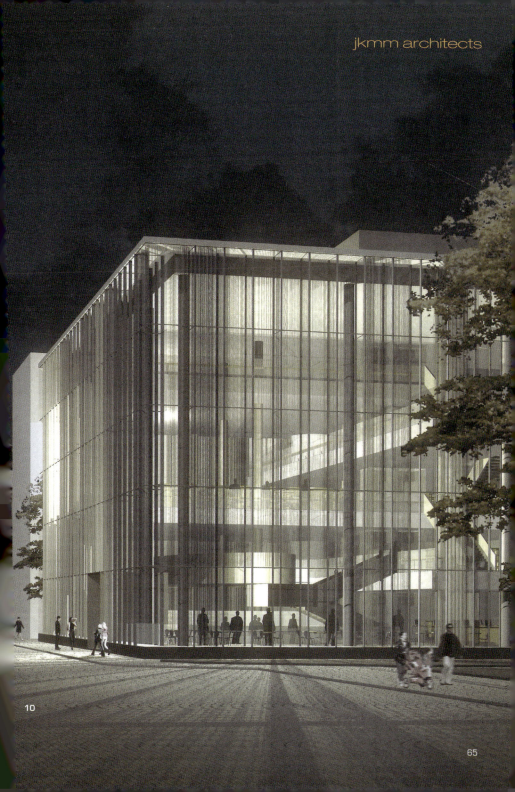

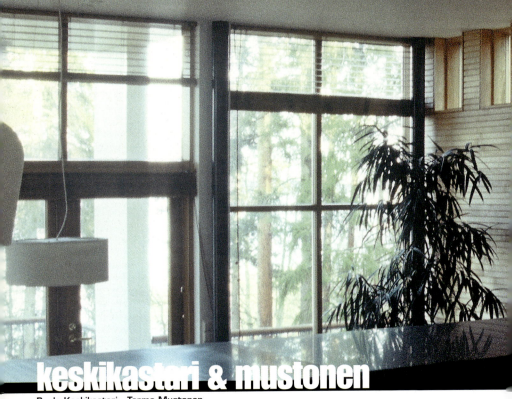

keskikastari & mustonen

Paula Keskikastari Tarmo Mustonen

In urban planning the spaces between the houses are as important as the changing views along the street. Buildings form the edges for different spaces and places; streets, 'piazzettas' and private courtyards. 'Low and dense', the ideal urban structure creates private outdoor spaces with a comfortable neighbourhood feel. When planning a house (as urban planners) our starting point is the environment. The building must take its neighbours and the overall feeling of place into consideration. Nature is as important to a new building as the neighbouring buildings. Trees, stones and other beautiful existing structures are the positive elements that tie the new building into its place.

The aim is to create comfortable spaces and places, warm southern walls and shielded corners, within the new buildings. Although architecture is strongly connected to the time in which it is created, our aim is to create sustainable architecture which ages without losing meaning.

In analyzing the task, we try to answer as many needs as we can possible. We find it It is easier to solve difficult and complicated tasks without diminishing the creative process. We aim for long-lasting buildings using genuine and honest materials. The details are planned carefully but are not conspicuous.

Interiors are extremely three-dimensional. Contrasts express different kinds of atmospheres, intimate low ceiling heights next to high ceilings, small spaces next to large spaces. We may use shadow areas in contrast to light ones to express the brightness of light.

keskikastari & mustonen

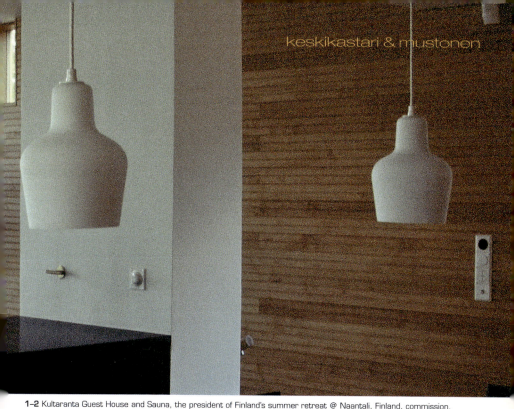

1-2 Kultaranta Guest House and Sauna, the president of Finland's summer retreat @ Naantali, Finland, commission, built 2000.

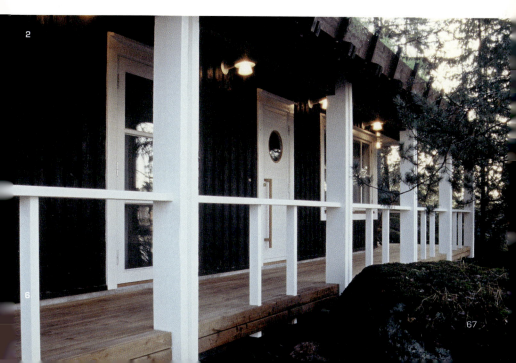

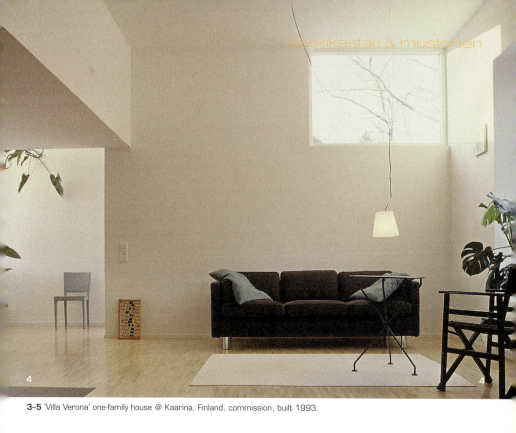

3–5 'Villa Verona' one-family house @ Kaarina, Finland, commission, built 1993.

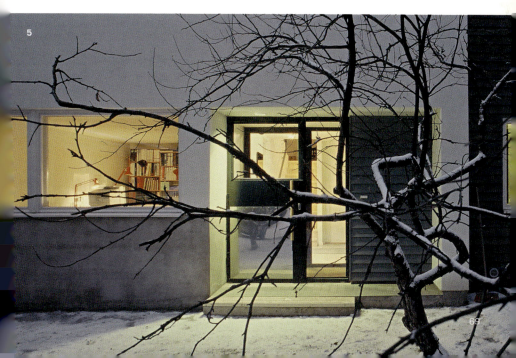

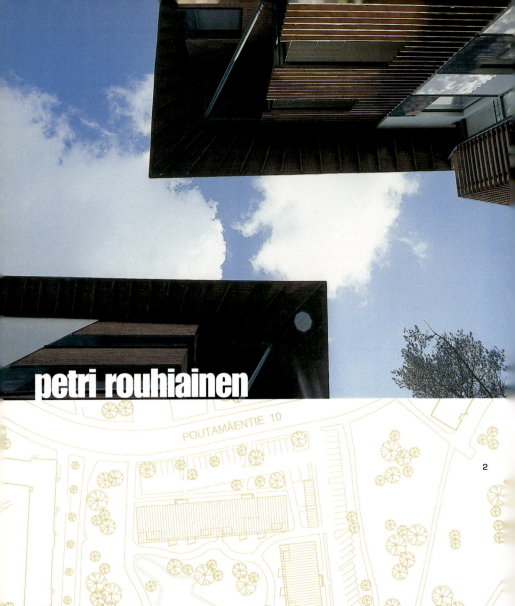

petri rouhiainen

On site I had to demonstrate to the contractor by hand that I did not want them to polish the facades too much but to let the handwork show. The close connection to nature continually enforces these ideas. We are currently living in rather stressful time. Here in Finland, we are also moving rather too much away from nature. As an architect I feel I can do something to remedy our housing environments. To help keep the pain away, so to speak, is how I often see my duty. Whenever I feel down I travel to my cottage in central Finland, to hear the silence of the lake and observe the immobility of the sky. And I try not to sing though I feel like living again. I remember we often spoke about music. I've always thought of my work as an an example of Unplugged Architecture. Like music that real people play with real instruments. Think of Crosby Stills Nash & Young and "My house". Or Neil Young and "Old Man". And listen to the harmony of voices and the somewhat ragged guitar sounds and the contrast between the two. These appeal to me!

petri rouhiainen

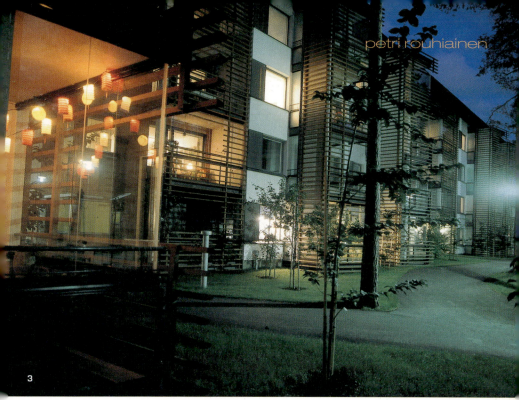

1–5 Poutamäentie 10 housing blocks @ Pajamäki, Helsinki, Finland, commission, built 1996–99 > **1** frog's eye view / **2** site plan / **3** nightview / **4** apartment buildings / **5** plans: ground floor, 2–5 floors, ground floor, 2–4 floors.

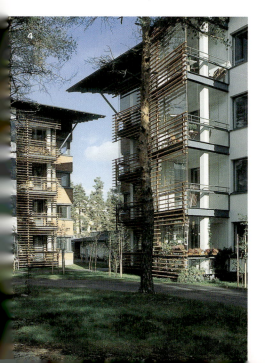

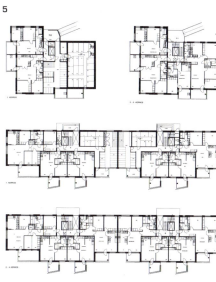

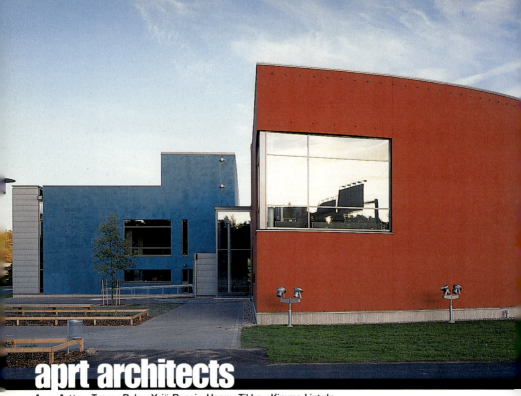

aprt architects

Aaro Artto Teemu Palo Yrjö Rossi Hannu Tikka Kimmo Lintula

As for many young architects much, if not all, of our work has originated from competitions which have allowed us to flex our architectural strength on prominent public buildings including concert halls, auditoriums and cultural centres. Urban planning is an important aspect in our work. APRT and our Danish partner KHRAS have been engaged for several years in a continuous urban development master plan for the Orestad area of Copenhagen, former green state-owned fields which the government hopes to develop into a new urban centre.

We conceive our projects from the grand scale allotting areas of land for specific uses down to the very detailed design of the pavements. This approach to urban planning is also evident in our buildings which we treat as miniature cities. In the design for the library and auditorium complex at Raisio and the Joutsa Leisure Centre, different uses were given separate buildings, all linked by a communal glazed foyer.

In the Gardenia Wintergarden in Helsinki, plants and people are zoned in spaces displaying varying degrees of openness.

Most of these aspects have culminated in our recent hotel project in the heart of Helsinki. Public space, railway traffic and Eliel Saarinen's Railway Station are surrounding an eight storey high building which consists of hotel rooms, offices and intimate roof gardens.

1–2 Raisio Library and Auditorium @ Raisio, Finland, competition 1st prize 1996, built 1999.

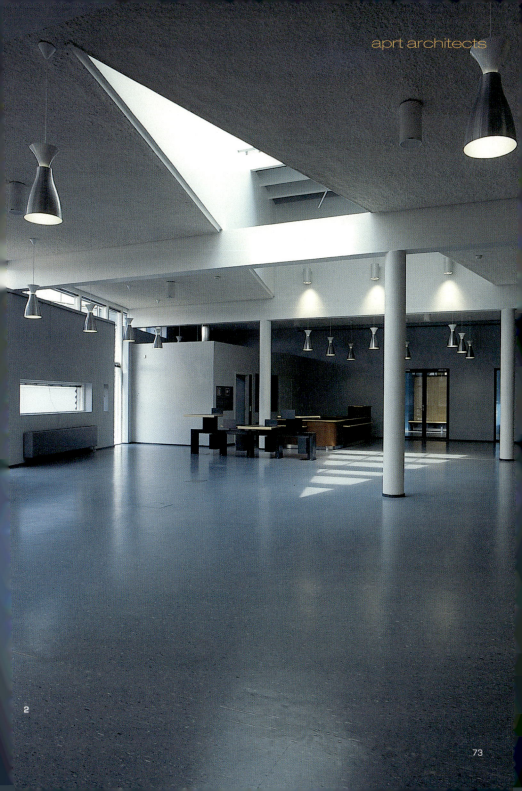

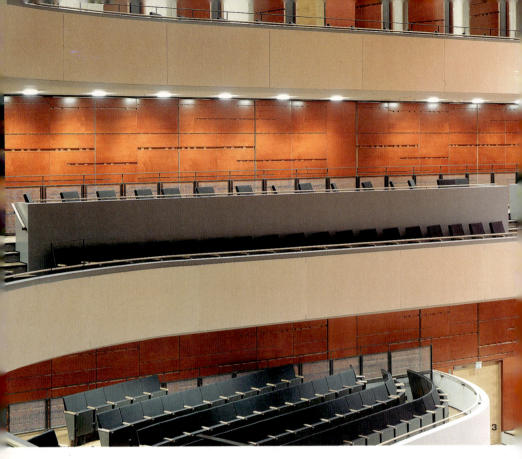
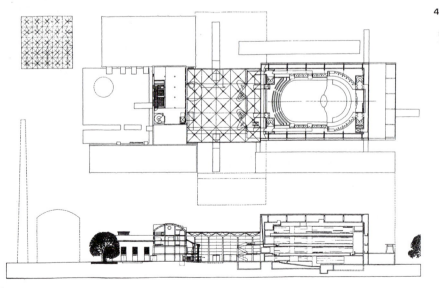

aprt architects

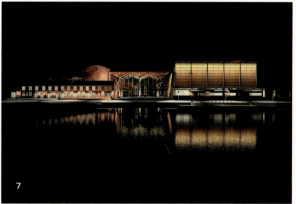
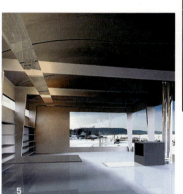
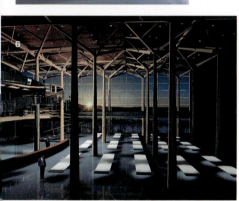

3–8 Sibelius Hall (wooden congress and concert hall) @ Lahti, Finland, competition 1st prize 1997, built 2000.

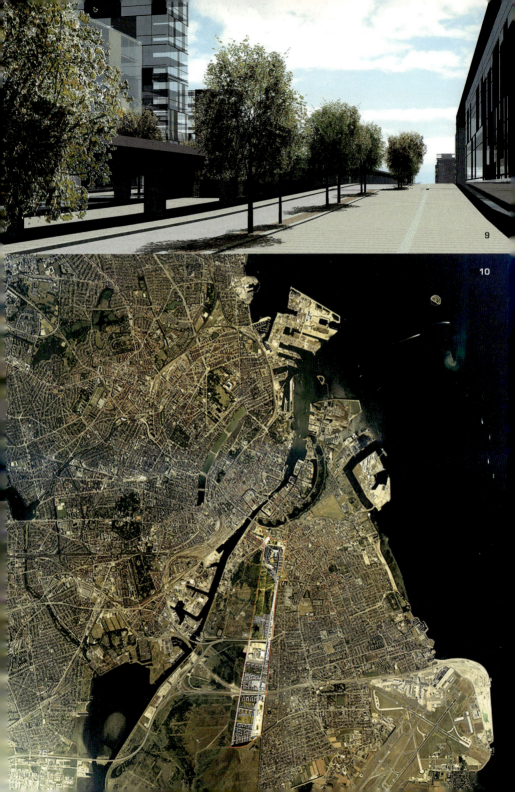

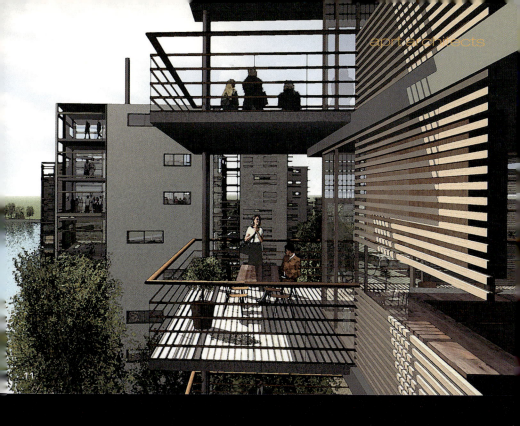

9-12 Ørestaden @ Copenhagen, Danmark, International Ideas Competition, 1st prize 1994, commission 1994-.

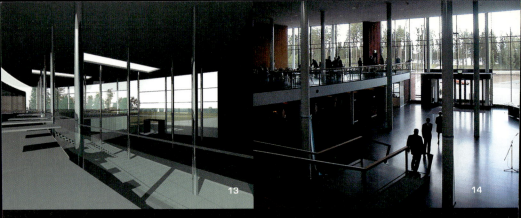

13–16 Lappeenranta University of Technology @ Lappeenranta, Finland, competition 1st prize 1997, built 2000.

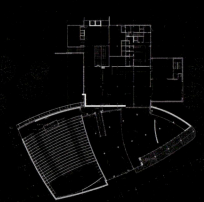

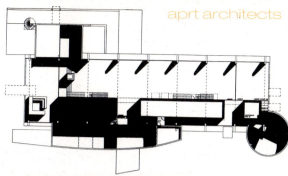

aprt architects

17

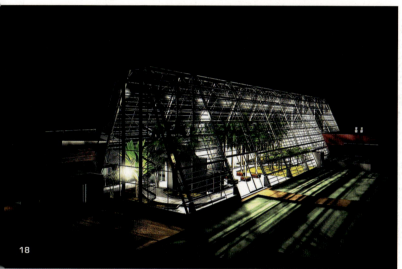

18

19

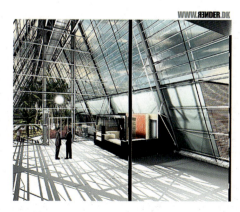

20

17–20 Helsinki-Gardenia @ Helsinki, Finland, competition 1st prize 1997, built 2001.

–Our electrically-configured world has forced us to move from the habit of data classification to the mode of pattern recognition. We can no longer build serially, block-by-block, step-by-step, because instant communication insures that all factors of the environment and of experience co-exist in a state of active interplay.
Marshall McLuhan

–Tomorrow's expert will have a particular care for his own internal life.
Fernando Pessoa

–Does your art lead you, or your gain lead you? You may like making money exceedingly; but if it comes to a fair question, whether you are to make five hundred pounds less by this business, or to spoil your building, and you choose to spoil your building, there's an end to you.
John Ruskin

In the 1980s the application of ideas and thinking from other cultures and disciplines infiltrated architecture. *Postmodernism* offered an influential if ambiguous source of motifs for architectural unrest. Phenomenology negotiated geography, new subjective humanism encountered chaos science. Yet despite these pressures, young Finnish architects seem to have retained a remarkable sense of their own history and their own legacy. If this legacy helps temper the rage for instant style and novelty, and offers opportunities to rescue a type of architecture that might otherwise have gone missing as we saw in the first section, we open our enquiry here to practices involved in transforming their experiences, fusing their ideas and breaking with convention.

Resistance to the globalism of images began to prove difficult as the 90s progressed. As trends gathered pace, it was personal mythologies and a personalized poetics of space which narrowed into a new symbolism. In Finland thinker-architects like Juhani Pallasmaa and Kai Wartiainen followed in the footsteps of Reima Pietilä and searched for ways of offering a constructive resistance. Meanwhile theorists like Kaj Nyman, Pauline von Bonsdorff and Altti Kuusamo widened the site of architectural writing as criticism began to explore new

ways of challenging historicist frames.

We used the term 'hip' here to speak of younger practices negotiating legacy and seeking a re-invigorated modernism. In this section, playfully and seriously, 'hop' suggests practices that emphasize collaborative, even transformative strategies. Here, too, we are also trying to capture those whose architecture might result from a fusion of different places, people, ideas and images. This is likely to be true of an increasing number who, as Eeva Pelkonen writes, 'have worked and studied abroad and who, in great numbers, choose a collaborative practice opposed rather than one dominated by single individuals.' Such practices in Finland are numerous and perhaps indicate a move away from the idea of an isolated architect guru, something we find critical history still regards as a singular creative and cognitive subject. In this section (Moga)M3 were prized in Europan for a Bucharest project, Mikko Mannberg speaks of Venice, Marco Steinberg teaches in Harvard and Pelkonen at Yale.

Further emphasizing this, we begin with two younger researchers and thinkers, Mikko Mannberg and Anni Vartola. Both use research to fuse their words into thinking about architecture, and thereby also challenging the critical histories we are used to. And if we begin with the poetics of a site like Venice we see through these to the wood transformations and net structures of Pook Architects, another practice not unconnected to the significant projects of Pelkonen, herself fusing an organic temperament with a slinky, hovering tectonic architecture in Vermont. From here we move almost seamlessly onto the accomplished tectonics and suggestive organic work of Matti Sanaksenaho.

Accepting no easy critical identification, we observe the micro scale of Anders Adlercreutz and Jesse Anttila, the light work and furniture design of Karola Sahi, along with the solar experiments and sustainability exercises of Heikki Viiri. Here 'minimalism' is not only aesthetically grounded but roots out more economical conditions for an intensely scaled architecture. Steinberg's plywood and bamboo studies deserve deeper scrutiny as does his plywood wheelchair prototype. This critical re-mapping of plywood back onto the modernist chair and then rigorously diagrammed into studies for a plywood wheelchair extends the boundaries of a modern material we thought we knew!

Finnishness, though we have seen still offers instant identity, is a paradigm that has critical consequences for the young. In

this second section, though most of these architects and practices might not agree on 'finnishness' in terms of their background, their thinking, their education, all would probably agree to the role of architecture as a transformation of critical conditions, the extension if its boundaries. The work of Pelkonen in New Haven and Steinberg in Harvard, deeply involved in what might be described as Finnish material concerns, are transforming accepted conventions. This re-mapping involves an understanding of the past in relation to influence, originality and innovation. The past is suddenly fertile for answers to quite different architectural solutions asked for in the 20th Century. Here 'transformations' expand ideas, issues and materials we might have considered already abandoned in favour of newer, trendier materials and increased novelty. Here the past is no static resource but an acquired learning tool increased and amplified, as Pelkonen says, by elective affinities and collaboration.

Let us allow Pelkonen define this pull toward collaboration: "I would argue that we have to approach collaboration first and foremost as a basic human condition. We are, as human beings and architects, conditioned by places and people we are surrounded by, ideas and images we are exposed to. I endorse the fact that the boundary between an individual and its surroundings tends to blur. The process resembles that of mimesis: we identify with the people close to us both mentally and physically. To collaborate means to let loose and subject oneself to influence."

Others shown here, by transforming their work, seek fresh answer to older content, a wider approach to familiar and newly posed issues. Re-framing the architectural story is part of this resource. Seeking to explore and position oneself within 'Finnishness' but transcending it at the same time relieves one of the heaviness of legacy. We are not talking here of adding weight and soul to Finnish architecture, we are seeing works here that do not seek such position, nor in fact strive for such accessible identification.

Though it might be a mistake here to ignore the solidarity and sensitivity a Finnish education may have produced, time and again, it is this sensitivity which is turned back on itself and reinvented. And special mention should be made here of the *Arkki* Day Care Centre located in the milieu of the old silk factory in Tikkurila, outside Helsinki in Vantaa. The new lightweight structures designed by Pihla Meskanen and Olli Pursiainen reflect the Reggio Emilia education philosophy. Here we are

speaking of a fusion of idea and reality, an architectural kindergarten where the architecture itself offers the flexibility and invitations to the child to observe and explore architecture, to learn to perceive their own location in relation to spatial configurations. Different materials create varied sensory experiences aiming for an operational strategy for child development containing architectonic, pedagogic, social, and economic elements.

We might loan this for ourselves. The transformations here begin to suggest how tectonic and exploratory adventures can go hand in hand with fantasy. Once again, though transformed and fused into newer patterns we come across a shared approach, as Meskanen and Pursiainen state: "Architecture is the interpreter of humanity, of people's existence in the world. In our architecture we bind together the physical and the mental environment. We want to evoke multisensory experiences. Finnish nature has an important influence on our architecture… Architecture provides the settings for human functions and, at its best, it enhances the probabilities of different actions."

As we observe the transformations many of these young Finns have gone through, both in Finland and abroad, both individually and in varying collaborative and interdisciplinary practices, we notice how unnecessary it is to invent new institutional slogans, new critical manoeuvres to rein in their work. In fact the work thrives on the very differences within shared intentions: the natural approach, the new typologies, the material discourse and sensitivity to landscape all in a way speak for themselves. "By touching humanity, it is possible to create environments to which different people can relate to, spaces they can fill with their own meanings," the *Arkki* architects state. "In our planning we consider ecology as an aspiration of durability, both materially and immaterially. Good architecture and its values are eternal. It always allows new interpretations."

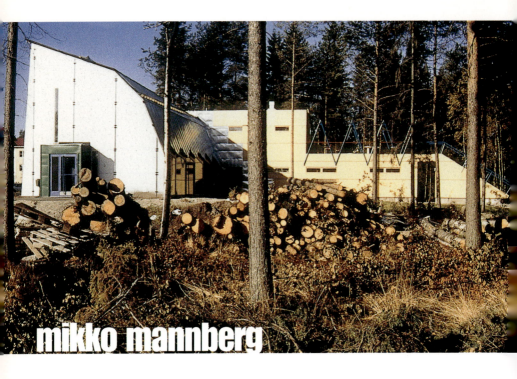

mikko mannberg

My architectural preferences lie somewhere between contextuality and conceptuality, complexity and simplicity, abstractiveness and figurativeness, rationality and irrationality. I am especially impressed by architecture or urban spaces which offer me spatial adventure, sensorial experiences, and formal ambiguity that excites my imagination – places where spaces, forms, materials and light form architectural events and experiental sequences. This kind of architecture gives room for my interpretations, it touches me. The most important qualities of architecture, then, are its imageability and its corporeality. Still there is also a level in architecture that appeals to my intellect.

Essential are not the meanings that the creator of a space have consciously set into his work or which art history analyzes, but those connotative meanings that speak about the surrounding world, processes and phenomena, and those subjective meanings that an experiencer or a user sets into a work while experiencing or using it. Architecture provides the physical frame upon which to set these meanings.

Architecture tells us what we are and what we could be. Its task is to create new kinds of spaces, forms, orders and relations for us to experience, and, on the other hand, to operate with those themes that have always been part of human existence.

In these times of efficiency, speed, lightness, transparency and virtuality we have to contemplate the speciality of architecture. Architecture is not capable of the velocity and flexibility of virtual reality, and why should it be? It is our reality. As a form of human cultural activity architecture must operate with those means that the other activities cannot: spatiality, materiality, tangible form, plasticity, weight, slowness. We must get back to architecture the forgotten dimensions, the poetry of spaces, the same excitement, mystery, and joy that I remember having felt as a child when arriving in a new place. After all, is it not exactly this excitement that first got us interested in architecture, in making architecture?

mikko mannberg

1–3 Clubhouse for Students of Technology @ Oulu, Finland, limited architectural competition, 1st prize, built 1991–1993 > Most materials used and labour were donated. With entrance canopy, the club building defines a courtyard which faces northwards to the lake and is divided into two parts / **3** first floor plan

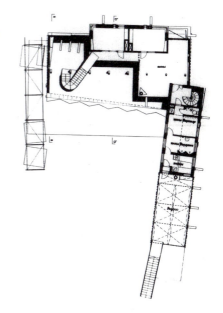

STUDENT CLUBHOUSE

The silver-coloured steel main interior, a two-storey-high space used for irrational rituals, continues visually through the zigzagging glass wall to the patio and courtyard. The blue plastered block and the ochre-yellow sauna wing with plywood-cladding penetrate into the mainspace. Where they join, hovering in the space, there is a sitting room with fireplace. The façade materials continue from the exterior into the interior. At the end of the sauna wing, towards the lake, in the most peaceful part of the site, there are cooling terraces, covered with canvas. The forms, materials, colours, functions and ideas of the two blocks contrast with and complement each other. My own associations and desires, images and memories were an integral part of the design process.

THE POETICS OF SPACE AND PLACE

Aestheticity is central to everyday life: all human action includes a conscious aesthetic dimension. The aesthetic need and sense – a sense of beauty – originated from man's experiences with nature and the environment; necessary for man's perceiving, structuring and understanding of his environment and acting within it, later expanded to the field of symbolic thinking. Experiencing the environment aesthetically has thus been essential for man's being-in-the-world. We satisfy our need for aesthetics with art, rituals, and environmental experiences.

The two aspects of architecture (as of all art) are aesthetic form and conscious or unconscious meaning. Phenomenologically, architecture and urban space are a means of collective and subjective experiencing; comprising the body, senses, memory and imagination. Our environmental experiences are characterized by concentricity. One with my environment, these experiences are affected by both subjective and collective factors: sense perceptions, memories and past experiences, associations and anticipation of imagination, and social relationships as well as collective meanings and cultural factors: traditions, beliefs and lifestyles created by the physical spiritual environment.

In Heidegger's philosophy the essence of all art is poetry. All art speaks in images, communicating meanings inexpressible in logical, rational concepts. Based on archetypal experiences, these images form the subconscious figurative language. They are an essential part of making [poesis] and experiencing art and environment. Thus the most essential quality of architecture and urban space is their ability to arouse images in one's mind, i.e. the imageability of a place. This implies creative intuition: a work of art or architecture is ultimately a subjective experience in one's mind.

5

The poetic environment explains man's being-in-the-world, or in Heidegger's words: dwelling. In Christian Norberg-Schulz's theory of place man dwells poetically in a place where he can orientate himself, which he can remember and identify himself with, and which arouses images in his mind; that is, in a place which is meaningful to him. Reflecting both a person and collective culture as well as our own time and place, the poetic environment is an authentic environment, real in a deep sense: it helps man to become aware of his own being.

Poeticality is the unity, complexity and intensity of an environment and the experience of it. The poetic environment deals with the relationships between nature, light and time; body, senses and imagination; spaces, events and rituals. The poetic space manifests the elements, rhythms and principles of nature, the cyclicity and linearity of time as well as temporal stratification. It lives in light and shadow, colours and tones, and appears in its day-being and night-being. It allows ritualistic behaviour, either personal or collective, sacral or profane.

The poetic space is separate from and intermediate to other different worlds, orders, happenings, forms of behaviour. It is material and rhythmic, and it manifests order or several simultaneous overlapping orders that are visual, spatial and experimental

With the help of a rhythm (repetition that varies the order) and the choreography of movement in space we organize spatial sequences out of spatial chaos. By means of internal proportions we perceive a space or a form as a whole, and by means of a scale we relate it to its context and to the dimensions of human body.

Primarily we experience our environment first and foremost intuitively with the means of analogical thinking through our senses, body and irrational imagination and

only secondarily consciously by the means of logical, rational, conceptual thinking.

The surprising spatiality, temporal stratification, rich materiality and ambiguous form of many old cities create an experience of uniqueness. Author Joseph Brodsky who regarded allusion as an excellent urban planning principle evaluated the quality of a city according to the quality of the dreams he dreamt there; in Venice he never woke up in nightmares. In his work, the architect builds man's reality, the world, and thus directly affects the form and quality of man's existence.

7

4–8 Photographs of Venice by Mikko Mannberg.

8

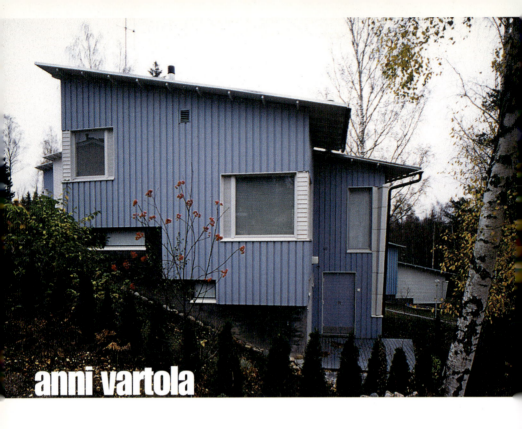

anni vartola

WHAT HAS THIS PLACE BEEN EATING?

My method is to dream. I start from the site, the urban tissue, the "genius loci", the shape of the terrain, the light and sound world, the trees, paths, movement etc. Then I dream of the house-to-be-true, taking imaginary walks, entering and looking around for the clients, imagining their house, their lives, their movement in it. The design evolves in my mind and only then can I draw anything on paper.

In reality, when there is a real decision to be made in the design, I close my eyes and enter the dreamed version of the house to solve the problem. The practising architect, John W. Wade says in his *Architecture, Problems, Purposes*, "can no longer say that he just took off and flew awhile until he came down with the solution". Well, that's exactly what I do.

For me, architecture is not a performance arena. The less it shouts, the better it is. Yet I do subscribe to the idea that there is no architecture without personal courage. Even though Peter Eisenman is a catastrophe as an architect, I like his phrase: "none of my houses is shaped for client's needs; they are designed to shake them out of those needs." My version of this would perhaps be: "none of my houses is shaped for the architects' needs; they are designed to make the architects see those needs."

I oppose anything that refers to the General Opinion of Good Architecture. This forms the conscious, rational element of my architecture. The biggest part of making architecture is to get the real issues on the table. Personally I trust my instincts but I also rely on architectural theory and rational thinking to distinguish between the immuta-

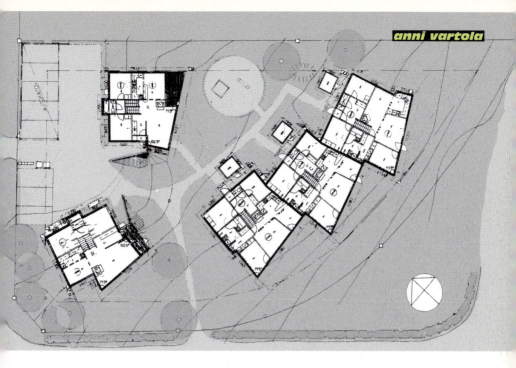

2

1–2 'Kiila' housing project @ Tuomarila, Espoo, Finland, commission, built 1997 > A low budget five-family house (with architect Harri Viljamaa).

ble values and the fluctuating preferences in the architectural profession.

I am – conclusively – a pathetically romantic conservative surrealist avant-garde rationalist. I don't believe in architecture that requires a user's handbook. Trouble is we tend to prefer big issues to little ones opting for the easiest possible architecture: the public building in the city centre, the extravagant private house for the extravagant client, the ingenious solution to the generous program, the latest doodle by the celebrated star architect! My hero is the one who can discuss the ugly landscape, the petty mediocrity of ordinary people, the discount building programs.

For me, the process of design is a debate; everything is a statement for or against something. The more grounded the statement is, the better it is. This has nothing to do with how you yielded to your statement in the first place. The arguments, the language, the vocabulary, the grammar and the logic changes from one commission, one situation, one program to another...

Any 'design method', any attempt toward The Architect's Encyclopaedia of the Rules of Thumb Universal Guidebook to True Artistic Experiences of Architecture is a dead duck, because architecture is not a matter of cooking it right. Rather let's figure out a hunger and build up a complete a la carte.

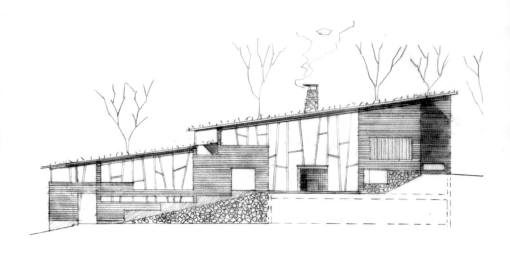

3

3-6 Hirsala Golf @ Hirsala, Kirkkonummi, Finland, commission, under design 2000 (with architect Harri Viljamaa).

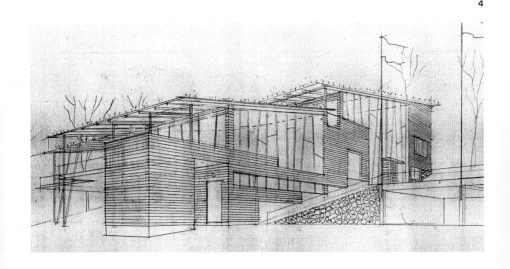

4

anni vartola

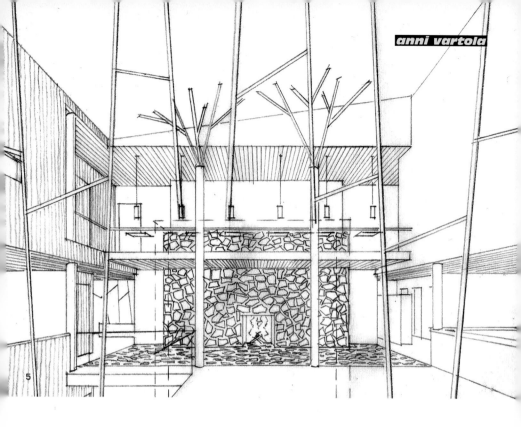

5

6

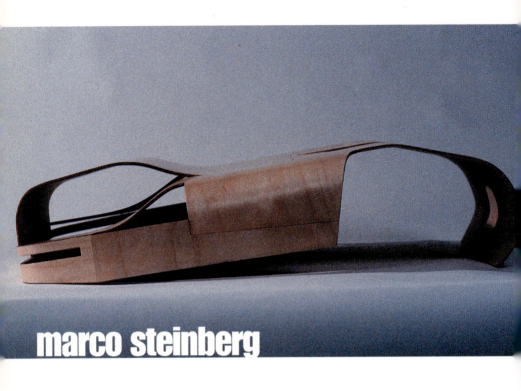

marco steinberg

DESIGNED MATERIALS

The term 'engineered materials' has been around for some time and gained credibility as a means of tailoring characteristics in the materials through the notion of "better performance". The idea of performance in these materials is, however, driven by a strict and insatiable appetite for the quantitative. They are, after all, strictly engineered. The interest in my work has been to explore the opportunities afforded by the idea of designing, rather than engineering, materials – how materials might be reconsidered as a result of both quantitative and qualitative agendas. With the advent of computer aided design and manufacturing, the relationship of architects to processes of material formation has dramatically changed. This has proposed innumerable unexplored opportunities for the profession. The work attempts to identify and explore opportunities that fall within our capacity as architects.

Homogeneity in materials: Traditionally materials have been valued for their character. We use steel for its strength, its luster, wood for its warmth and grain. What happens when a material is – apparently – devoid of character? As a result of selective performance engineering, many products we work with lack the traditional character central to "common" materials. Often one imagines that lack of character is problematic.

How does then an architect work with materials that do not present particular, unique or apparent characteristics? Looking at the reconstituted and composite panel industry, three materials have been identified for investigation: Homasote, Medium Density Fiberboard (MDF) and Drywall. The work with these materials seeks to look at the idea of anonymity and homogeneity as positive attributes – seamlessness and the question of "truth" in materials becoming central to a new range of opportunities.

1, 3–15 Molded Plywood Research: Permobil Wheelchair 1997- / **2** Homasote Research 2001.

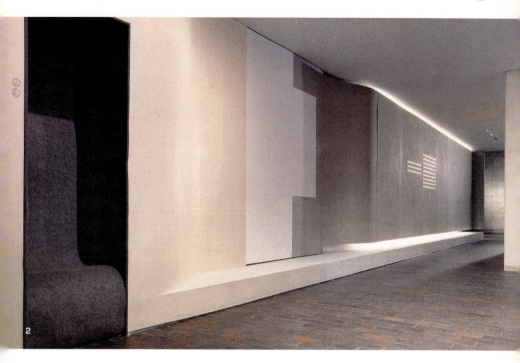

HOMASOTE RESEARCH

Construction-related materials often have latent possibilities that extend well beyond the uses for which they were created. Usually generated in response to quantitative criteria, these materials tend to have significant (though often unsuspected) potential for innovation and progress. Our research objective was to find opportunities for innovation while testing our role-and limitations-as designers in material processes.

Principal Investigator for a research course offering at Harvard's Design School, the project investigated new uses and construction techniques for recycled paper based construction panels. Sample explorations unveiled a new and expanded palate of expression for the material; the installation tested the viability of those propositions.

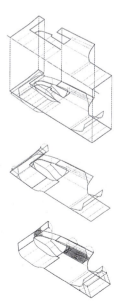

marco steinberg

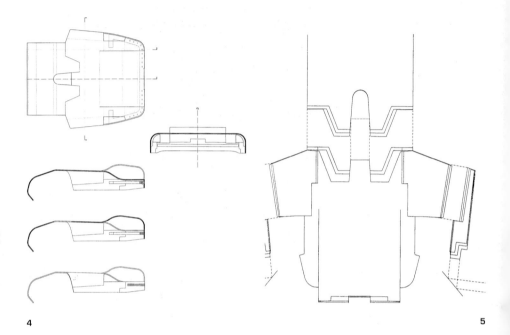

4 5

MOLDED PLYWOOD RESEARCH: PERMOBIL WHEELCHAIR

The advent of computers in both design and manufacturing has brought about a radical transformation in the design world. It has created a direct means by which design can again become an integral part of the fabrication process, intertwining the "qualitative" with the "quantitative." This revolutionizes the designer's relationship to materials and manufacturers. It is precisely this new potential that the wheelchair design project explored, developing in the process a new spectrum of possibilities for using plywood

In 1997 the Swedish wheelchair manufacturer Permobil commissioned the prototyping on a new, plywood, motorized wheelchair. This brought about the opportunity to develop and explore computer based processes producing complexly molded plywood components for the wheelchair's skin. Using CAD/CAM technology the prototypes allowed for the development of new, serially produced, smart and complexly molded plywood product. In the process it developed a new way of looking at the wheelchair – a wheelchair transformed as a furniture element.

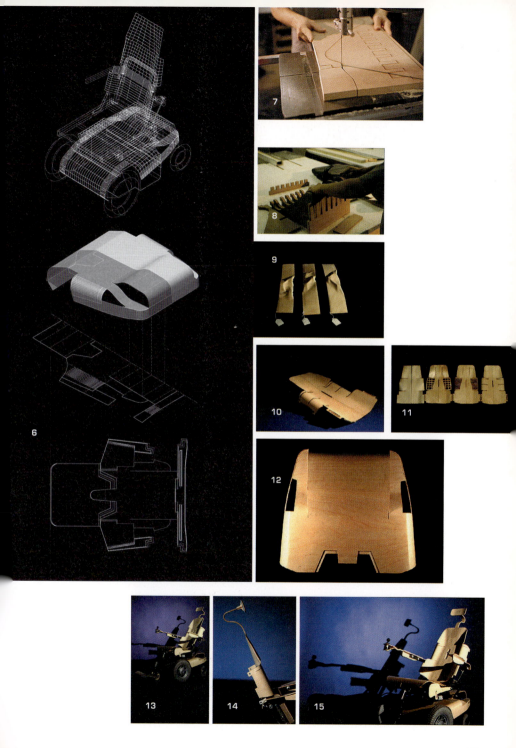

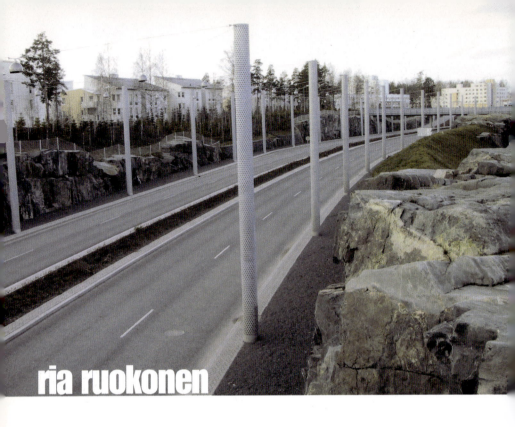

ria ruokonen

VUOSAARI ROADSCAPES

Sources of inspiration for this large scale street landscape were speed and motion. First came the idea of using materials from the site to shape new forms to direct the movement. Most important is the terrain that was treated in a minimalistic way.

The complete change of the surroundings (from a remote suburb to a busy local centre) was turned into a metamorphosis of material – the exquisite 'diorite' bedrock of Helsinki was processed into different stone surfaces and structures. Strong features of vegetation were translated into new plantings. The stream-lined composition is also the setting for the street lights. An important challenge naturally was the game between aesthetical aims and an economical balance.

Vuosaari will be one of the focal points of east Helsinki, with 20,000 new inhabitants and a new harbour.

The road leading from 'Itäkeskus' through to Puotila, Rastila and Vuosaari and on toward the harbour is connected with the ground level metro running alongside. The four lane road Meripellontie-Vuotie and the railway separate the different sides of the new town from each other. The traffic lanes are mostly carved out of the hard 'diorite' bedrock. There are 12 bridges over the road and noise barriers of various types. The Metro emerges from a tunnel before the Vuosaari bridge and in Juorumäki, a wind barrier constructed out of plough shaped hills and planted with trees, is located in order to prevent the cold, humid winds blowing from the sea into the tunnel

Materials from the site are used in the road construction. In Vuosaari, the local bedrock is deep black diorite and is used in many ways. This stone becomes one of the themes used in the visible constructions, an impor-

ria ruokonen

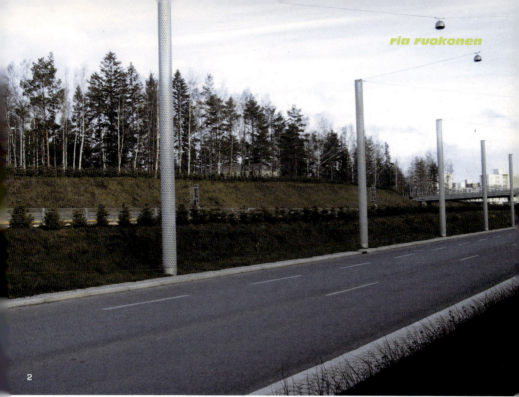

1–3 Vuotie Section of Vuosaari Roadscapes @ Helsinki, Finland, commission 2000.

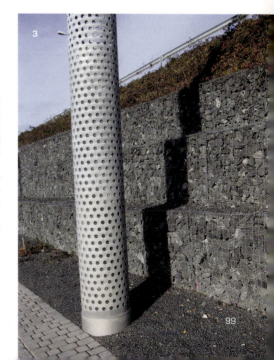

tant part of which is the simple and exact sloping of the surfaces. Closer to town (Itäkeskus) the stone is more tooled. Toward the harbour broken, blasted stone is used and then gravel. Stone covered walls, terraced gabions and vector walls are used to keep the stone slopes from falling in.

Large plant masses are used as ground cover. Low green surfaces contrast to the evergreen tree walls, similar to the old spruce hedges of the Rastila manor house. The sunny and hot south facing slopes are grassed. Climbing plants cover the stone surfaces adding autumn colour.

(Meripellontie: Under construction, completed july 2001
Vuotie: First part constructed 1997-1999, second part under construction 2001 Juorumäki: Completed 1998
Uutelantien silta: Under construction, completed 2001
Terminaalisillan porras: Construction started 2001)

anders adlercreutz

I believe that a strong aesthetic experience is possible when something common, something familiar, in an intriguing way, blends with something new and unexpected. The concrete interleaves with the abstract in a way that challenges the spectator. Traditional Finnish architecture is wooden to a large extent. Until the second half of the 20th century it was strongly attached to a "from-father-to-son" building tradition. Most Finns still have a very personal relationship with this architectural heritage even if they increasingly live in industrially produced dwellings.

We have, however, managed to distance ourselves from this shared collective memory to a degree where we run the risk of superficially reproducing it in bursts of nostalgia.

The architect has the tools, through abstraction, to conceive architecture, may it be wooden or not, that appeals to the dormant collective memory within us, while at the same time offering something new and unseen, something still abstract.

In the house for Jorma Panula, an archaic handmade timber structure is combined with an independent roof-structure. The uniform height of the timber frame resolves the problem of having to deal with the gradual lowering of the log-structure – the connection between roof and wall is identical around the whole building. You have a direct, haptic contact to something that directly relates to our collective memory while at the same time being in a contemporary space.

1–3 House for the Conductor, Jorma Panula @ Kirkkonummi, Finland, commission, built 1998–2000 > **3** facades, plan and section.

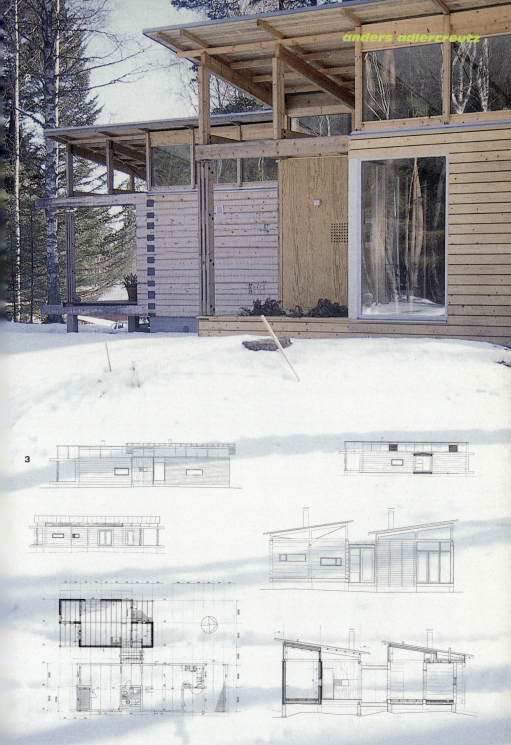

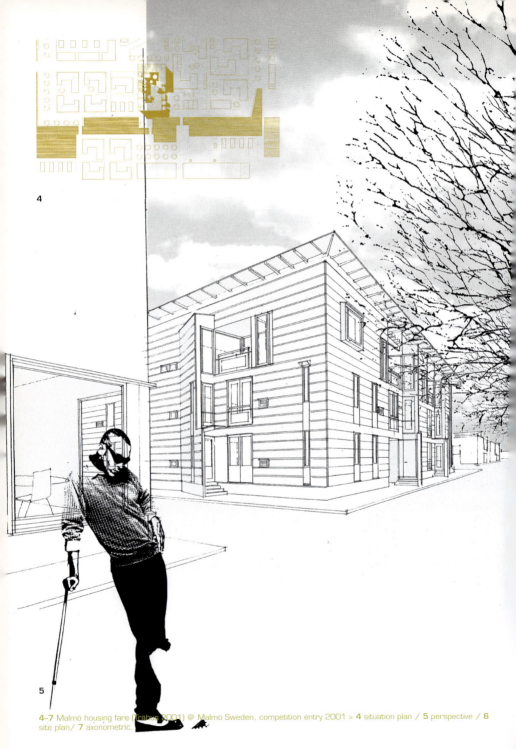

4–7 Malmö housing fare (Trabys 2001) @ Malmö Sweden, competition entry 2001 > **4** situation plan / **5** perspective / **6** site plan / **7** axonometric.

anders adlercreutz

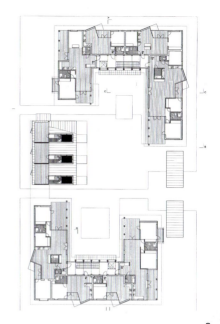

6

7

anders adlercreutz

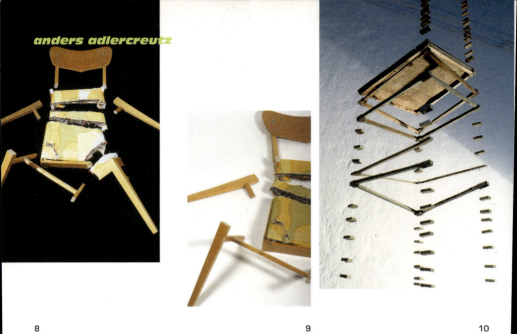

8 9 10

8–11 Painting and Built Space exhibition work @ Taidehalli, Helsinki, Finland 1995 / **12–15** Acoustic Plywood Boards 1996: 'Träkamp i Trä' competition 2nd prize 1998, Finnish Wood Innovation competition, Uusimaa, 3rd prize 1997.

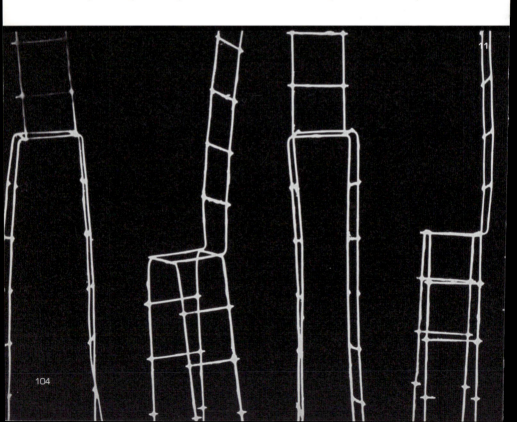

m3 architects

Jukka Mäkinen Kari Nykänen Henrika Ojala Janne Pihlajaniemi Jyrki Rihu

The modern city can be compared to nature: always ready for different appearances and rapid change. Still, each of these changes can only be perceived and validated by comparing the present to the past. Therefore each urban intervention by a designer must be based on solid ground. The Future always follows the past. In the city the present does not exist.

Bucharest 2000 was a competition in which we examined the effects of urban act(ion)s: Each act(ion) caused a react(ion). The existing urban wound was stitched up with vectors which were created by a series of react(ions). Each vector was generated by specific rules, which were based on the qualities of each building site. The collision of two vectors (double vector) created a posit(ion), which was considered a site where unpredictable events, rehabilitation of the lost qualities and 'otherness', could take place.

Nature is an essential element of architecture. The fundamental values of a pleasant space can be found in a forest. A clearing in the woods can be seen as a primary, human scale spatial element. The nature and history of the site is the only natural history for a new building in a rural environment.

For us, a metaphor in terms of architecture denotes a 'vague revelation of the hidden qualities of invisible meanings'. Hiidenkivi (Glacial Boulder) Museum and Miilu (Charcoal Pit) present two different kinds of architectural metaphors: The first is a metaphor of Finnish nature brought into the city centre, the latter is a portion of the site history transferred into the present day natural environment.

The ultimate task for a modern architect is to find ideas which are unambiguous and definite but at the same time flexible. Modern architecture is based on the concept of incompleteness: No function or form is final. The only guide is aesthetics, the "mathematics" of architecture. The structures of personal interpretation are born when present ideas meet future ambitions.

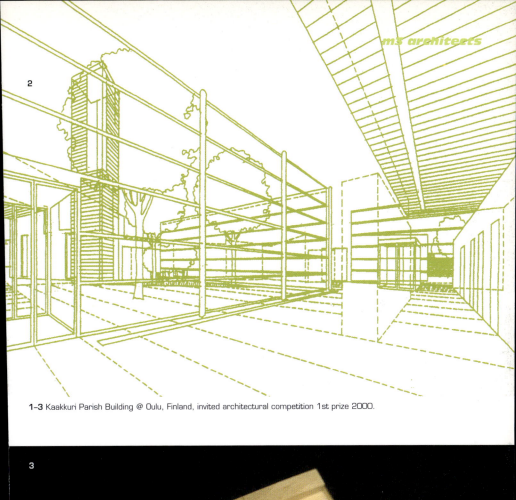

1–3 Kaakkuri Parish Building @ Oulu, Finland, invited architectural competition 1st prize 2000.

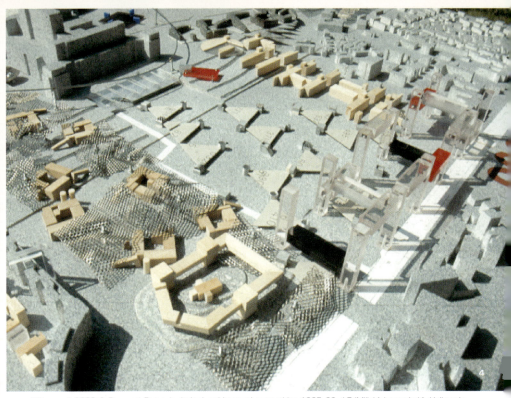

4 Bucurest 2000 @ Bucurest Rumania, invited architectural competition 1995–96 / **5** 'Miilu' (charcoal pit), Hallantalo multi-purpose building @ Hyrynsalmi, Finland, student competition 1st prize 1996.

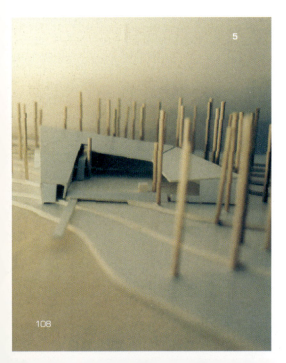

m3 architects

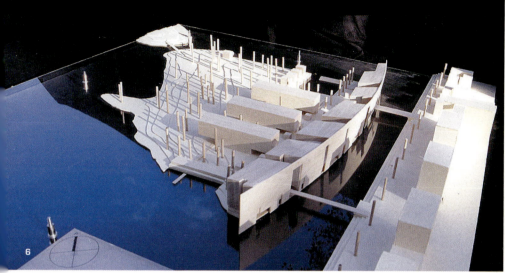

6 'Puu-Kiikeli', diploma work 1998, model view (Jyrki Rihu) / **7** 'Hiidenkivi' (Glacial Boulder) Jyväskylä Music and Art Centre @ Finland, architectural competition 1997.

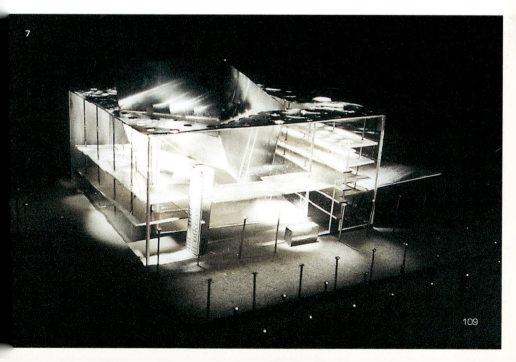

pook

Katariina Rautiala Pentti Raiski

People are driven by flows of altering functions. These flows form a continuous movement that needs to be guided and sheltered. Our senses of sight, touch, hearing, taste and smell guide us according to given impulses. As architects we should provide accurate signals to perceive the environment, to secure and channel us in the flow. For us an architectural design is a synthesis of structural forces, functional variants and material signals.

Environmental, seemingly constant, factors from sun to gravity gain a response from the flows of structural forces. These flows are designed to meet the altering demands of functions but to remain visible and understandable as an entity. The aim is to create a structurally defined and clear design.

Functions evolve in time, a building will evolve accordingly. Functional variants are the changing requirements that a design will fulfill in its lifetime. Variants operate in the building both during and after the design process. A design is complete only for a period of time, that is for a specific group of variants. After that new factors will put demands on the design. Success is evaluated over time.

Materials are close to our senses, giving us perpetual impulses. A material should respect its properties, possibly contrast its surroundings, but remain in elaborate equilibrium to the whole. For us, wood represents a material with more properties and potential than are commonly used in buildings.

We use a combination of drafting, scale models and 3D-Cad to shape the design, each part giving complementary values. Computing is used as a tool for real-time customer interaction and has proved essential when visualizing flows of forces. Scale models give a view of the entity, and drafting is most sensitive to functional variants. The flow of forces shelters the function.

1–2 Experimental Wooden Building @ Espoo, Finland, diploma work and commission 2000.

EXPERIMENTAL WOODEN BUILDING

This Master's thesis is based on the preliminary plans of an experimental wooden building carried out by The Building and Environment Department. The building follows the study of net-like wooden ruled surfaces. This type of shell structure appears to be the ultimate in lightness of construction. As shell structures, these surfaces have the advantage of being formed from straight form boards even though they are surfaces of double curvature. Essential topics for further applications of the surfaces include manufacturing techniques, the permanence of transformations and the joints and twisting of wood boards (tested in a small scale of the experimental building). The thesis consists of the architectural design and the essential technical details of the building.

The building includes office facilities, an exposition room, two accommodation rooms and a jointly-used kitchen/bathroom module, with a total floor area of 295 square meters. The building is composed of load bearing wooden walls and roofs derived from quadric surfaces, a variable experimental wall unit and pre-stressed wooden floor slabs. The constructions are to be partly prefabricated and partly built on site. All the experimental constructions are to be instrumented and the real time information of the structure is stored in a database.

The geometry and architecture are founded on the use of portions of a hyperbolic paraboloid that have been cut along ruled lines. Therefore no parabolic, nor hyperbolic arches are required in the construction. The load bearing ruled elements give form to the night and day appearance of the building. The design process was carried out utilising 3D CAD-models and scale-models, through which the shapes were studied and developed in close cooperation with civil engineers. CAD-integration in between architectural design and structural engineering was performed using surface models.

(Pentti Raiski; Controller of the Diploma Work: Jan Söderlund, Supervisor Eero Paloheimo, Project Planner for the Diploma Work stage: Hannu Hirsi)

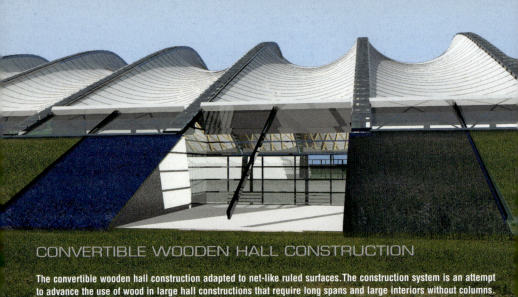

CONVERTIBLE WOODEN HALL CONSTRUCTION

The convertible wooden hall construction adapted to net-like ruled surfaces. The construction system is an attempt to advance the use of wood in large hall constructions that require long spans and large interiors without columns. This construction solution sets a precedent. The roof, which is a portion of a hyperboloid of one sheet, would span 42 metres, which exceeds the possibilities that can be reached with slab structures and wooden post-and-lintel structures. The roof structure is constructed on site. The joists are made out of sawn timber in four layers and secured by nails. When cutting the structure at different angles and turning it on its longitudinal axis, different variations of the shape can be generated.

(Katariina Rautiala; Controller of the Diploma Work: Eero Paloheimo, Supervisor Jan Söderlund) 3

3-4 Convertible Wooden Hall Construction @ Hämeenlinna, Finland: diploma work, commission 2002 / **5** Netlike Wooden Structures Research Project @ Helsinki University of Technology, commission 1998.

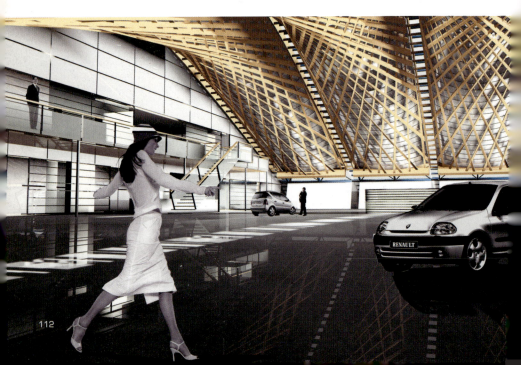

NETLIKE WOODEN STRUCTURES RESEARCH PROJECT

The aim of the project was to study, design and visualize netlike wooden structures that could be exploited by the building industry. At the same time a new wooden structure system was being developed. The system would be open and consist of design principles only, rather than fixed dimensions and measures. The research is presented through designs of six different buildings that vary from a temporary shelter to a fully covered football hall.

(Pentti Raiski and Katariina Rautiala; Project Management: Prof. Eero Paloheimo (HUT, Wood Constructions); Architectural Design: POOK Arkkitehtitoimisto (architects' office) / Pentti Raiski and Katariina Rautiala; Civil Engineering: Nuvo Engineering Ltd / Jarmo Tommola, Lauri Salokangas, Hannu Hirsi; Scale Models: Heinola-Instituutti: Students of Cabinet Making; Scale Model photos: Arja Lampinen (H.U.T.); Assistant: Ake Möller; Co-operation Puuinfo Ltd, TE-Keskus, Finnforest Ltd, Vierumäen Teollisuus Ltd)

heikki viiri

SIMPLICITY

I believe in simplicity in architecture. For me it is never the first or easiest thing which comes out of my pen, but more like the goal I am aiming towards. There is a stage when I know all pieces are together in harmony. I always like to make a long lasting solution for the design. And yet the design should always have that little bit of something which connects it to the present. In this way I feel the design work will contain a certain amount of natural sustainability.

I believe that a finished project is a result of so many things that you could almost call it a coincidence. Making architecture is a process that you can't totally control. On the contrary, one should learn to see this as an opportunity to add something personal and unexpected to the design.

I never draw a line before analyzing the site and the nature around it. I don't like to visit the site first (which would be too detached to reality) but rather analyze it in order to get an image or a frame to work within. I like to set limits for my work. This could mean either tight boundaries in an urban context or a very sensitive natural state of the site. In both cases I respect the situation as it is.

Idols: Carlo Scarpa, Giuseppe Terragni, J.P. Oud, Tadao Ando, Gunnar Asplund, Alvar Aalto, Viljo Revell

I have worked in several architectural offices and teams, on local projects in Lapland, national projects in Helsinki, international projects in the Netherlands and Austria. Experiencing all this helps now when decisions seem difficult. It also gives some kind of character to my personal work as an architect.

1 Cafe Kaldi @ Oulu, Finland, commission 1999, built 2000.

heikki viiri

2 Apartment Satu @ Helsinki, Finland, commission 2000 / **3** Solarhouse @ Haukipudas, Finland, commission 1994–97 (with Juha-Paavo Mikkonen).

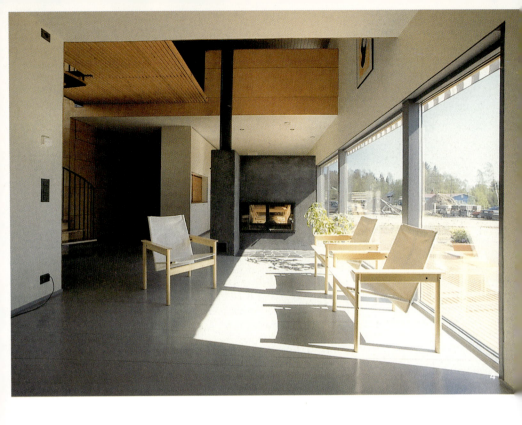

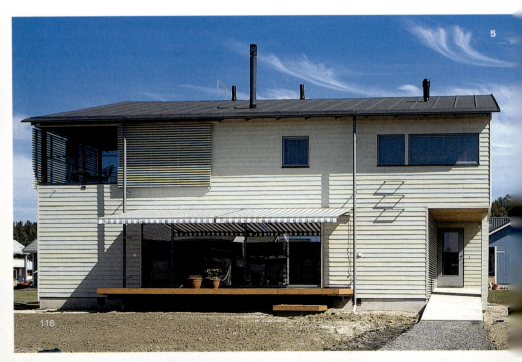

heikki viiri

4–7 House Kreivi Kangas @ Oulu, Finland, commission 1997–98.

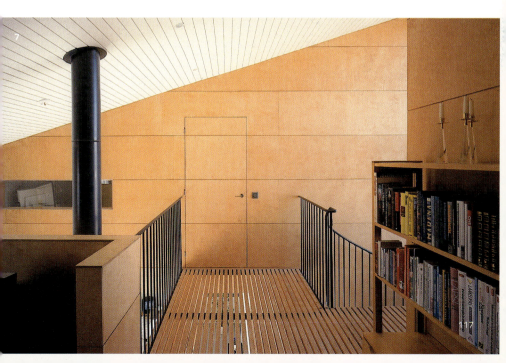

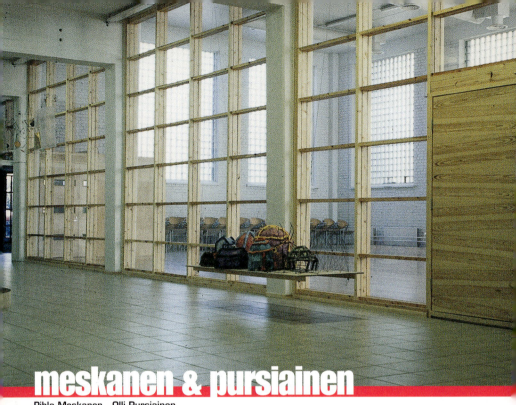

meskanen & pursiainen

Pihla Meskanen Olli Pursiainen

ARKKI DAY CARE CENTRE: STARTING POINT AND WORK

The town of Reggio Emilia in northern Italy has formulated one of the world's most progressive and interesting child development cultures, in which the child's ability to live in active interaction with his environment is supported and stimulated in the most educational ways and by environmental planning methods. The Reggio approach sees the educational environment as forming an operational strategy containing architectonic, pedagogic, social, and economic elements. In Reggio thinking, child development culture or a pedagogic project is always intertwined with the architectonic project. The theory is that every child can develop into a creative, active developer and producer of culture with strong self-awareness, instead of just a receiver and consumer of culture.

Following the Reggio Emilia child development ethos, day care centre Arkki has aspired to the creation of a cultural and architectonic context which supports the children's learning processes in the various languages of expression. The central mode of operation is project work, a learning adventure lasting several months, in which subject matter is investigated from different angles and through different languages of expression. "It's not learning to draw, it's drawing to learn". At their best "play" and "work" cannot be separated and the motto for guiding the learning process is "with joy!".

In the exploratory adventures fact and fantasy go hand in hand, enlivening and enriching each other. Through subjective investigation, experimentation and activity children develop a sensitive ability to observe their surroundings, thus forming a strong, rich, living bond with both the natural and the built environment. (Tuuli Tiitola-Meskanen)

1–2 Arkki Day Care Centre @ Tikkurila, Vantaa, Finland, commission, built 1996 > **1** main street / **2** Hut exhibition in River Hall / **3** Scenery Theatre @ Sukeva, Finland, artwork 2000 (team: Salla Hoppu, Pihla Meskanen, Olli Pursiainen, Pentti Raiski, Katariina Rautiala).

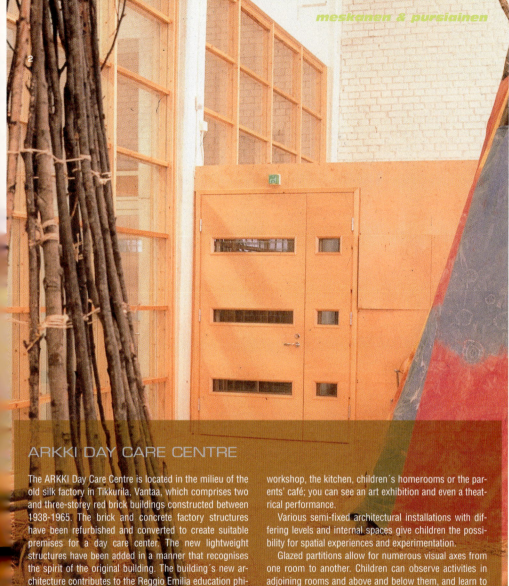

ARKKI DAY CARE CENTRE

The ARKKI Day Care Centre is located in the milieu of the old silk factory in Tikkurila, Vantaa, which comprises two and three-storey red brick buildings constructed between 1938-1965. The brick and concrete factory structures have been refurbished and converted to create suitable premises for a day care center. The new lightweight structures have been added in a manner that recognises the spirit of the original building. The building's new architecture contributes to the Reggio Emilia education philosophy applied in the day care centre. The architectural design provides a stimulating and flexible environment, which invites the child to observe and explore.

The rooms are grouped around the central "street" that winds through the day-care centre. From the street, you can observe activities in the studio, the carpentry workshop, the kitchen, children´s homerooms or the parents' café; you can see an art exhibition and even a theatrical performance.

Various semi-fixed architectural installations with differing levels and internal spaces give children the possibility for spatial experiences and experimentation.

Glazed partitions allow for numerous visual axes from one room to another. Children can observe activities in adjoining rooms and above and below them, and learn to perceive their own location in relation to the three-dimensional spatial configuration. In addition to glass, a variety of translucent materials has been used, creating different effects of light and shadow. The design objective was to use different materials to create varied sensory experiences. (Pihla Meskanen)

3

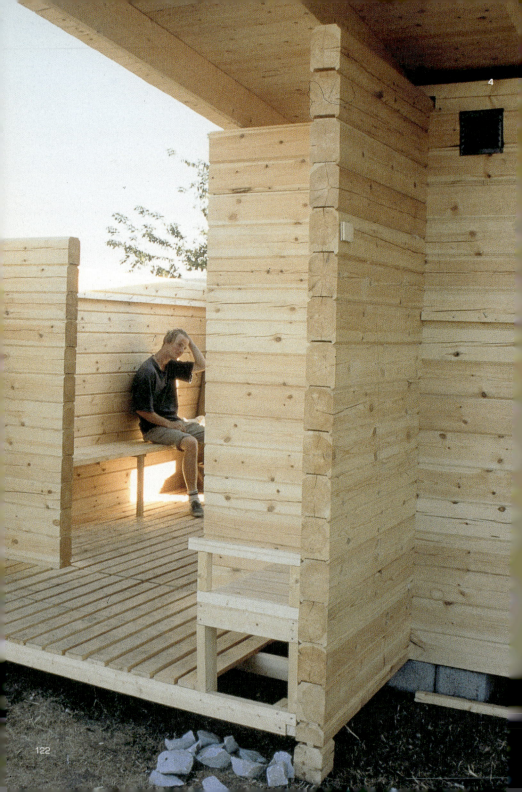

meskanen & pursiainen

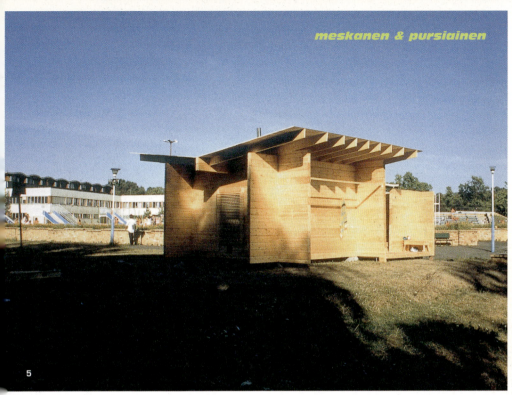

4–6 Sauna in Poland @ Zamosc, Poland, commission, built 1995 (Olli Pursiainen).

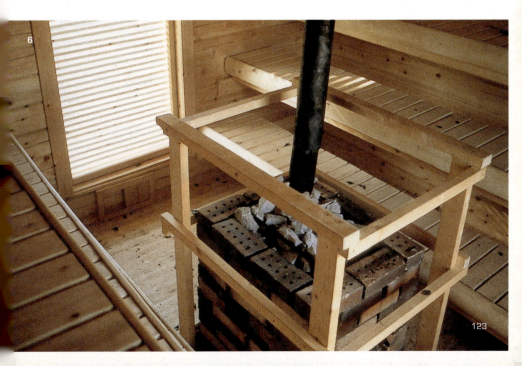

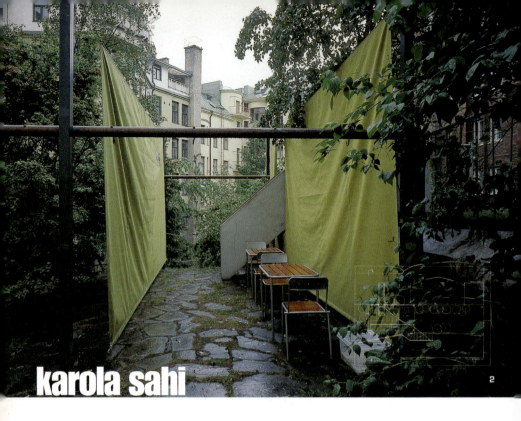

karola sahi

ONE WAY OF THINKING

Lost dimension in architecture? Less is enough. We are living in a world of enormous consumption. On several levels we produce more waste than ever. When thinking about the future this is ecologically unbearable. We should always strive for ecologically longlasting solutions. In architecture, for me, an ecological approach could mean clarity in design as well as the use of long lasting and repairable materials.

It seems we have lost respect for fine quality of work. Quantity beats quality. Yet good quality work has less probability to end up waste. For me working in details means attempting longlasting results rather than producing more waste.

However, hopefully minimalistic designs do not appear timeless. From the past we should learn and for the future we should give something to learn from.

1–2 Labyrinth-project-Summer Room @ Helsinki, Finland 2000 > installation, view & plan / 3 Experimental kitchen furniture @ Gallery Bau, Helsinki, Finland, Hima (home)-exhibition 1998.

SUMMER ROOM

"Labyrinth" opened a path through the courtyards of Etu-Töölö in Helsinki and connected the gardens with art and architectural elements, offering citizens a possibility to see their environment from a new point of view. The installation in the courtyard of Temppelikatu 5 and Tunturikatu 4 was one of the works along the Labyrinth path. "Summer Room" – a place for the residents to sit down was situated on an existing slate-floor airing space. Courtyards in different levels were connected with steel steps. The main intention of the installation was to create an intensive space with minimal elements. Materials used were stainless steel in steps and cabled canvas installed as walls.

In these projects I am working on the edge of architecture, art and design. A chance to play with ideas with an experimental attitude. Whatever scale, the minimalistic approach and thinking about details are combined as essential parts of the result. (Project accomplished in collaboration with Heikki Viiri.)

karola sahi

EXPERIMENTAL KITCHEN FURNITURE

A group of designers searched for new ideas on the design of a home. The starting point was simplicity in design. Instead of fixed units the furniture consists of freestanding, movable parts. The intention was to find alternative materials to kitchen design, easy to maintain but also aesthetic.

LIGHT SURFACES 'WINTER'/PROTOTYPES

The source of inspiration for these lamps is the long period of winter darkness in our country. The starting point was the idea of a continuous presence of light, otherwise we are surrounded by darkness. Low energy lights are installed as part of the interior – for instance they glow as nightlights in bedrooms – as a brightspot in darkness.

karola sahi

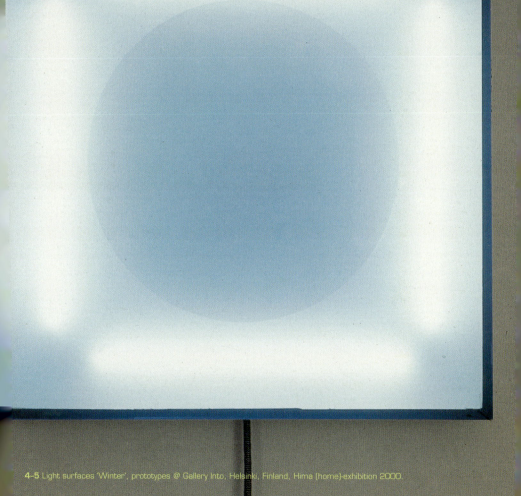

4–5 Light surfaces 'Winter', prototypes @ Gallery Into, Helsinki, Finland, Hima (home)-exhibition 2000.

5

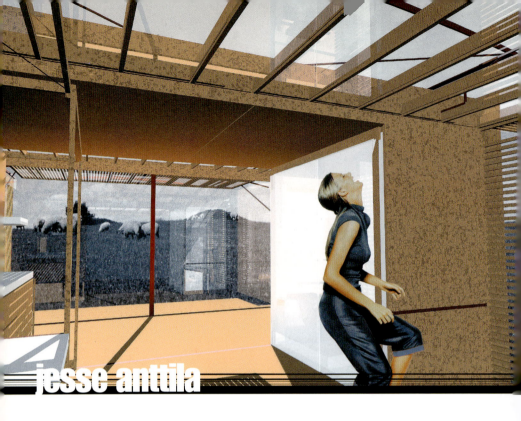

jesse anttila

THE ARK OF HOUSING

When the Paloheimo group needed a visionary wooden holiday housing scheme for the group's 110th anniversary in 1999, it resulted as The Ark of Housing, two exhibitions and a master's thesis.

The objective was to find answers to the new upcoming challenges concerning holiday housing by studying typical Finnish summer housing typologies.

The Ark of Housing is a synthesis between a place bound weekend cottage, in the wilderness, with a moving recreational vehicle unit. In addition to the strict technical and structural limitations concerning size, weight, materials and functionality, a moving building lacks the essential starting-point of architecture – an actual site context.

Architectural objects in comparison with their sites are temporary in their nature. Architecture's relation to the site can be seen as a temporary location, where the construction spreads out for a limited period of time. The permanence of the object's site context is replaced by a function that gives new meaning to the site. It determines and limits territory, manifests being and creates meaning. This is a provisional gesture that can be repeated at a different location.

Ark is a visitor. It visits a place for a while and withdraws when it is time to fend off or move, reassembled to a new place. In the visitor's mind, the place leaves a more permanent memory. Simple and distinct materials, translucence and small scale, emphasize this. The Ark can be seen as an experimental mental heir of an ascetic-modernistic summer cottage – an urban-nomad's hut – and the traditional Japanese Shinto architecture.

Constructing is an abstract parallel to the marking of a location. It binds a place to being by giving a form and a measure to those untouchable things that occupy that particular place. Architectural elements can become visible and true by being transparently bounded to a transitory state.

1–6 The Ark of Housing, visionary wooden holiday housing scheme, commission 1999.

jesse anttila

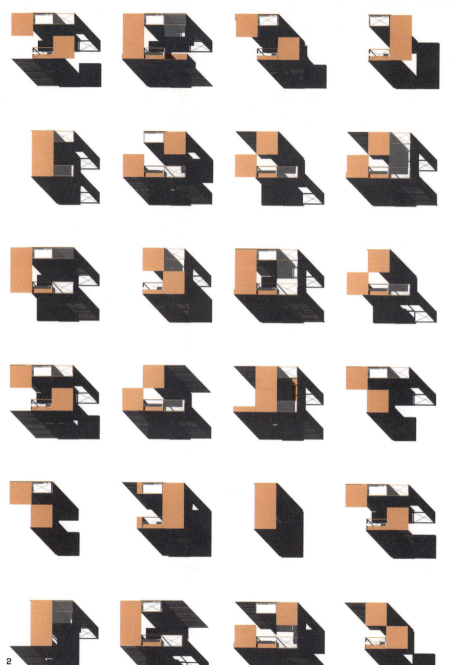

jesse anttila

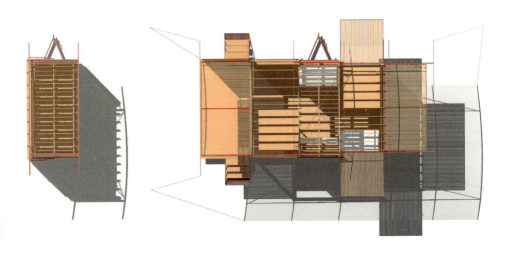

▶ The Ark of Housing is capable of moving from one place to another. When it is at it's destination, it unfolds to meet the minimum requirements for a holiday house. When opened the house is a 27 sqm dwelling with a kitchen, a bathroom and a 11 sqm covered terrace.

▶ When unfolding Ark, the individual can decide the level of openess/closeness of the walls and how the views from the inside are directed.

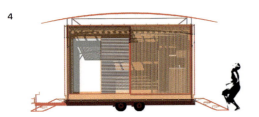

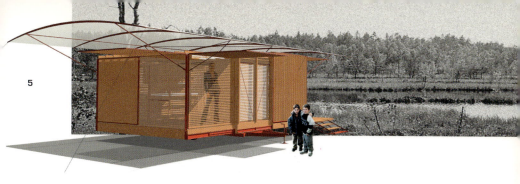

5

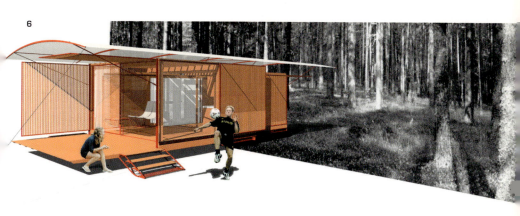

6

➡ The building has a transparent polycarbonate skin as a raincoat, moving outer- and inner lattice-elements and two moving inner ceiling elements. By moving these parts in relation to each other, one can change the transparency of the walls following the day. For the night time one can completely shut the sleeping section to a solid wooden box.

➡ Holiday cottage is a phenomenon of urban city culture. It satellites between a rural and more natural environment.

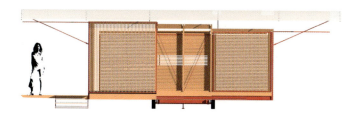

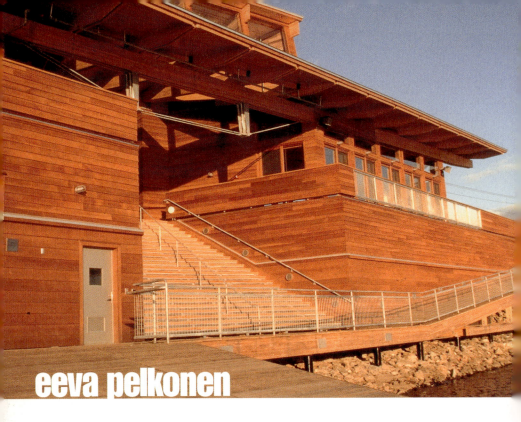

eeva pelkonen

EMPATHETIC AFFINITIES

My own aesthetic sensibility is informed by what could be called the organic approach to architecture, exposed during my early work with Raili and Reima Pietilä Architects and later with Volker Giencke in Graz, Austria. The four years spent in Graz at Giencke's office influencedme perhaps the most. The architecture paid tribute to Hans Scharoun and the German organic school where function and fantasy together give birth to form. Together these two sensibilities – American and European – allow form, function and landscape to engage in a playful dance.

My architectural and intellectual formation is a result of different places, people, ideas and images, which I have been exposed to in the past eighteen years or so. I would argue this to be true of an increasing number in my generation who have worked and studied abroad and who, in great numbers, choose a collaborative practice opposed rather than one dominated by single individuals. Such practices in Finland are numerous: Alli, A-men, Quad, Valvomo, the former 8-Studio, and many more. In fact, I am much more interested in collaboration than the idea of a single isolated architect guru, something architectural history still emphasizes as that isolated cognitive subject. I would argue that we have to approach collaboration first and foremost as a basic human condition. We are, as human beings and architects, conditioned by places and people we are surrounded by, ideas and images we are exposed to. I endorse the fact that the boundary between an individual and its surroundings tends to blur. The process resembles that of mimesis: we identify with the people close to us both mentally and physically. To collaborate means to let loose and subject oneself to influence.

1–2 Crew Boathouse for Yale University @ Derby, Connecticut, USA, invited competition, 1st prize 1998, planning and construction 1998–2000 > **1** river front with the boat-ramp, **2** view through the building.

eeva pelkonen

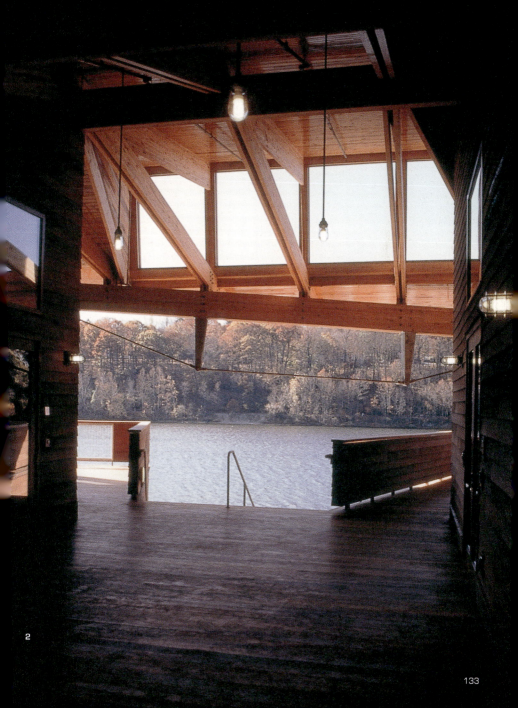

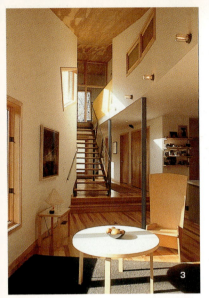

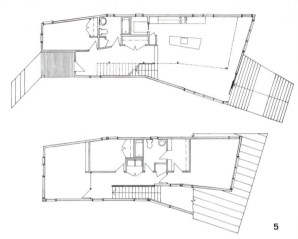
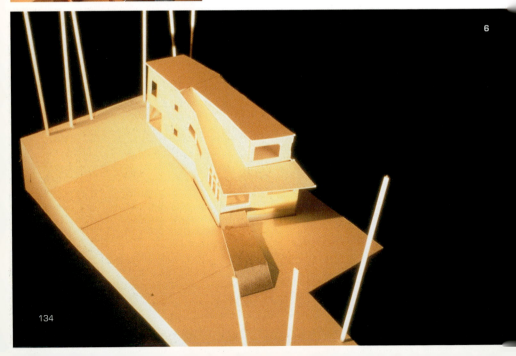

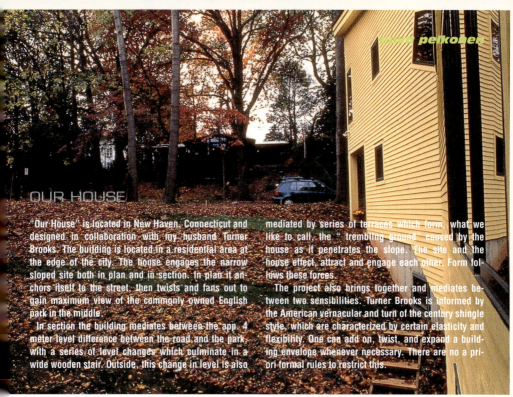

OUR HOUSE

"Our House" is located in New Haven, Connecticut and designed in collaboration with my husband Turner Brooks. The building is located in a residential area at the edge of the city. The house engages the narrow sloped site both in plan and in section. In plan it anchors itself to the street, then twists and fans out to gain maximum view of the commonly owned English park in the middle.

In section the building mediates between the app. 4 meter level difference between the road and the park, with a series of level changes which culminate in a wide wooden stair. Outside, this change in level is also mediated by series of terraces which form, what we like to call, the " trembling ground" caused by the house as it penetrates the slope. The site and the house effect, attract and engage each other. Form follows these forces.

The project also brings together and mediates between two sensibilities. Turner Brooks is informed by the American vernacular and turn of the century shingle style, which are characterized by certain elasticity and flexibility. One can add on, twist, and expand a building envelope whenever necessary. There are no a priori formal rules to restrict this.

3–8 Our House @ New Haven, Connecticut, USA, single family residence, planning and construction 1999–2000 > **3** view from the living room to the study / **4** stair and railing / **5** 1st and 2nd floor plans / **6** model / **7** "trembling grounds" / **8** south elevation.

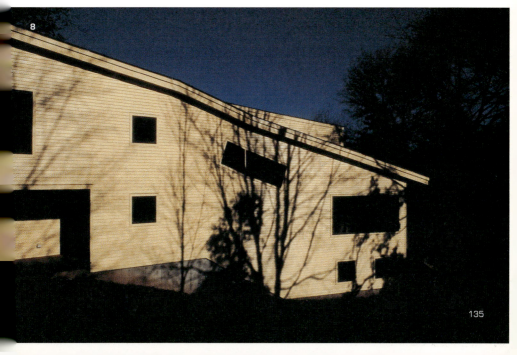

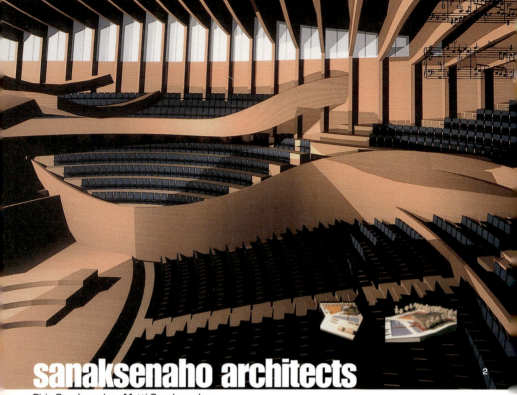

sanaksenaho architects
Pirjo Sanaksenaho Matti Sanaksenaho

MUSIC CENTRE "KONTRAPUNKTI"

Part of the dynamic of the local urban structure, the shaft between the buildings continues the diagonal route from the main Helsinki Railway Station to the National Museum, connecting two parts of the city.

The presence of the music is to be sensed from afar, the atmosphere festive as the composition moves from bright and disciplined to natural and emotional, like walking from the city to the park. Immediately recognisable, the concert facilities and the Sibelius Academy both have their own natural form. Parkside, the concert halls rise as a folding, brass covered "grand piano" above the water. In contrast to the gentle "BRASS", the Sibelius Academy has the abrasive "KANTELE" form. Entering the Sibelius Academy from the park, the glazed interior street connects the music-centre with everyday life. The tempo of the street is fast.

The tempo slows when moving from the street to the lobby, to "the smooth waters", the muted string instruments. The horizontal space opens to the park, calming visitors, preparing them. The audience moves in a long stream, avoiding crowding. Water frames the lobby as restaurant and cafeteria extend outside as terraces, decks out to the water. The "Bellies" of the auditoriums are visible above the lobby as soft blows. A sunken winter garden is located around the glass-triangle of the Sibelius Academy, onto which most of the school rooms open, bringing natural light and the landscape to every room. The Information Centre continues the open sequence of spaces, leading to the reading rooms connected to the garden; muted string instruments.

The "BRASS" rises grandly above the water and opens the three public foyers to the park. The lower foyer is reached from the lobby by arched staircases in a round shaft resembling the long arches of the string instruments. The middle foyer contains suspended balconies and bridges. Walking up the arched and spiral staircases is an organic dance, a rhythmical process. The upper foyer repeats the geometry of the first foyer with arched

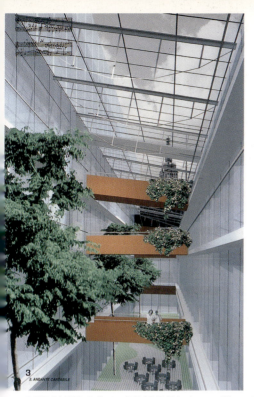 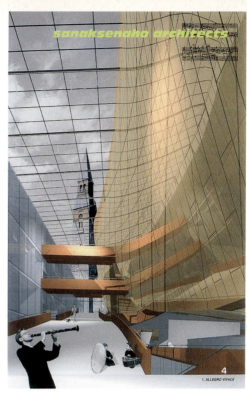

1–5 Helsinki Music Centre @ Helsinki, Finland, competition entry 2000.

staircases. The tension between the landscape and the "BRASS", between open and closed, grows to a crescendo before entering the halls. The string instruments and the wind instruments maintain a simple dialogue.

The auditoriums are the high point of the composition. They form the soft womb of the Music Centre. The audience is gathered around the musicians, not in a strict, rectangular form, but in a circle, as a street-musician in the middle of an audience. The auditoriums, violins in their cases, red-toned wood with golden brass, create a festive atmosphere. The small hall, Rondo, functions with a fast tempo, strategically visible. From here there is direct connection to the big auditorium, to the public foyer, to the orchestra foyer and to the school. It is a stage for the contemporary events in the music centre. Inside the large auditorium, the "FINALE" of the Music Centre, is like being within a huge cello. The string instruments play a simple four-toned theme. Glue-laminated beams maintain a repetitive rhythm through the sculptural space.

Natural light falls indirectly from above. Strongly folding terraces and balconies surround the circle shaped stage. The Finale ends to the fanfare of drums and trumpets.

(Architect: Matti Sanaksenaho, Sanaksenaho Architects. Design team: Sakurako Funabiki, Arttu Hyttinen, Jari Jetsonen, Timo Kiukkola, Sari Lehtonen, Aaron Letki, Jari Mänttäri, Pirjo Sanaksenaho, Jan Schneidewind. Music consultant: Marja Tunturi. Acoustic consultant: Alpo Halme. Structural consultants: Matti Ollila, Tero Aaltonen)

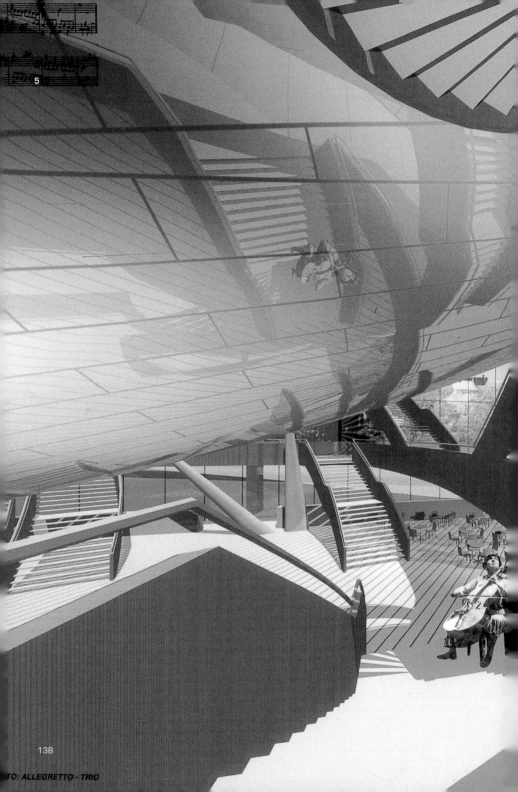

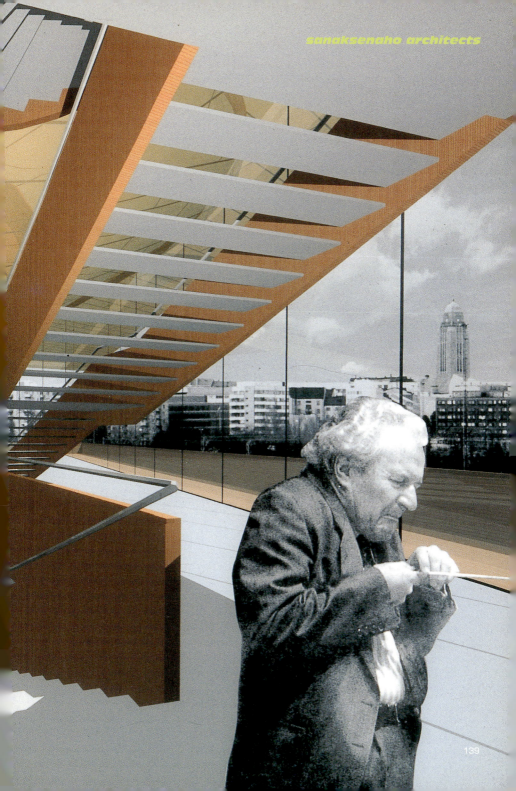

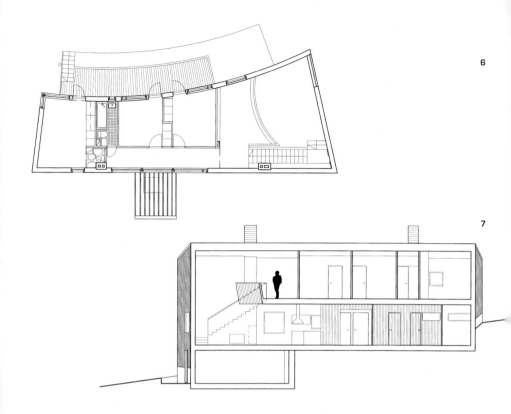

HOUSE TAMMIMÄKI

The project is situated on a lake site outside of Helsinki. The plot is on a short peninsula which opens to the lake to the south and the west. There are small bays on both sides. The site is called "birdlake" because of the wide variety of different birds to found there. The sound of them is remarkable.

Behind the peninsula, a hill rises up and provides shelter for the site towards the north-east. There are a number of old oaks on the peninsula and on the hill. That is how the area gained it's name Tammimäki, (Oakhill). The peninsula and hill is occupied by one-family houses, most of them built on the slope.

The project includes a one-family house built on the slope. For the future extension of the project there is the possibility for a studio on the same plot. Together the buildings create an sheltered yard opening to the lake. The scale of the main building grows from the small scale at the entrance to the bigger scale towards the landscape to the west.

The building provides shelter from the street to the north by means of a closed rear wall. While the south facade is more alive and sensitive. The south-elevation turns with a gentle curve round the garden, around an old oak tree in the middle. The curve follows the form of the little bay to the south, relating to the existing form of landscape established by the gentle hill.

The form of the landscape gives the atmosphere of home. The interior spaces connect strongly to the landscape giving a feeling of living in nature. For some people it sounds romantic and old fashioned. In this case the users of the house believe it is in the spirit of the 21st century.

Technical innovations and information technology have developed to such an extent that it is now possible to choose a way of living that is more flexible than ever before. In this case, returning to nature is not running away from something, it is coming back. The sequence

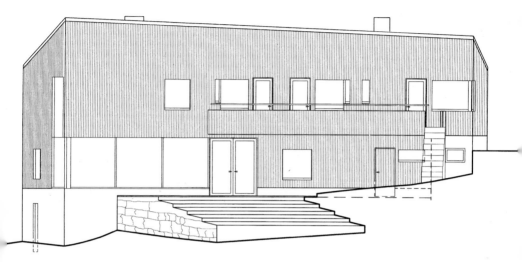

6–8 House Tammimäki @ Lippajärvi, Espoo, Finland, commission 1998–2001.

of open spaces goes from living and dining room to the garden of rounded terraces and from there to the open nature.

A lot of time in one-family house living is spent outside, therefore the outside spaces such as terraces, balconies and garden are important. The more public functions such as entrance, hall, kitchen, dining and living are situated on the first floor. These spaces are arranged from east to west, from more private to very public, from the sauna to the living room.

The curved wall is the guiding principle for the sequence of interior spaces. The private section: master bedroom, bedrooms for the children and balcony for drafting are situated on the upper floor. The bedrooms open to a balcony towards the lakeside. The double-high living room creates the feeling of being outside, in the woods. The natural light from the top of the studio emphasises this feeling. One takes the staircases up to the balcony via the library over the fireplace.

The building material for the basement is plastered stone. It is the stone foundation which carries the light timber structure of the rest of the building. The outside panelling is of "blackened wood", this is wood which is heated in an oven at a low temperature. In this way the water evaporates from the material and it gains a high weather resistance and a darker tone, like the wood of an aged timber cabin.

(Architect: Pirjo and Matti Sanaksenaho, Sanaksenaho Architects, Project team: Sari Lehtonen, Jari Mänttäri. Structural consultant: Tero Aaltonen, Ventilation and plumbing consultant: Markku Kallio, Electrical consultant: Juhani Mäntylä)

house

—Finally, architecture is a dangerous profession because it is a poisonous mixture of impotence and omnipotence, in the sense that the architect almost invariably harbours megalomaniacal dreams that depend upon others, and upon circumstances, to impose and to realise those fantasies and dreams.
Rem Koolhaas

—Today we live in a Karaoke world. A world without any particular point of view: where high culture and low culture have their edges blurred. Karaoke is mouthing the words of other people's songs, singing someone else' lyrics. Karaoke is an amateur performance of other people's ideas. It is a virtual replay of something that has happened before. Life by proxy - liberated by hindsight, unencumbered by the messy process of creativity and free from any real responsibility beyond the actual performance.
Malcolm Maclaren

—If you want to create something new search for that which is ancient.
Aulis Blomstedt

In the 1990s architects begin to ask themselves how the seduction of chaos and disorder which pluralism invited could be trimmed. It was important to find a strategy to co-opt the apparent plurality and licence available in the 1980s. To move on, to transform, it was important to keep one's own version of architecture under control. It might appear, as we come to the third section – 'house' – that we have done some sort of 'hip-hop' jump and arrived at the more radical practices in contemporary Finnish architecture. It is of course possible to argue that these practices shown here seek more radical transformations, wider disciplinary contact for architecture, and an increased energy and fusion. Yet at the same time this work can be seen to be formed from many of the ideas discussed in the first two sections. And it is because there are clear innovations in the previous projects that we begin this section with the increasingly successful work of Quad, a group of young architects who express a strong interest in 'inconspicuity', and end our collection with the creative digital movements and inventions of the architects, Ocean North.

In between we show the successful larger works of practices like Antti-Matti Siikala

and Sarlotta Narjus, Tiina Parkkinen and Alfred Berger, and Kirsti Rantanen whilst introducing the reader to more unknown works from Harri Hautajärvi, Päivi Jääskeläinen, Kaisa Soini and Antti Ahlava. In this way we bring together architectural ideas that are not always fully formed, ideas that may not always make up an architectural site or project which we might be familiar with. These may be ideas which may have begun beyond the field of architecture but by doing so may wish to widen the site of architectural production itself. Whether this widens the architectural solutions into something as yet unknown remains to be seen.

Here we also see the multiple and fused talents of Amen, Livady, Reflex and Valvomo where architecture invites musical echo, integrates with graphics and advertising, navigates itself through research and product semantics. Here architectural intervention blurs the constants, blurs the predictable and de-limits architecture. Some are instant solutions, fast-track ideas leading to installation architecture, interior designs, restaurants with attitude. Others are installations needing to avoid the architecture they suggest too easily.

As young architects begin to understand the legacy of the 20th Century and the role of artistic influence, as they slowly widen the site of architecture itself, the imagination seems to resonate with a new horizon, Do we enter a new unassertive, unimposed architecture, full of fun, fashion and trends? Or, fused together, is this an architecture entirely dependent on everything, learning to accumulate its own notions, avoiding its own fashions?

The words of Mikko Metsähonkala, a member of Quad, help us identify a more rigorous, programmatic hint on how to avoid the constant fashion in architecture. Many agree. Considering renovation and infill may form an increasing part of the architects' work in the 21st Century, buildings will be perceived more as part of a much wider drama, rather than autonomous artefacts. Inconspicuous architecture, according to Metsähonkala re-scripts context: "an indicative building will be posited in a relative zero-point within the surrounding structure." Importantly this leads to the disappearance of the independent unit as work blends, fuses if you like, into larger structures, wider networks which include more than the built form. "Inconspicuous architecture," Metsähonkala continues, "does not impose any demands on the user, yet by yielding to the conditions of its surroundings it resigns from momentary whims. People and

ideologies change, buildings stay."

The careful, controlled, 'rationalist' strain of Finnish architecture represented by the astonishing number of successful projects coming from established Finnish firms in the 1990s saw a new 'Internationalism' appear. Spectacular steel and glass buildings, double facades, proliferated. These buildings offered a way to re-assess Finnishness whilst at the same time questioning the critical label itself. For what was so Finnish about steel and glass?

As if to answer the impossible question, the careful uninflected works of Quad can be seen in relation to the more spectacular, totemic images produced by Siikala and Narjus. Both are remarkable for their tectonic finesse, both are programmatic in the way they wish not to bring more to their architecture than they wish, whilst both also share similarities with the contemporary images we see used by Rantanen and Parkkinen.

Architects, painters, artists and students, with new ideas, do not always conform to the ways these ideas can be integrated within the profession and society. Along with plurality there is a 'horizontality' which the young take for granted, a thrill in the unrest and an accommodation of uncertainty that must spill over into new architecture. Here it is worth noting the similarities yet differences between the experimental works of Hautajärvi, Jääskeläinen and the painterly experiments of Soini. Perhaps Soini in her 'Paintings of Architecture' indicates the pull away from architecture which always invites architecture back in, whether through canvas, exhibition or space. Intrigued by, and taking off from, Borges' story of the cartographers, the drawn, the representation of and for architecture and the built form, produces the gap within which Soini positions her work.

"I have been intrigued by this story when puzzling out the two realities in architecture: drawings or representations and buildings. They do not strictly coincide but rather create a space or a gap in between. This has been the space for my work. Buildings are coded in architecture drawings. The drawings are based on projections that orthogonally section the built object... whether these drawings are just a means to the end or whether they have a bearing on the resulting buildings is arguable. Consequently, the space concept of drawing continues to hold an unsettling grip on architecture."

Not all these 'house' practices seek a unique aesthetics and sense of expression, but all probably discover their own

ndsensuality in architecture, developing their own compositions from the hand, the eye, the touch. Soini invites us to be more circumspect: "Just as the human body is present in the act of drawing so the changing weight of hand, tension, sensibility, hesitations, errors and their corrections are also present."

We should therefore be intrigued by error as much as certainty. It is also clear that today inter-disciplinary and collaborative work no longer need definition, so mutual and so widespread have they become in architecture. Fused between innovation and responsibility, many of the new works in this section acknowledge the strength of the past, whilst they begin to edge us away from the grander mission architects dreamed of in the last century. That 'brave' attempt to organise architecture into an organisation of life itself!

New attitudes invite new gaming strategies and imaginary soliloquies for architecture. These became momentarily as inhabitable and inevitable as they were improbable. No purpose, no agenda, there results a privatization of architectural meaning. This is why the works of the last five practices indicate why collaboration is likely to delimit architecture itself: Ahlava's machine metaphors, Reflex's careful design extensions allied with research, Livady's attempt to widen their own visions constantly yet carefully, the already known work of Valvomo – 'Snowcrash' & 'Glow' – ending finally with the digital excitement and pulsing rhythms of Ocean North.

Ocean North look likely to pioneer information transfer, data visualisation and an increasingly choreographed architectural site within and, of course, beyond Finnish architecture. And if we talk of a choreographed or a sculptured site for architectural drama, this should not frighten us, nor is this taking us beyond the concept of 'house'. Liquid the drawn images may be, liquid we might become, the envelope will answer back, the buildings stay!

For now at least!

Whether 3D geometry leads to a 4D architecture negotiating time itself, we are pulled back to business. Impossibility in the drawn leads to looped infinities, universal data flows and hypertextual architecture. The attention to detail goes elsewhere and the soul laments whilst natures call for 'unplugged architecture'.. In many ways these digital creations bring us full circle, back yet on to Lukander's Villa Sälteskär, the black cube!

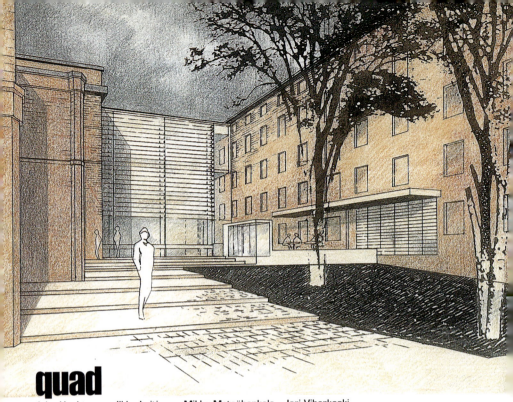

quad

Juha Huuhtanen Ilkka Laitinen Mikko Metsähonkala Jari Viherkoski

A building should be perceived in relationship to its environment and not as an autonomous artefact. Architecture that is perceptive to its environment is indicative. It commits itself to the conditions set by the location and turns the viewer's gaze away from itself to a wider whole, and in so doing creates a justification for the surrounding buildings.

In repair-and-infill buildings all historical stages have their own value. New building parts form within this whole their own important strata. In design one must nevertheless strive for timelessness and permanence. In its permanence, the building joins the user to his or her environment and the user through his or her actions to history. Renovation and infill construction will form an increasing part of architects' work in the 21st century.

The architectonic solutions in each project, be it residential or working environments, are evenly matched, valuing each user. The user, as an individual, is part of the network of social interactions. The private environment of the design is interconnected with the already built public environment through carefully considered semi-public spaces. From these starting points, each design respects and supports also the viewpoint of the town planner.

Inconspicuous architecture is indicative. The word 'indicative' refers both to the anonymous basic form of the verb and to the act of indicating, directing someone's attention somewhere. An indicative building will be posited in a relative zero-point within the surrounding structure. It will disappear from view as an independent unit and blend into a larger structure, in which the imprints left by time and history beome more visible.

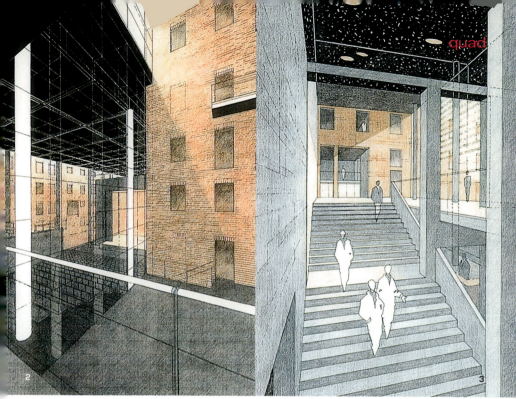

1–4 Fab Academill, Åbo Akademi, Österbottens Högskola @ Vaasa, Finland, competition entry, 1st prize 1999, completion 2003 > illustrations and plan sketches.

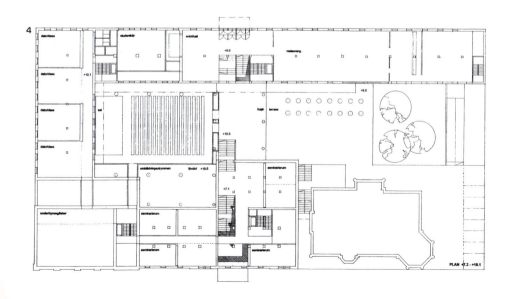

5–7 Baltic Art Centre in Björkanderska Magasinet @ Visby, Gotland, Sweden, competition entry, 1st prize 1997 > illustrations and plan sketches / **8–9** Europan 4 Housing Competition 1996 @ Vukovar, Croatia, competition entry > model, apartments variation.

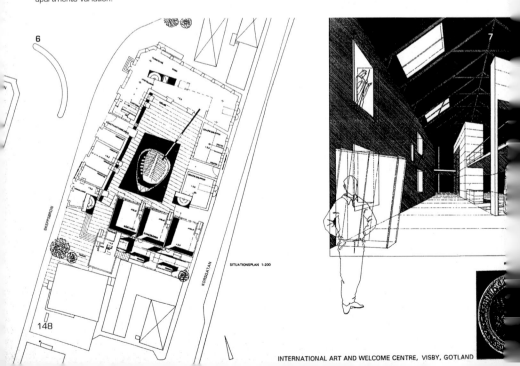

INTERNATIONAL ART AND WELCOME CENTRE, VISBY, GOTLAND

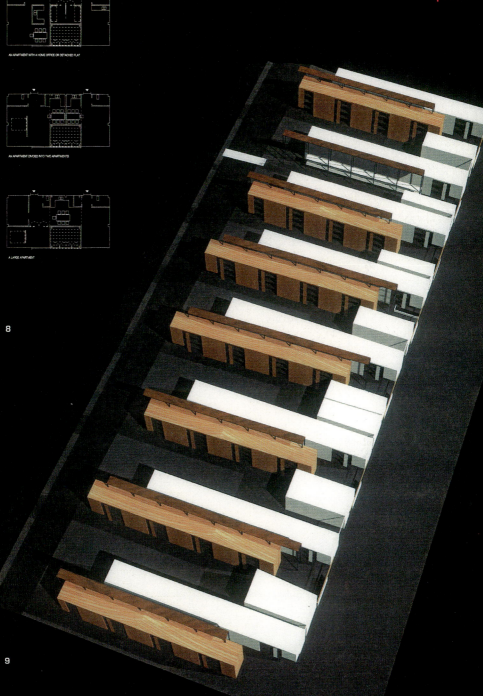

quad

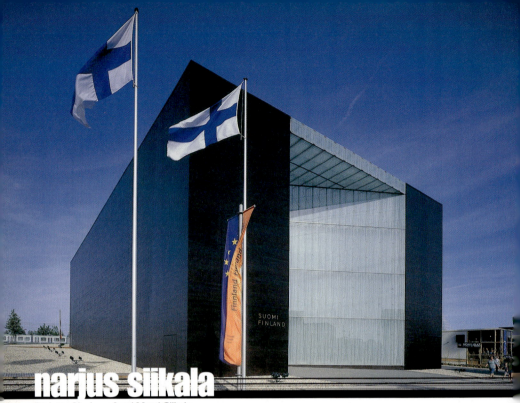

narjus siikala

Sarlotta Narjus Antti-Matti Siikala

T he best spatial entities are arresting, without any kind of analysis, often through their own simplicity. The theorising of the adult world and its ability to analyse the surroundings often destroys, deep down, the ability to experience primitive innocent reactions at first sight. Retaining this ability, nourishing one's own internal childlike mind and keeping faith with it is an important characteristic for the architect, which must not be sacrificed on the altar of project administration or buried by the drudgery of the daily grind.

1–2 Expo 2000 Finnish pavilion @ Hannover, Germany, open competition 1st prize, built 2000 > **1** entrance facade / **2** side facade.

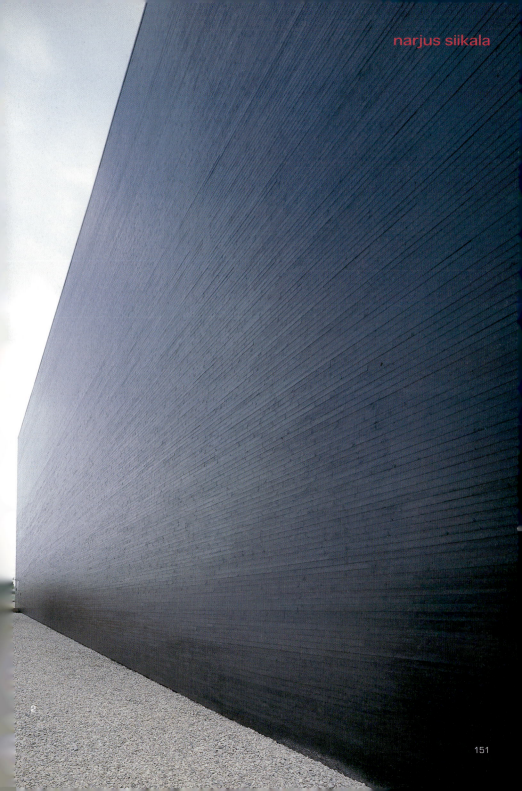

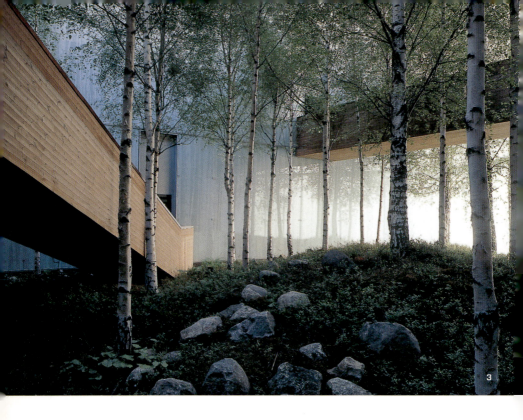

3

4

1. SISÄÄNKÄYNTI / EINGANG / ENTRANCE
2. SISÄÄNKÄYNTI VIP / EINGANG VIP / ENTRANCE VIP
3. LAITURI / STEG / QUAY

5

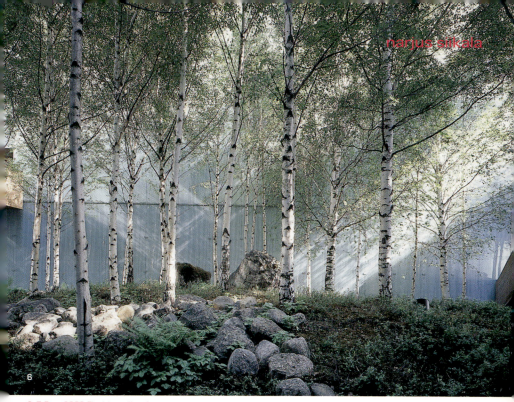

3–7 Expo 2000 Finnish pavilion @ Hannover, Germany, open competition, 1st prize, built 2000 > **3** entrance facade / **4** site plan / **5** longitudinal section / **6** birch grove / **7** transversal section.

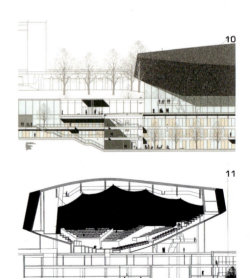

narjus siikala

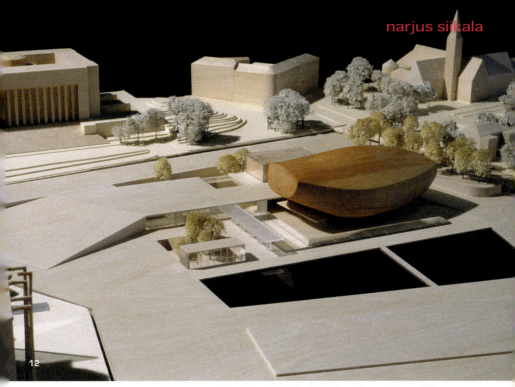

8–14 Helsinki Music Centre @ Finland, open competition, 2nd prize 2000 > **8** view from Kiasma Museum of Contemporary Art / **9** site plan / **10** partial section / **11** concert hall section / **12** scale model view / **13** plan level 1.5 m / **14** ground floor plan.

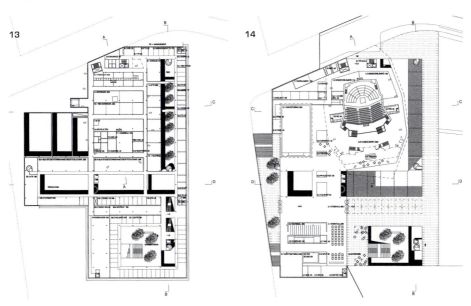

berger+parkkinen

Tiina Parkkinen Alfred Berger

LEAVING ARCHITECTURE IS MAYBE THE BEST WAY TO ACHIEVE ARCHITECTURE

Architecture needs to start from an idea. Where the basic idea is missing, architecture cannot emerge. In our work the idea is always linked to the situation and to the program. Situation means: site / topography / micro climate / history / building codes / social and economic climate and all other relevant facts and things present when the work starts. Program means the actual program + the inherent potentials + conceptions of a possible future development.

This strategy requires a clean table and an open mind to start – NO IMAGES!

Our projects are specific. The idea generating a project is based on the unique geography behind it. The quality of a design depends also on its capacity of integration.

Our work deals with the expansion of possibilities. All sorts of actions and proceedings, no matter if they are casual or ritual, generate differently in new spaces. On this level buildings exercise a sustainable influence on the society. Every built space is a fixing. New space has to avoid the mistake of mono-functional design. It has to open possibilities.

Architecture in town: "The house in the town shares its destiny with the tree in the woods."

After a promenade in a woods we may memorise the woods by means of density, climate, topography, atmosphere and light, or the lay out of the paths running through the woods and the topography of the ground – but usually we do not remember single trees.

2

1–3 Altona Station @ Hamburg, Germany, invited competition, 1st prize 2000.

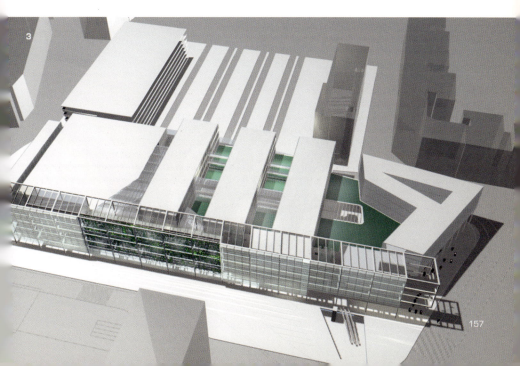

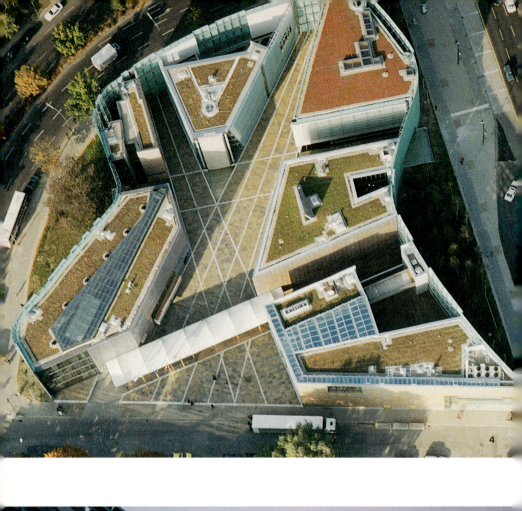
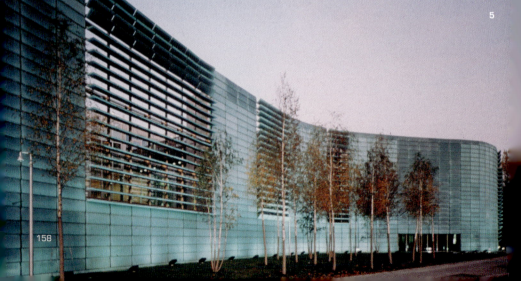

berger+parkkinen

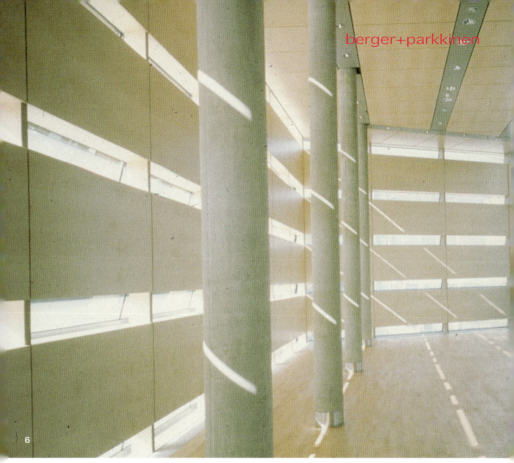

4–7 The Embassies of the Nordic Countries in Berlin @ Germany, competition, 1st prize 1995, built 1999 > **4** a view from the air / **5** copper band surrounding the area / **6** venue on the first storey of the Community Building / **7** the Community Building façade.

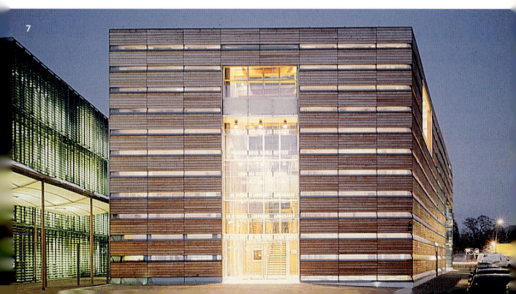

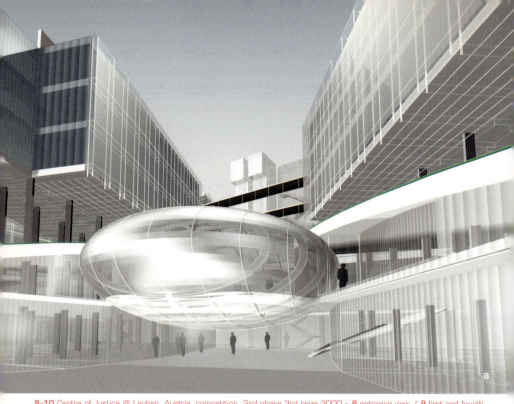

8–10 Centre of Justice @ Leoben, Austria, competition, 2nd phase 3rd prize 2000 > **8** entrance view / **9** first and fourth floor plans / **10** (from top) east facade, north facade, section, west facade, ground floor. The area consists of three law-courts: country-court superior, court-public prosecutors office and a prison.

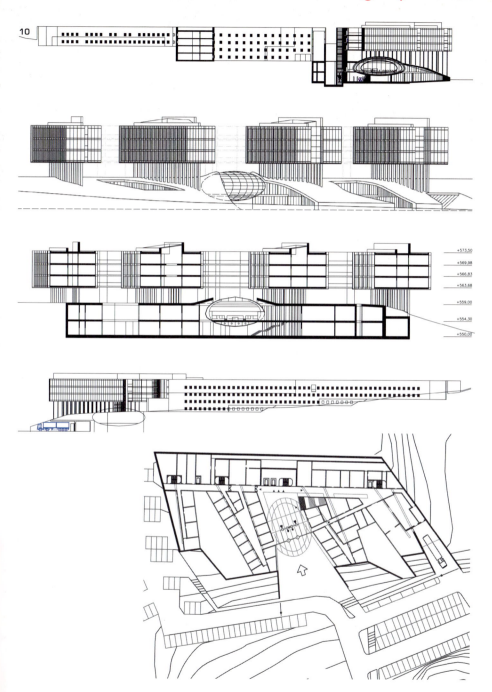

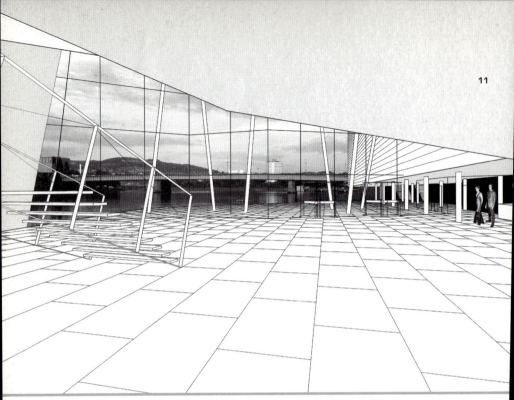

11–13 Opera House and Music Theatre @ Linz, Austria, competition, 2nd phase 3rd prize 1997–1998 > **11** foyer perspective / **12** (from left) ground floor, sections / **13** night view / **14–15** Science Centre Wolfsburg @ Germany, invited competition 2000 > **14** model / **15** (from left) site plans, examples of plans, sections.

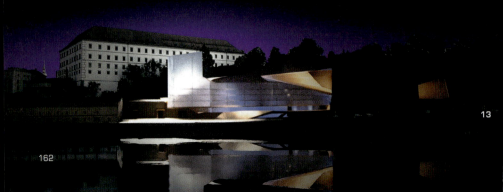

berger+parkkinen

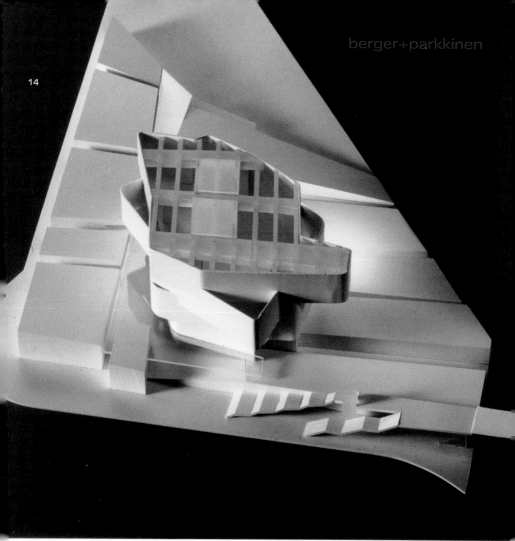

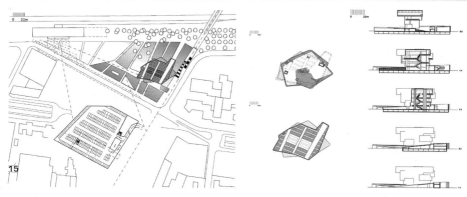

kirsti rantanen mauri korkka

MYLLYPURO ENVIRONMENTAL ART COMPETITION

The winning entry in a environmental art competition held by the City of Helsinki to which four landscape architects, one architect and one artist were invited (Autumn 2000). On the site a housing area had been constructed in the early 1980s. Later it was discovered that the underlying ground had been polluted whilst used in the fifties and sixties as a refuse dump.

A decision was made to demolish the residential blocks, and seal and cover the toxic wasteland. The task of the competition was to redesign the place, giving it a new, positive meaning.

The city lives and shifts in the embrace of time, as a spiral which rotates around itself, embracing one who wanders therein.

On the hill there is a meadow in bloom and as a jigsaw puzzle an iconic image, a single day wander through the Paris arrondissements, a helical path.

A number of lightweight pavilions in which a small tree has been planted have been constructed for the visitor. The pavilions contain transparent photographic images of Paris which have been taken according to a predetermined principle on one particular day.

On an autumn evening the basic lighting which filters through the pavilions is produced by coloured optic-fibres according to impulses from the visitor.

In winter the pavilions are involved in a play of light and snow, as water which swirls peacefully.

To the southern side of the hill there is a slice of Manhattan as a labyrinth image in the centre of a lawn. The external boundaries of Central Park have been moved to the centre of Manhattan for the duration of an afternoon walk.

Creepers grow amongst the high crystalline peaks of urban space; at the crossings of streets are photographs of New York, all taken on a single day, from these same crossroads.

kirsti rantanen mauri korkka

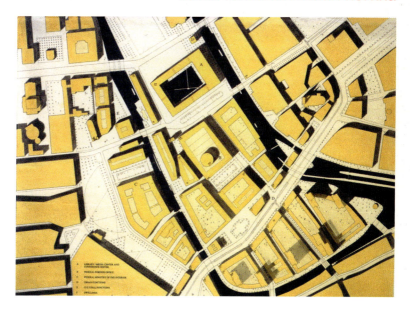

2

1 Raisio City Centre @ Raisio Finland, urban design consultation 1999–2000 > lighting structures / **2** Berlin Stadtmitte Spreeinseln urban design competition 2nd phase entry @ Berlin, Germany 1993–94 (with Sari Lehtonen) / **3–4** Myllypuro environmental art competition @ Helsinki, Finland 2000 > **3** "Central Park, New York" / **4** a folly: "Paris 7. Arrondissement Cour d'Hôtel des Invalides".

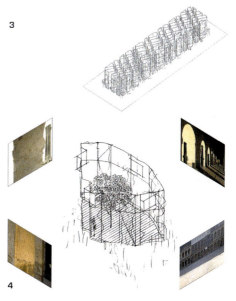

This Manhattan too breathes life during the dark season from light with its visitors.

The eastern lawn is lit partly from ground level. Concert-goers to the eastern part of the lawn are bathed in warm light.

From the southern part of the lawn, within one's sight, a view of the wetlands and the open-air swimming pool, a meeting of the urban park and recreation ground.

5

6

5–6 Myllypuro environmental art competition @ Helsinki, Finland 2000 > **5** a view towards the "Paris Arrondissements Hill" and its follies / **6** "Manhattan" as a green labyrinth on the front.

kirsti rantanen mauri korkka

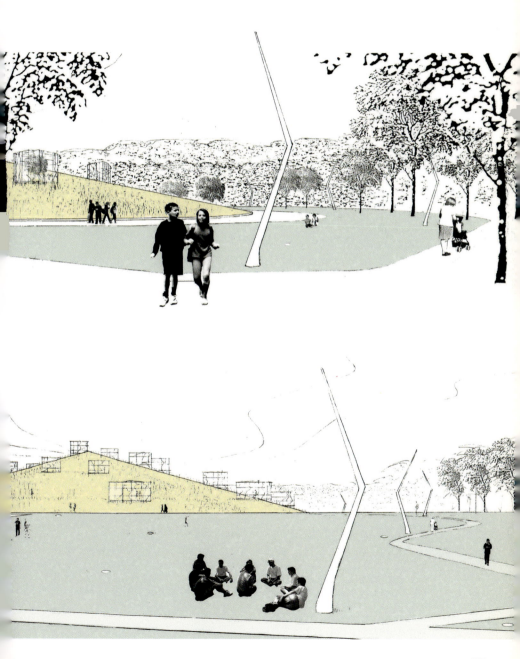

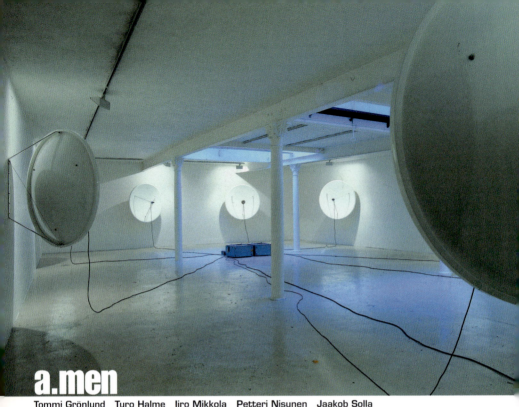

a.men

Tommi Grönlund Turo Halme Iiro Mikkola Petteri Nisunen Jaakob Solla

Tommi Grönlund, Turo Halme, Iiro Mikkola, Petteri Nisunen and Jaakob Solla have known each other since their student days at Tampere School of Architecture. They moved to Helsinki in the early 1990s where since 1993 they have run their joint studio-practice a.men Architects. In addition to the partners there have usually been between 3–5 members participating on various projects. Turo Halme has, for many years, worked mainly outside the office. From the beginning the studio has taken on a wide range of projects reflecting the group's many interests: besides architecture, interior design, furniture design, product design and graphic design. The aim of the practice has been to create a working environment that fosters freedom of design whilst increasing the synergy amongst the group. Mikkola and Solla concentrate mostly on architecture and interior design whilst Grön-lund and Nisunen, who have also worked together since 1993 as artists responsible for many solo and joint exhibitions in Finland and abroad, have also done various public art works. Within the studio space Tommi Grönlund's also runs his own record company, Sähkö Recordings.

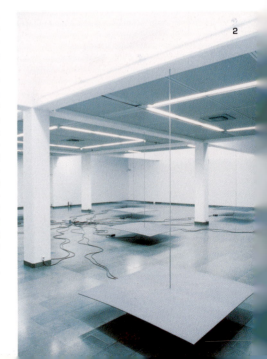

2

a.men

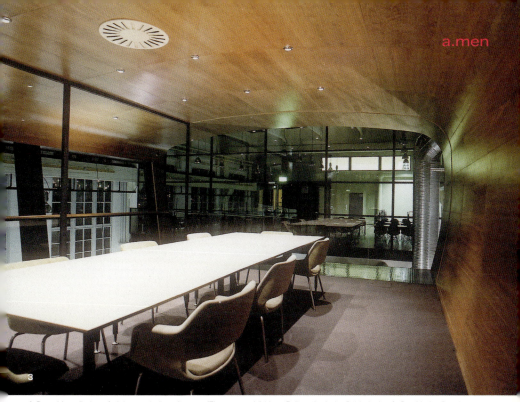

1 Sound Installation of eight parabolic reflectors (Elements exhibition, Gallery Andrehn-Schiptjenko @ Stockholm Sweden 1998 (Tommi Grönlund, Petteri Nisunen) / **2** 'Electromagnet Installation' Young Artist of the Year 1997-exhibition @ Tampere Art Museum, Tampere 1997 (Tommi Grönlund, Petteri Nisunen) / **3–5** Satama Interactive new media company renovation in old factory building @ Helsinki Finland 2000 > **5** Grand Conference Tube.

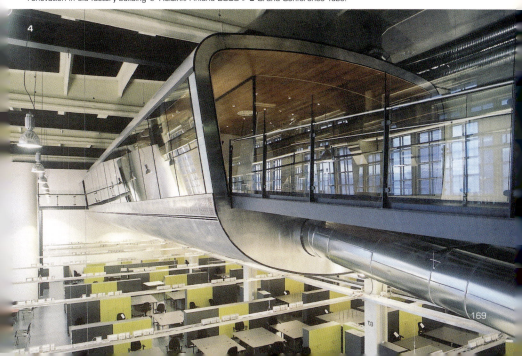

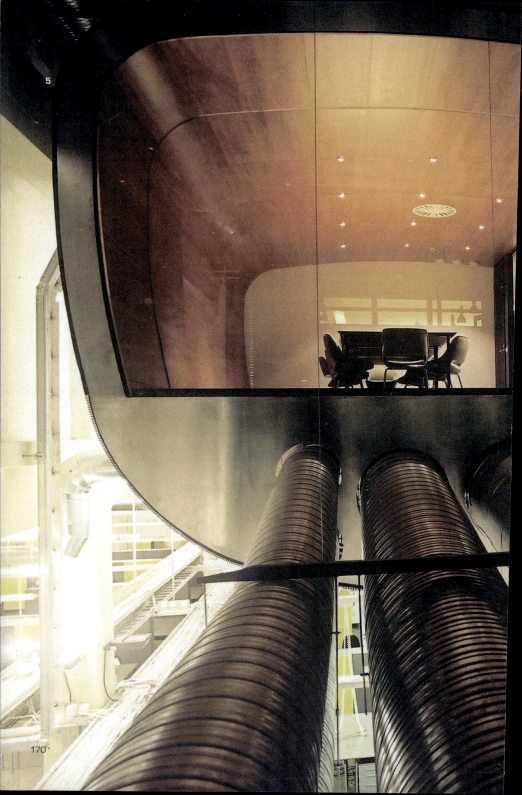

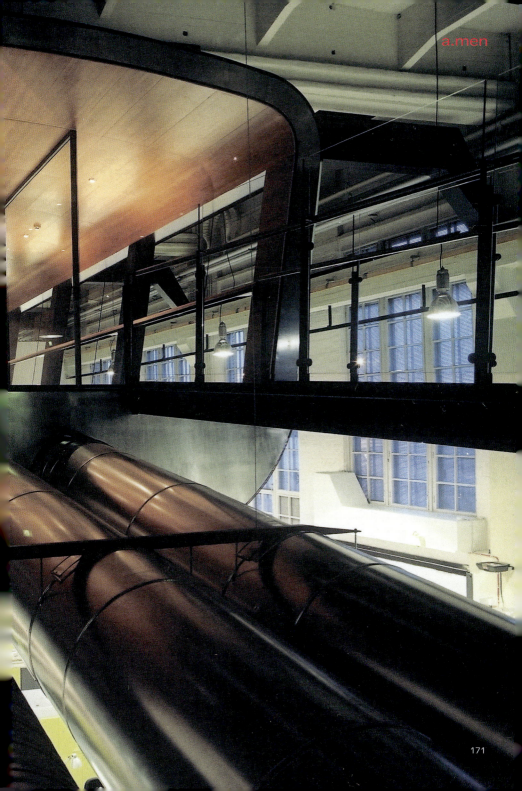

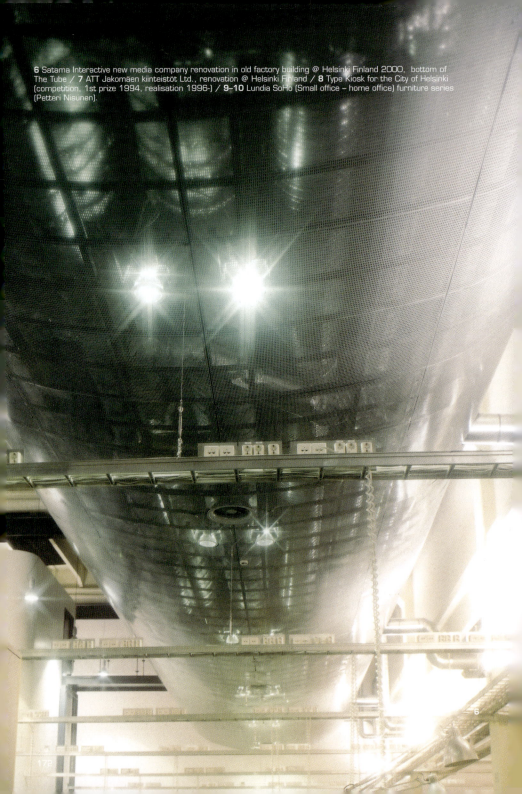

6 Satama Interactive new media company renovation in old factory building @ Helsinki Finland 2000, bottom of The Tube / **7** ATT Jakomäen kiinteistöt Ltd., renovation @ Helsinki Finland / **8** Type Kiosk for the City of Helsinki (competition, 1st prize 1994, realisation 1996-) / **9-10** Lundia SoHo (Small office – home office) furniture series (Petteri Nisunen).

a.men

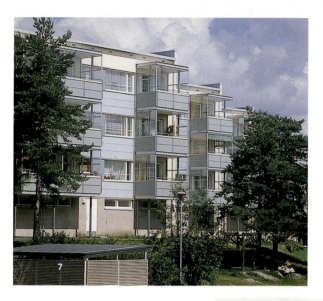

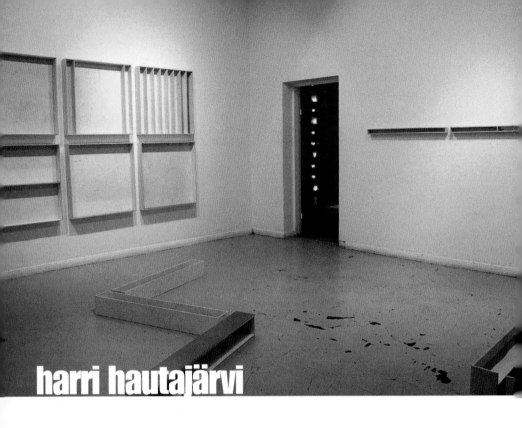

harri hautajärvi

ARCHITECTS IN THE CHANGING WORLD

The times we live in are in constant change. In the early 20th century European architects aimed at constructing the affluent society. Social values were high on their scale of values. Now great principles and the dreams based on them have come adrift. Ideals like industrially-produced residential areas and enormous streams of traffic belong to the past. The modern societies of the world now form a shattered pluralism, a mosaic of the utmost diversity between cultures, subcultures and identities. The consumer-oriented and egoistic western culture is reflected more and more disastrously in our environment. The architect's expertise is held in low esteem and results in bad environments. Social aspects have become less and less important as architecture is accused of superficiality and fashion.

It is likely that we will no longer see any great architectural heroes and unique personalities from the past. And though there are many talented architects in Finland, it is harder and harder to find a personal and individual approach to architecture. Instead of designing building, many young architects today design graphics, web pages, industrial products, furniture and interiors or then pursue research.

The work of architects has gone through some major changes over the last few decades. Up to the 1950's the two leading principles in building were durability and good quality. People were more fortunate then. Their health was not in danger as it is today due to various discharges within buildings.

During the mass industrialised building period, bad mistakes were made, standard models reproduced everywhere. Every day countless new, often synthetic and sometimes harmful products meant for the building industry come on to the market. The actual users of buildings, those who live and work within them, become the guinea pigs of architects, engineers and building contractors as they try out new materials and structures.

Those designers who are aware of their responsibility

harri hautajärvi

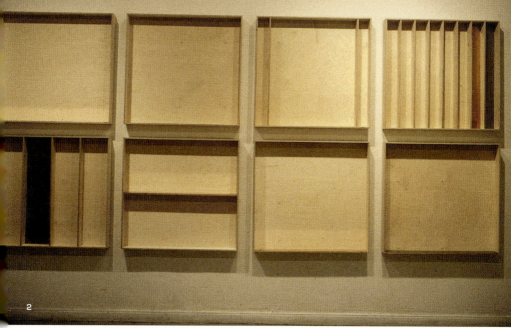

1–4 Art Installations @ Helsinki by Harri Hautajärvi 1996–98.

and concern for ecology and ethics are still few in number. As professionals and individuals architects they hold the key to important, long-term questions. Building in fact is one the most important factors affecting an ecological balance. The special characteristics of the different regions of our planet should be rediscovered. Architecture should be created on the basis of these. Important here are the borderless determinants and local conditions: climate, landscape, soil, vegetation, nature, building heritage, cultures and the identities of the individual.

Architects in the new millennium are beginning to understand ethical choices. They value solutions based on the use of local materials with along life span that ages with beauty. They value structures that can withstand the climate, produce healthy indoor air, use the natural cycle of materials, and use the sun as a source of light and energy. The task of architecture is to improve people's physical circumstances by means of harmonious and sustainable building.

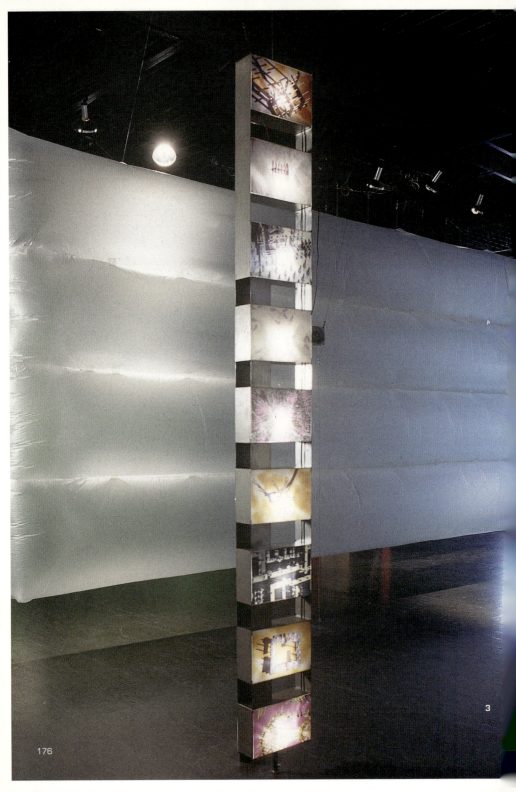

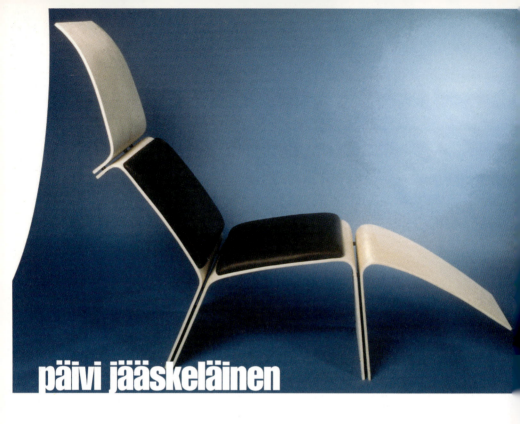

päivi jääskeläinen

APPROACHING ARCHITECTURE AS THE DESIGN OF A LIVING SPACE

Ideas come basically intuitively from nature. Organic form, spatial wholeness, unity, feeling of material, relations and division of spaces, volume and visibility are the main elements of my design. I approach architecture by emphasizing volumes. A volume without boundaries is undefined; it doesn't feel safe, but it gives a suggestion of freedom. A volume has directions unless it is totally closed; its character is specified by its openness, transparency, colours and textures.

By varying these factors the volume – "a space particle" – changes accordingly: a light living volume might change into a darker sleeping area by the change of light or size.

High spaces possess favourable preconditions for qualitative design since the intermingling of the volumes is possible in three dimensions (z-factor). Attics and industrial buildings often have this character.

A capsule for sleeping can be considered as a volume: a tent, a hut and a cave posess the extreme qualitives of minimum living.

Non-spaces are left-overs; they might still have a meaning and purpose as storage. They get their form when bigger spaces collide. Non-spaces are like fractals; they are not whole but originally part of something more voluminous. Such small "containers" play a significant role in space design as hidden volumes.

I am constantly contemplating the division of a (living) space into different areas, and the forms of the *living particles (*volumes of different functions) in an apartment defined according to the needs of the dweller.

Entering a pre-defined space makes one adjust to a pre-planned way of living, instead of creating the space and forms by independent means. The division should happen according to the importance of a certain function

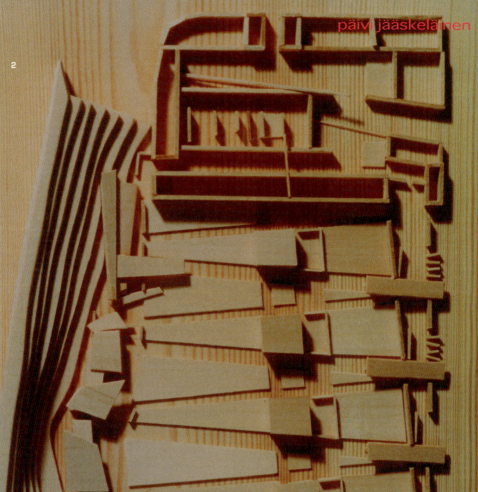

päivi jääskeläinen

and the possibilities of the volume.

The planning of a dwelling area should be started by examining the space, by mapping (a spatial chart, a map of the *living particles*) its possibilities. The assumed importance of different areas should be questioned.

Relations between areas are important: whether some spaces should be located next to each other or not; how do their volumes interact; what are the best locations and directions for different activities?

In many of Paul Klee's paintings some areas pop out as if pointing at something important. In the same way a plan of an apartment, an enclosed area for living, can point up the importance of different areas, their character and meaning.

In the future living space, the meaning of space for the inhabitant should be more important: a space that has a chance to change according to different living situations offers the dweller both freedom and safety, a framework for daily life.

1 'Toukka' ('Maggot') chair, model 1994 / **2** Borghetto Flaminio @ Rome, Italy, competition 1994.

päivi jääskeläinen

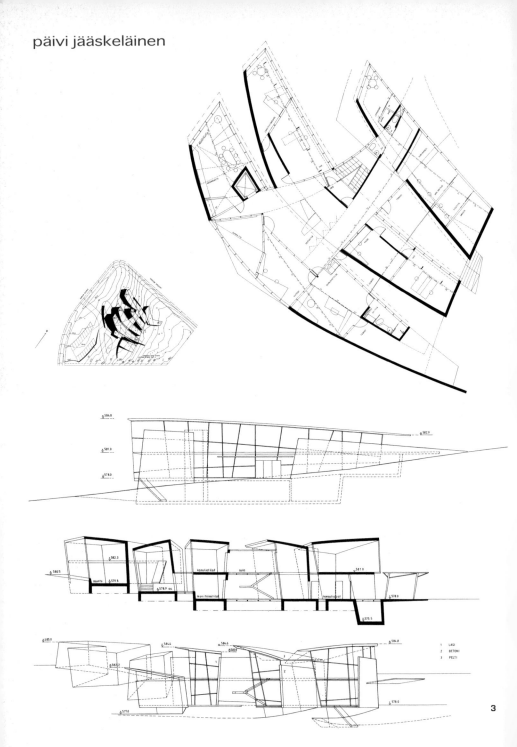

3 The Finnish Embassy in Canberra @ Australia, competition entry, honorary mention 1997 > site plan, plan, south facade, section, west façade / **4** Flat renovation Tehtaankatu 36 B 18 @ Helsinki, Finland 1993 / **5** Forms' Artwork @ Studio Mezzo, Pietarinkatu 22, Helsinki 2000.

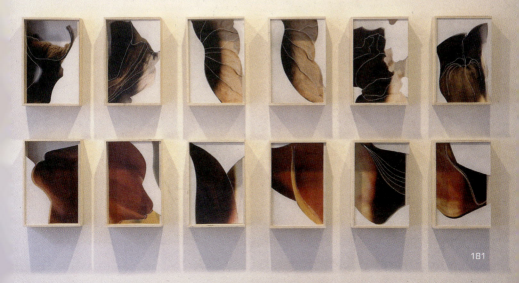

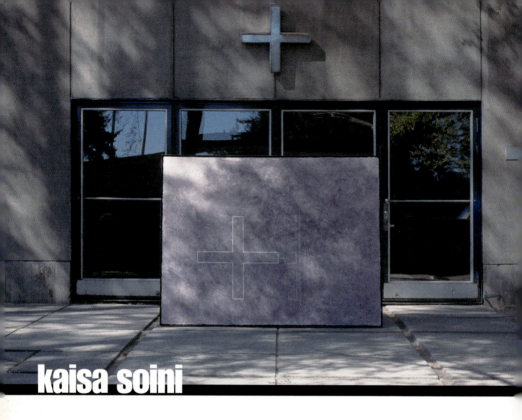

kaisa soini

PAINTINGS OF ARCHITECTURE

Jorge Luis Borges has a story of an empire where the cartographers came up with a map of similar scale, coinciding point for point, as the empire itself. This has always intrigued me when puzzling out the two realities in architecture: drawings or representations, and buildings. These do not strictly coincide; rather they create a space or gap in-between. This has been the space for my work.

Buildings are coded in architecture drawings. The drawings are based on projections that orthogonally section the built object: slicing occurs in a virtual 3-d euclidian grid which then heavily influences the images. Whether these drawings are just a means to the end or exert a direct bearing on the resulting buildings is arguable. However, the conceptual space of the drawn continues to hold an unsettling grip on architecture.

Architectural drawings possess unique aesthetics and expressive sense. Suddenly I discover linear compositions; a line here defining a door or one there a window. And just as the human body is present in the act of drawing, so the changing weight of the hand, tension, sensibility, hesitation, error and correction are also present.

Driven to find a space between architecture and painting, I paint architecture. The work stands on its own as painting, yet is based on the visual concepts of architecture drawings.

I have been driven by an idea to find a spot where architecture and painting could emerge from which I have derived a series of exhibitions on architectural representations. The binding thread in the work is the simple aim to make paintings of architecture so that the work would stand on its own, as paintings, yet be based on the visual concepts of architectural drawings.

1 'Pääsisäänkäynnin risti' (Main Entrance Cross) 150x200 cm applied fresco from the exhibition 'Pinnassa' – Tapiolan kirkon detaljipiirustuksia (In The Surface – The Tapiola Church Details) 1998 / **2** 'Leca-harkkoseinän detaljeja' (Brick Wall Details) 200x150 cm applied fresco 1998 (detail).

DET E

3 'Annankatu 22 kortteli' (Annankatu 22 quartier) various sizes oil, sand and gold paint from the exhibition 'Kartassa ja rajoilla' – asemakaavakartta (In Maps – Detail Plan) 1997 / **4** 'Pilari ja palkki' (Pillar and Beam) 180x60 pigment and oil from the exhibition 'Rihma' (The Thread – Plan, Section and Elevation) 1997.

3

kaisa soini

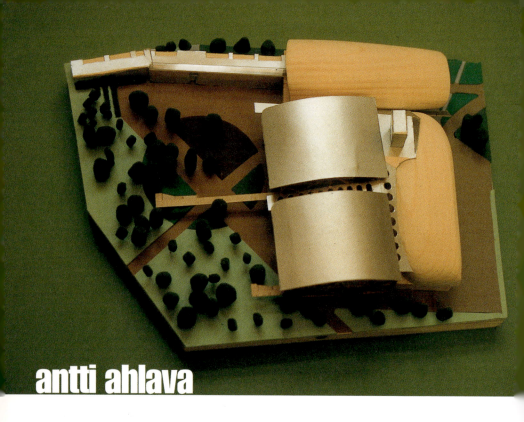

antti ahlava

FOR EXPERIMENTAL ARCHITECTURE

During the days when all kind of retro references seem to have become an obligation in architecture and design, it is nonsense to say that architecture is anything else than a mass medium urging people to personalisation and commodities valued by fashionability. The commodification is not necessarily a failure. As Georg Simmel says, fashion helps people to orientate in a world which is random and chaotic. Presently, the 50's, 60's and 70's architecture have become fashionable, only now supported by the latest technologies and ecological ideology. The local characteristics of our architecture during these times of global telecommunication turn out to be often just fashionable recourses to the Scandinavian history of design. There is nothing necessarily wrong with that! The belief in anything eternal in architecture is highly suspect. Anyway, fashion does not have to mean recourse to history. I like to explore new principles and forms in architecture rather than just recycle old ideas. New aesthetics require fresh thinking!

It is so easy to be an individualist nowadays, the culture industry encourages everybody becoming one. In doing so, one only ends up resembling everyone else. The challenge in life disappears. That is why one must find ways to avoid the cheap traps of consumer society and the media. New architecture should be a challenge to its environment, not in contrast or to become one: An undefinable, enchanting, mysterious object made for the future!

In pursuing this task, I have used the strategies of *snobbism* and *panic*. Here, the supposed laws governing design and planning are taken as playful rules of a game. The German painter Gerhard Richter has inspired me a lot.

1–4 Vessel school @ Vuosaari, Helsinki, Finland, competition 1999: An exploration of the exciting rather than factual base of the education system > **1** scale model / **2** facade detail / **3** first floor plan / **4** courtyard perspective.

antti ahlava

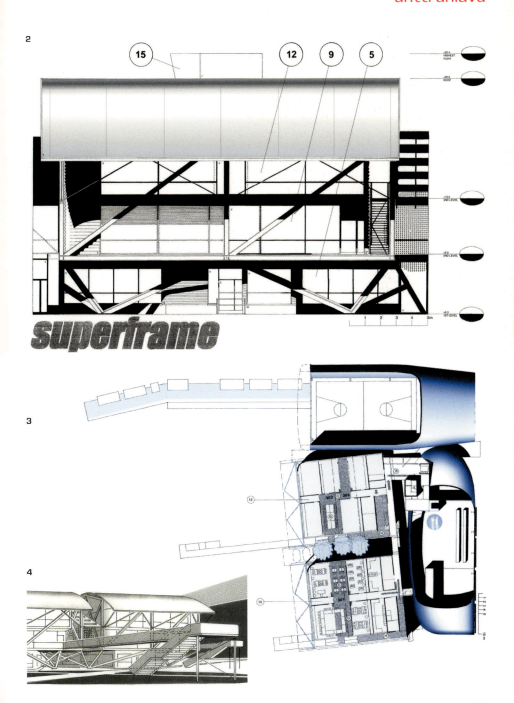

superframe

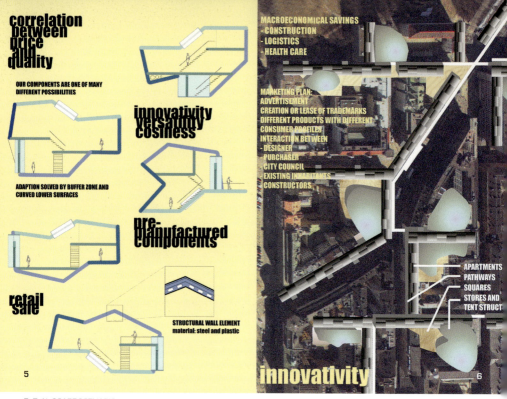

5–7 AirSCAPE SCENARIO competition entry @ Tokyo, Japan 1999 > **5** combinations of pre-manufactured components / **6** site plan / **7** the whole idea.

AirSCAPE SCENARIO

The theme in this competition was "An Architecture Which Is Kind to the Earth". The jury demanded a long-term view of how architecture could create a better relationship between mankind and the global environment. There were no restrictions on the building type, or its size. Our idea was to take ecology as a certain kind of game. Here, flexibility and portability are taken to extremes: The aim is to create a versatile building system which enables "retail" housing over the roofs of existing cities, taking advantage of the prevailing superstructures.

The project relates to architecture as a socio-economic system rather as a biological or technological entity. A house "kind to Earth" is, in this sense, additional housing which shelters the Earth by leaving areas in a natural state as they are, and intensifies existing efficiency. The social benefit lies also in the project's capacity to generate positive feelings rather than only defining a specific object.

(In collaboration with Sebastien Tison)

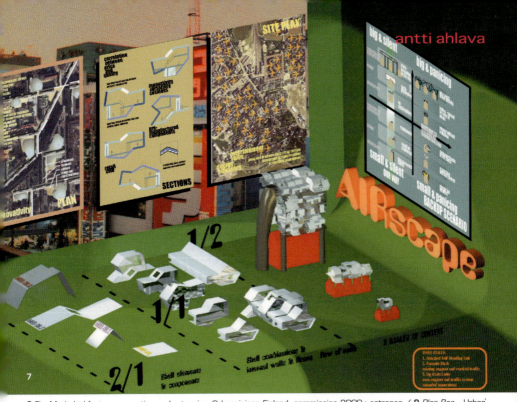

8 FinnMarin Ltd factory renovation and extension @ Luopioinen Finland, commission 2000-: entrance / **9** *Plan Bee* – Urban Renewal Plan & Design @ Jyväskylä Finland, Soundings for Architecture workshop design 2000- / **10–12** *Station* – archaeological centre @ Yli-Ii Finland, competition 1999: scale model, perspective view, flexibility diagram.

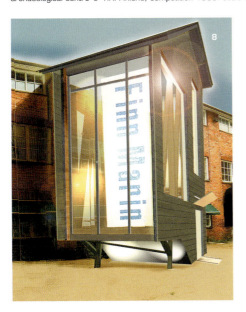
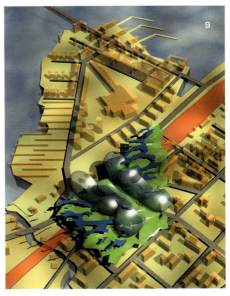

STATION ARCHAEO-LOGICAL CENTRE

The "panic" strategy in the Kierikki Archaeological Centre is applied through a certain ultra-flexibility and consequently ultra-conformity. The rectangular forms of the Station's wings are not constitutionally committed to simplicity but to maximum transformability (and boredom, when necessary). I tried to create sophisticated presuppositions for contemporary exhibition and research activities. Thus Station defines an extremely effective and functioning archaeological centre, even if I had a presentiment that the clients preferred an entertainment centre. The instrument-like shape of the building, raised

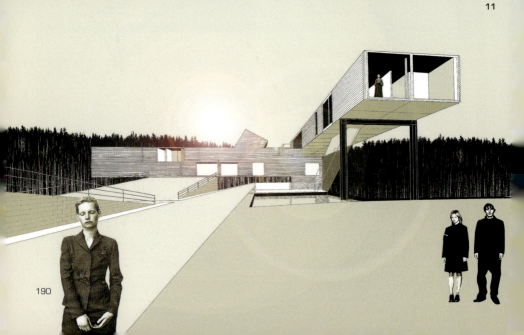

antti ahlava

over pillars, represents this being at the peak of progress. The research and exhibition activities are gathered around the relics, to which one relates with piety and love. Still, I have not wanted to make the architecture of the centre a rudimentary relic in itself. The oblique processing of the landscape related to the parking arrangement is a signal of the landscape and archaeology.

The aesthetic intention is to erect a compositional tension between the rectangularity of the building and the obliqueness of the landscape. The construction of Station is based upon an idea of extremely wide transformability, right up to the point of positive inhumanity. The spaces can easily be modified, by tilting and sliding the wall, floor and roof elements manually.

12

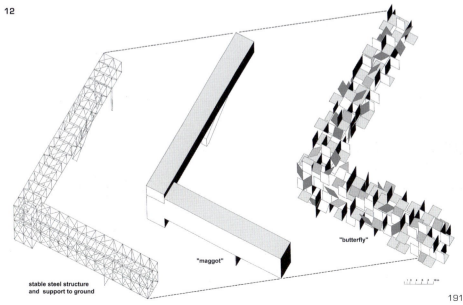

stable steel structure and support to ground

"maggot"

"butterfly"

reflex design
Sari Anttonen Nicolas Favet

REFLEXIVE PRACTISE

Reflex Design was chosen in reference to the concept of reflexivity discussed in social sciences. Reflexive modernisation is a process occuring surreptitiously within the framework of the modern institution, within the framework of normality. It demonstrates the fragmentation of society in numerous sub-cultures and leads to the growing role of individuals on many levels.

The processing of each projects do not follow standard procedures but rather reflects each context and constraint. Every project, as it concerns and involves many agents from producers to users becomes, through this process, one of the most efficient means to transform society. Designing the procedure is strategic for enabling the transformation of professional and cultural positions.

Design solutions are in a constant loop between project procedure, problem setting, realization and appropriation. Contrary to formalism, stylism or a priori functionalist rigidity, an innovative versatile reflexive design approach is preferred. This involves feed back loops between aspects and guarantees innovative and unique solutions.

Objects have a potential for integration. They can reflexively generate their own evolution while simultaneously transforming their users. This allows great flexibility and adaptability in the object or its implementation, whilst avoiding fixed images, fixed function or fixed structure. A strategic cultural construction.

Technical expertise, theoretical developments, visual culture converge in an activity of academic research, experimentation, education and publications. 'Transversality' between fields ensures reflexive reaction to normal routines. Reflexivity involves the ethics of design and underscores the main commitment to ecological design in all projects and actions.

reflex design

1 Piiroinen Showroom (Sari Anttonen, Nicolas Favet) @ Helsinki, Finland, interior design commission, built 2001.
2 Kiss Chair (Sari Anttonen, produced by Piiroinen, Finland) furniture design commission 1998.

2

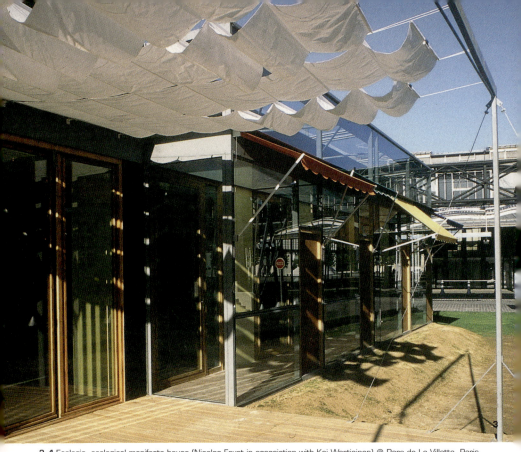

3–4 Ecologis, ecological manifesto house (Nicolas Favet in assosiation with Kai Wartiainen) @ Parc de La Villette, Paris, France, 1st prize in the international competition, built 1996.

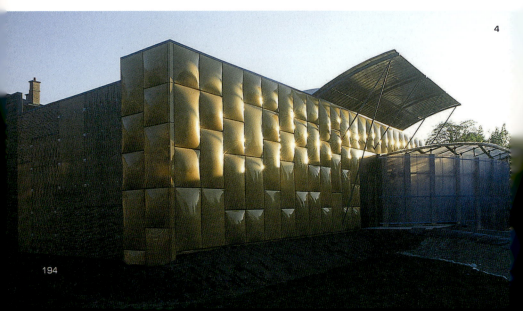

reflex design

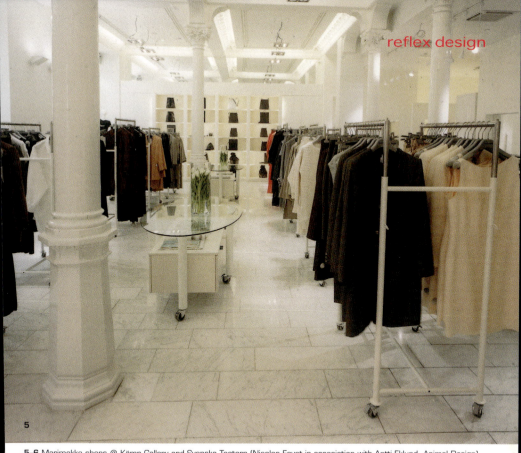

5–6 Marimekko shops @ Kämp Gallery and Svenska Teatern (Nicolas Favet in assosiation with Antti Eklund, Animal Design) > **5** Kämp Gallery (1999) / **6** Svenska Teatern (1994).

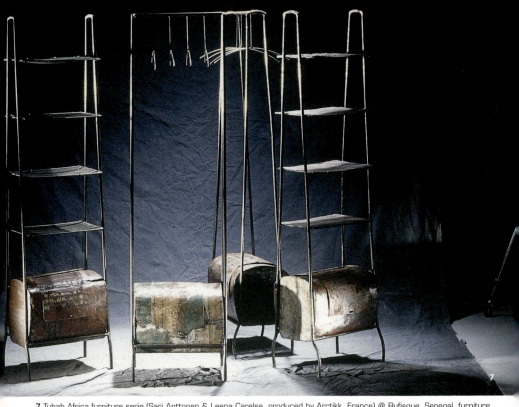

7 Tubab Africa furniture serie (Sari Anttonen & Leena Carelse, produced by Arctikk, France) @ Rufisque, Senegal, furniture design commission 1996-1999 / **8** Kiasma glass for Kiasma Museum of Contemporary Art (Sari Anttonen, produced by Reflex Design, Finland), 1998.

reflex design

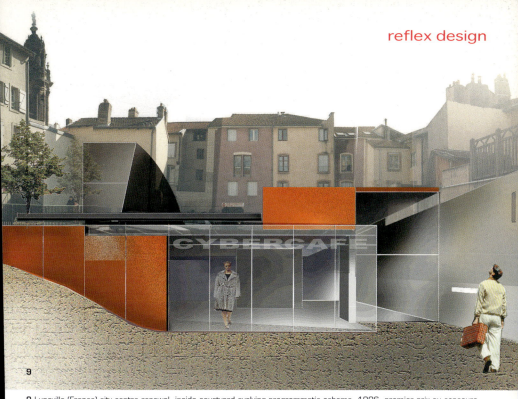

9 Luneville (France) city centre renewal, inside courtyard evolving programmatic scheme, 1996, premier prix au concours. computer rendering > **10** Munkkisaari OPEN/CITY scheme in Helsinki for the urban planning competition (N. Favet, P. Lehtovuori, F. Louveau), a strategy of open landscape, 1999, special mention of the jury. Scale model.

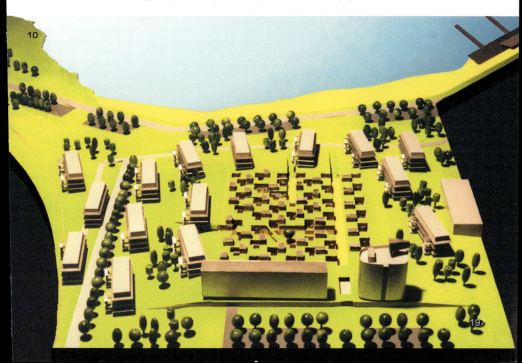

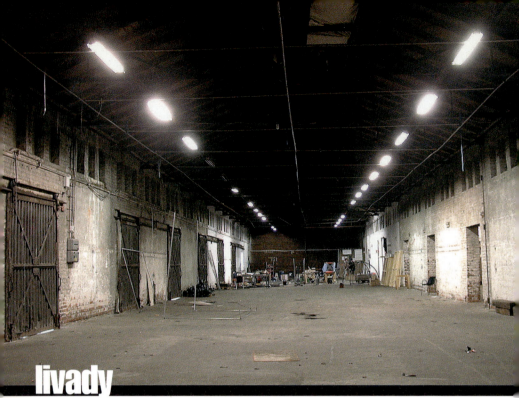

livady

Mikko Bonsdorff Marko Huttunen Pekka Lehtinen Panu Lehtovuori
Mikko Mälkki Janne Prokkola Lauri Saarinen

THE CITY HAPPENS

"Public space is not something essentially defined through 'space', but through 'public': the community. The city as a public space opens up wherever there is a dispute to be resolved, where the clash of different desires hangs over and penetrates into the space and connects some of the desires."[1]

A topical dispute in Helsinki concerns the former State Railway warehouses on Töölönlahti Bay. Different plans for Töölönlahti have been proposed for almost a century; the most important of these include Pro Helsingfors by Eliel Saarinen (1918) and Alvar Aalto's city centre plans (1960s). The State Railway vacated the warehouses and the surrounding cargo yard in the late 1980s, and new buildings are now rising in the area. The Museum of Contemporary Art Kiasma was completed in 1998 and the HQ for the Sanoma publishing company in 1999. According to the plans, the warehouses are to be demolished to make way for the new music centre. Official planning has taken demolition for granted.

In late 2000, our team compiled a re-use plan for the warehouses at the request of Oranssi, an NGO best known for promoting alternative youth housing policies. During the study, we were convinced that planners have failed to pay appropriate attention to the quality of the warehouses and the activities they have facilitated. Contrary to the claims of the authorities, the demolition of the warehouses is hardly an uncontroversial issue, and certainly not inevitable. The following stepping stones discuss some of the forgotten qualities and touch on the deeper question of how to understand the city and its planning.

The first stepping stone: a space that is not a product.
There is something special about the site: the space, the old halls, the grass springing up between the stones, the sounds of the city somewhere in the distance. Although the rails have been dismantled, it is not difficult to imagine the clinking sound of wagons being joined together, men shouting, the steam and the smell of coal.

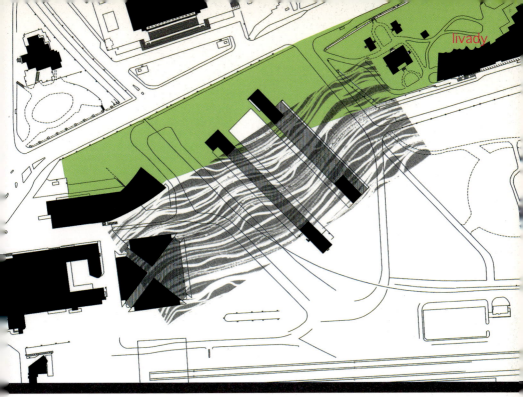

1–2 Railway Warehouses Project @ Töölö Bay, Helsinki, Finland 2000 > **1** present state / **2** site location between (clockwise from top) Parliament Building, City Museum and Finlandia Hall, the railway, Sanoma Office Building and Kiasma Museum of Contemporary Art. A proposed zone of intensive uses links the warehouse halls to the surrounding park.

Meanwhile a Brave New Helsinki is growing around the warehouses; all that is new so eager to assert its openness. Kiasma has no thresholds; the glazed façade of the Sanoma HQ is likewise open, its corporate plaza inviting everyone to drop in. Yet there are a number of codes in both shopping plazas and museum cafés. In the warehouses, the codes are not equally clear: the place is neither fixed nor defined making the warehouses unique. While cities, Helsinki included, are being turned into products, waste lands remain beyond this logic. The warehouses provide a 'waste land' with a form.

The second stepping stone: a space of happening
During its history, Helsinki has been a city of central power and image fabrication. People who live in Helsinki have always been somehow in a second row, when big development issues are at hand. In the mid-1980s this changed. New forms of urban culture and consumption began to enliven the gray and cold scene, converting Helsinki to a more "European" and alive city.[2]

The warehouses have played a central role in this cultural change and reform. Thanks to their open and undefined quality, they have become the city's most popular and versatile venue for events. Their broad courtyard has provided a stage for a snowboarding competitions and a Middle Ages festival; the halls have housed business promotion events and raves alike, plus the beloved flea market (the most popular in Helsinki between 1992 and 1998, with 400,000 visitors annually – April-October weekends). The warehouses have become a symbol of bustling urban culture.[3]

The third stepping stone: history carved in stone
The warehouses of Töölö goods station were designed in 1899. They are a manifestation of the production flow of a city that industrialised at a rapid pace. The form of the buildings was dictated by the necessity of the maximum goods passing through the shortest route. The warehouses are a sieve, a space of flows.

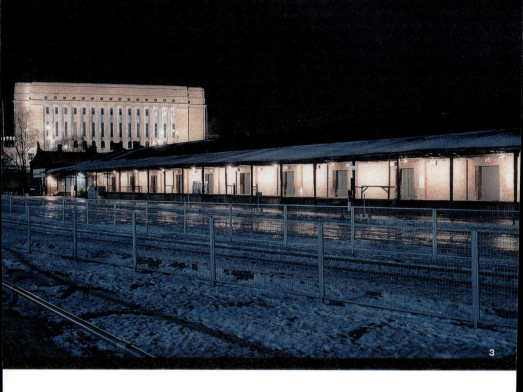

In the Finnish context, the warehouses are old: as such a good reason to preserve them. Furthermore, the warehouses are well suited to mass events.

The fourth stepping stone: it is not difficult to save the warehouses!
Our research proved that it is easy to reinforce the current uses with minor actions. Excessive and costly refurbishment would actually do more harm than good. The central qualities of our proposal are openness and accessibility and – for renovation – lightness, feasibility and economy.

Accessibility and visibility would be improved by removing unnecessary fencing, protective walls and level differences. The wide eaves obstructing the façades would be replaced by lightweight awnings facilitating the easy change of appearance according to season or event. The interiors, the courtyard and its extensions would form a coherent venue for events. The platform edges would be turned into seating areas without requiring railings. The raw, open, quality of the yard would be retained. Movable bridges would contribute to the adaptability of the space and the actual halls would be adequately refurbished service-wise, creating a semi-warm space. The sliding doors would be repaired and the warm and technical spaces would remain located at the ends of the wings. Such renovation would make them a true, viable part of the new city centre.

Reality of planning vs. reality of the city
Why planners have failed to recognize such an urban opportunity? We believe the reason lies in their thinking about the city from above. To see from a distance, as a whole, is something fascinating, intoxicating. City planning has turned this intoxication into a professional practice. Planning transforms urban reality into a concept of a city, replacing the variety of a city and its multiple agents by an anonymous, apparently rational subject, the city.[4] Planning only sees its own reality, instead of the reality of the city.

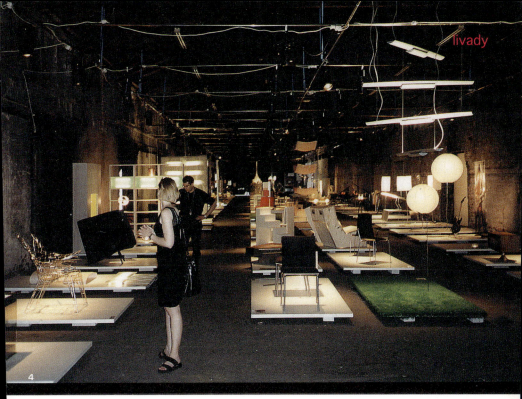

3–4 Railway Warehouses Project @ Töölö Bay, Helsinki, Finland 2000 > **3** present state (exterior) / **4** a furniture exhibition recently held in the warehouses.

With regard to the Töölönlahti Bay, three aspects frame its planning: 1) the idea of the area as a "green wedge", 2) a land and real estate policy contract dating from 1986, and 3) a notion of what is important enough occupy such a central spot. In all these respects, the warehouses are inconvenient or "in the way". They block the imaginary vista from the south toward the north and the desired water pool, occupying an expensive plot which the city could use to make money. Their versatile, alternative uses do not seem to fit into the official cityscape dominated by the Parliament Building. Thus it is in the interests of Helsinki city planners and many politicians to demolish them. However, all three points are imaginary, ignoring the fact that the actively used warehouses are there!

The city happens

The activities and significance of the warehouses are a manifestation of a city lived in. The warehouses are a "proto-urban space"[5]; their position in the minds of the people of Helsinki manifests something essential indeed about this city. The dispute over the warehouses is an expression of affinity, of love.

If the city is regarded as in constant change and happening instead of frames carved in stone, also its planning must be re-conceptualized. It becomes rather like negotiating a path full of surprises than aiming at an eternal image.

If it ain't broke, we say, don't fix it.

References
1 Rajanti, Taina (1999). Kaupunki on ihmisen koti. Helsinki: Tutkijaliitto; 2 Ruoppila, Sampo & Cantell, Timo (2000). Ravintolat ja Helsingin elävöityminen. In Stadipiiri (eds.). Urbs. Kirja Helsingin kaupunkikulttuurista. Helsinki: City of Helsinki Urban Facts (pp. 35–53); 3 Mäenpää, Pasi (2000). Urbaani elinvoimaisuus ja dialektiikka. In Rakennustaiteen seuran jäsentiedote 3:2000 (pp. 8–10); 4 Certeau, Michel de (1993). Walking in the City. In During, Simon (ed.), The Cultural Studies Reader, Lontoo: Routledge (pp. 151–160); 5 Chora (Bunschoten, Raoul; Hoshino, Takuro; Marguc, Petra et al.) (1999). CHORA Manifesto. Daidalos 72/1999 (pp. 42–51).

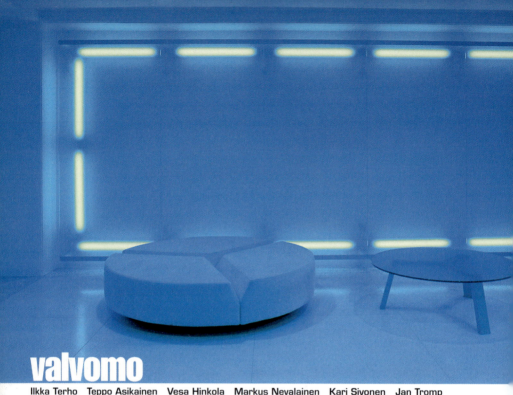

valvomo

Ilkka Terho Teppo Asikainen Vesa Hinkola Markus Nevalainen Kari Sivonen Jan Tromp
Rane Vaskivuori Timo Vierros

"The problem for us is the city/nature/etc part, we are hopeless writers. We do have opinions (of course, who wouldn´t) but we need an interview to pull them out. So if you think our views could be something, I suggest someone would interview us?"

Our philosophy is to create socially stimulating design and architecture. Every work must start from a clean slate. We do not aim for any special style.

The key concepts in both product design and interior design are space, purpose and special atmosphere. Our design is world class, but for us, this "world" does not mean the traditional functional Nordic modernism. It is the future design of global tribes. Take for example the Netsurfer divan. The reception given to the Netsurfer is very revealing. The strangest people from all over world have fallen in love with it. Information technology unites different people from various professions and lifestyles.

Another example is Chip. This seat was created just after the Netsurfer. Computer divan Netsurfer has 200 parts. Chip has the same seat form, but has only two parts. Both seats confuse and amuse. The consumer, especially in front of Chip, becomes a curious child. "How to use this piece?" they ask and at the same time try to find their own solutions.

Chip is actually a very nihilistic piece, originally created for the designers needs. It is practical. It may stand against a cramped studio. It is suitable for a sunbath or swing.

valvomo

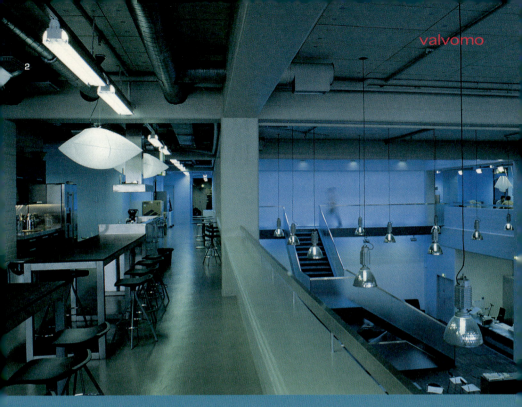

1–2 Razorfish new media company @ Helsinki, Finland, commission 2000 (Nevalainen, Vaskivuori, Hinkola) / **3** (clockwise from left) Globlow (floor) inflating light, Netsurfer Classic (Asikainen, Terho), Globlow (led, large), dress Chair (Vaskivuori, Vierros), models 2000.

valvomo

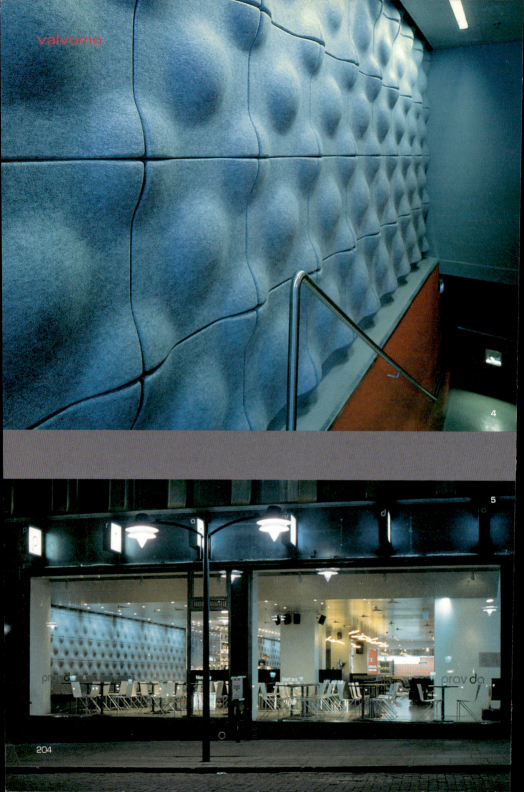

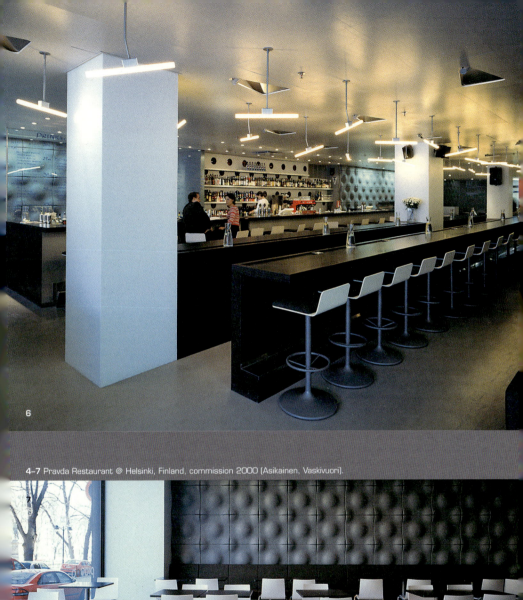

4–7 Pravda Restaurant @ Helsinki, Finland, commission 2000 (Asikainen, Vaskivuori).

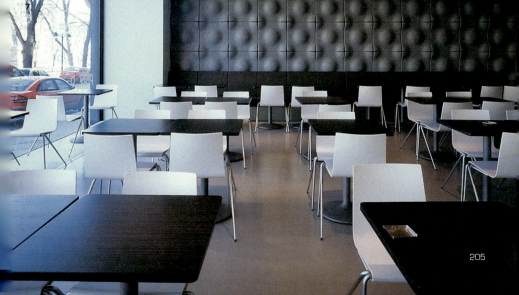

valvomo

8–10 'Nosturi' (crane) Centre for live music @ Helsinki, Finland, commission 2000 (Tromp, Nevalainen, Sivonen).

valvomo

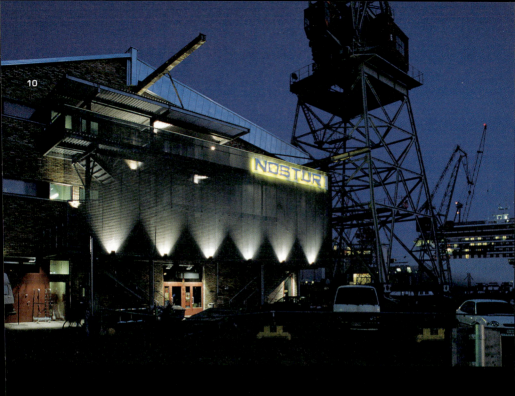

Valvomo considers itself a unique studio as it does not want to be burdened by conventional definitions. We believe everything should be re-defined and re-assessed. We have a thirst for innovations in product design and interior design. We aim for comprehensive projects. Valvomo consists of eight young designers/architects/partners. We are colleagues and friends simultaneously. Every designer has his own special field in the office, but the truth is that all Valvomo designers do various things. There is no reason for categories. We freely test our ideas against each other's. Even the most serious matters are aired. But all ideas must be subjected to a rigorous test. If a sufficiently large group has confidence in them, they may be implemented. In Valvomo, internal criticism ensures external quality of design. Our future aims are to expand our furniture design services and to find more opportunities in the field of architechture; to do more new building design.

Socially stimulating design is far from boring. For us, form follows not only function but also fun.

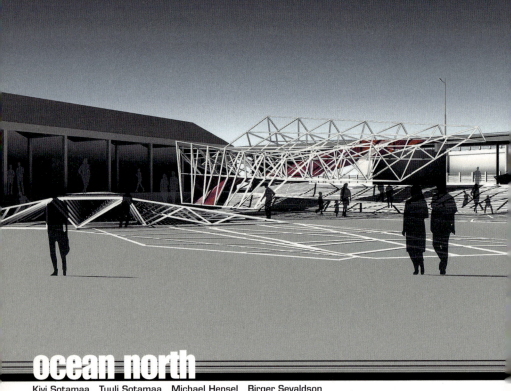

ocean north

Kivi Sotamaa Tuuli Sotamaa Michael Hensel Birger Sevaldson

OCEAN NORTH is a trans-disciplinary practice that pursues research in design alongside commissioned design work. The group's portfolio comprises works in architecture, urban design, product design, spatial installations, and the organization of cultural events. OCEAN NORTH is led by Kivi Sotamaa, Tuuli Sotamaa, Birger Sevaldson and Michael Hensel with its main production studio located in Helsinki, and with branch studios in Oslo and London.

The organisation pursues research agenda as an alternative to mainstream production. The research agenda negotiates the challenges the heterogeneous, spontaneous, evolutionary and undetermined nature of cities poses to architecture and design.

ocean north

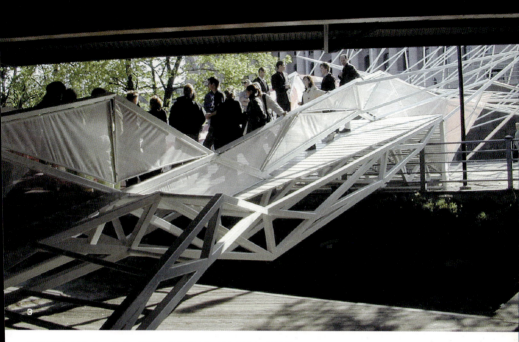

1, 3–5 IntenCities Installation, ArtGenda 2000 @ Helsinki Finland (Kivi Sotamaa, Michael Hensel, Tuuli Sotamaa, Lasse Wager, assistants: Stephanie Valcroze, Toni Kauppila) / **2** New York Times Capsule, invited design competition by the New York Times, finalist entry @ South Polar Region 1999 > sectional view of a rapid prototype model of a typical capsule.

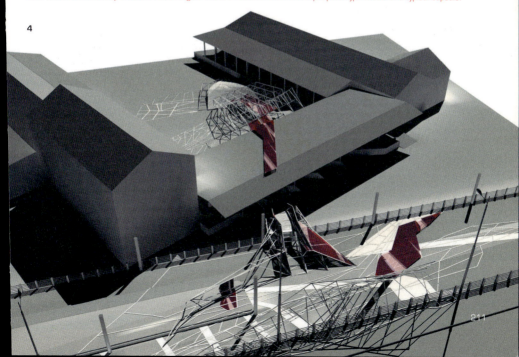

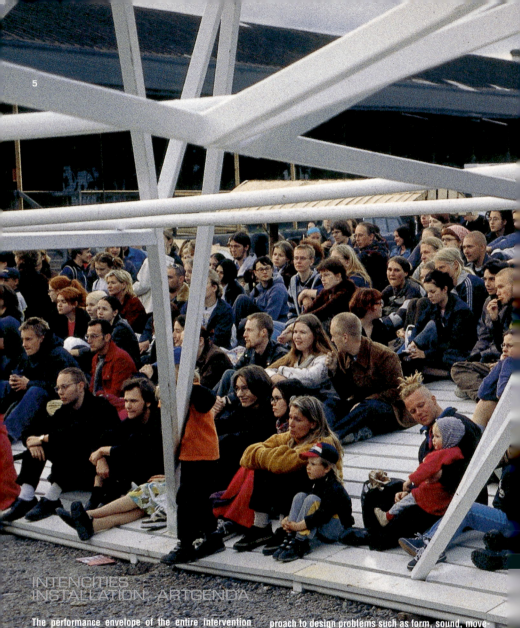

INTENCITIES
INSTALLATION, ARTGENDA

The performance envelope of the entire intervention unfolds from the interactions between its components. The different intensities of sound, performance, design and art works converge and diverge in ever-changing pattern and reflect upon the urban condition of today.

The Helsinki AG team commenced the design in variably combined groups of expertise to achieve a high degree of synergy between the various elements of the intervention. The team formulated a shared approach to design problems such as form, sound, movement, organisation, colour, tactility, materiality, etc.

The site is defined as the gap between the official Helsinki, the House of Parliament, and the "backyard" of Helsinki, the old railroad warehouses (Makasiinit). This area sets up a series of spaces starting from the demonstration lawn in front of the Parliament, across the Mannerheim Street, to the ex-railway depots.

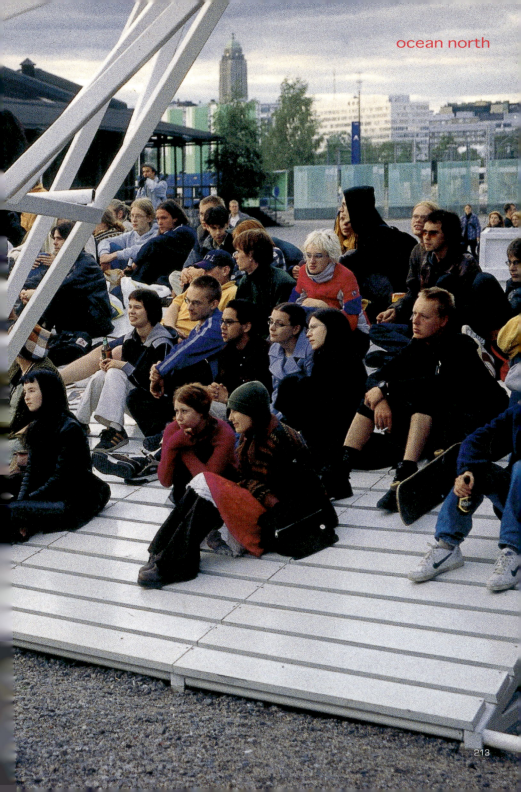

THE FINNISH EMBASSY IN CANBERRA

Resolving the program requirements within interstitial spaces, which are partly imbedded in the ground, yields favourable temperature regulation in all areas of the building zone throughout the year. The outer-surface articulation in the project forms a counter-movement to the extension of the site topology into the building zone. In order to activate the topographic surface of the site, the material and geometric articulation of the exoskeleton is matched with a general landscape program.

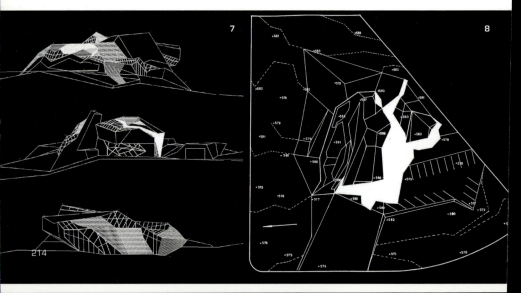

ocean north

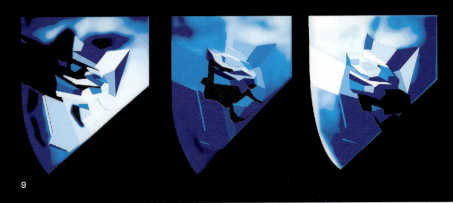

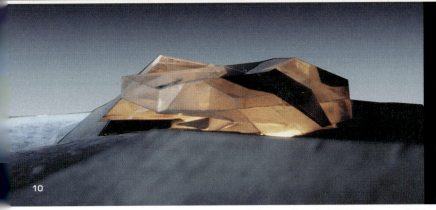

6-11 The Finnish Embassy in Canberra competition entry @ Canberra Australia 1997 (Kivi Sotamaa & Johan Bettum with Lasse Wager, Markus Holmstén, Kim Baumann-Larsen, Bonsak Schieldrop, Birger Sevaldson Assistants: Marianne Pulli, Niina Kettunen).

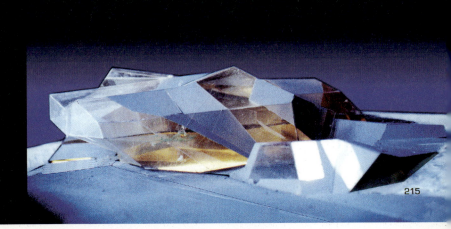

ocean north

13

12–15 New York Times Capsule, invited design competition by New York Times @ South Polar Region 1999 > **12** "content based skinning geometries" animation frames / **13** view of an analogue model of a typical inner capsule / **14** X-ray view of a model of typical capsule, animation / **15** frames, sectional axonometrics of a typical inner capsule.

14

15

NEW YORK TIMES CAPSULE

The capsules are carriers of generic information able to convey the sensibility of our culture at the close of the 2nd millennium. Each capsule is made of multiple layers and the aggregate integument proliferates variation on inert form across the sectional datum of the envelopes. The capsules are made of advanced ceramic composites and titanium and filled according to the program. Moving outwards from the geometry of the content at the core of the capsule, the resonance in the geometry becomes weaker until it is a barely recognisable deformation of the outer titanium shell.

(Kivi Sotamaa, Michael Hensel, Tuuli Sotamaa, Johan Bettum, Birger Sevaldson Consultants: Tero Kolhinen, Laboratory of Metallurgy, HUT & Steinar Killi-Aho).

–Nevertheless, to simplify matters, we use the word 'architecture' where the word 'collection' or 'assemblage' would in fact be enough.
Reima Pietilä

the assemblage

Toward the end of the 20th century much talk on architecture centred on the critical and radical undoing of the discipline. Philosophy crept into its schools and universities, sometimes rewardingly, sometimes at the expense of a more conventional, comprehensive study of history, tectonics and theories of architecture. Few foresaw how the legacy of French thinking would remain strong, trickling down as it did into a bewildering number of other disciplines. Though it is clear that younger thinkers certainly came through the last years of the 20th Century with some attraction to philosophy and theory, it is just as true to say however that very few were breaking open the champagne bottles.

It is sometimes difficult to tell which city one is now in: Vienna, Stockholm, Tallinn or Helsinki.

Whilst various philosophers and philosophical works created a

re-siting architecture

real awareness of comparative validity and critical generosity, we are less sure today whether this thinking pre-empted a new way to negotiate theory, or even fuse theory with architecture. In the global access to information, in the bewildering increase in software and the media's control of architecture, there was a growing sense that thinking could only be timed for the present. In the very urgency of 'now', critical language and claims made for and against architecture were suddenly as exhausting as they had once been exciting.

Whilst original interiors from the 1930s, 1940s and 1950s were destroyed, these very decades can now be recycled and fused within 'new' interiors. Restaurants take on names like Mockba, Pravda, Soda, No.9, Erotica. Cities become seamless too. It is sometimes difficult to tell which city one is now in: Vienna, Stockholm, Tallinn or Helsinki. Finland had arrived into the 21st Century. The mobile phone carried out a quiet revolution. And the next stage was to be a Virtual Helsinki.

If the Postmodern Condition was a question of tolerance, flexibility and comparative validities, we now know it was also a broken contract with meaning itself. Architecture looks as if it will now attempt to become a self-correcting project. In this way will it follow contemporary politics and culture? If reality can be denied, as J.G. Ballard encourages us to imagine, how are we to recognise architecture going the same way? Language itself still invests architecture with promises that it doesn't, cannot, always live up to. Some younger thinkers imply that the theoretical fetish will lead to a grand embarrassment with the architectural archive. We are useless writers, they say. Can't put two words together, but we can build, we can invent. They do, often brilliantly!

Is it only today that fashion touches the very core of architecture's activity? All night utopias are fast on their way to becoming our own virtual realities. An improbable set of invisible architectures encouraged by cyberspace might include us in its own script, whether we like the menu or not. Danger: today the future in architecture is beginning to ask more of the souvenirs it

feels familiar with. Or is the past truly free?

Caught up in the necessity to pitch and advertise their own work, students and young architects also had to learn how to write the press release, prepare the press pack, plan the exhibition, design the poster and organise the vernissage of a project. Talents had to be widened, extended. Sampling, spinning, weaving and diagramming became part of design methodology. Architecture became the hot medium in McLuhan's sense. Increased competition within the profession and the building industry combined with critical exhaustion and changing trends produced a levelling of all horizons. Notions of the avant garde were suspect. This might usefully, and momentarily, be described as a *deradicalism*.

'Deradicalism' works at many levels, sometimes revealing, sometimes disguising its own creativity, talent and tension. Issues are re-framed, ideas about architecture are held back by failed progress or then explode into invention. A notion like 'legacy' is no longer negative. Influence, too, is acceptable under the right conditions. Assimilation of past ideas no longer causes constant unease, as strategies fuse to be made new again. Heroism is, of course, assumed to be less of a concern.

Surveying this assemblage of work by younger practices in Finland we would in fact be advised to use the word 'legacy' with extreme caution. Through the respect with which earlier Finnish 'modernism' is now held, we must acknowledge in much of this work the strength of an architecture that attempts not to assert more than its past, but treats that past with an inventiveness belonging and stemming only from the present. Most of these young architects are aware of their own legacy, aware of the 'continuum', the strength of the architecture of their elders and the status it has given to the profession. Avoiding concessions to popular taste, there is also an acknowledgement that architecture has come a long way since Postmodernism of-

re-siting architecture

fered its own disco-world. Modernism, it seems, has been healthily relieved of its weightier heroism. Is this why it is now creating the images it could not quite achieve in the past? Is this history playing games with itself, or the way progress 'progresses'?

There has been an attempt to create from these attitudes a radical new architecture, visible and invisible, conspicuous and inconspicuous. Own houses, house for parents, summer cottages, clubs, surfing interiors and restaurants once again proved an invaluable laboratory. Already many of these young practices suggest a seamless architectural thinking within fluid design teams. They prefer altering their skills and collaboration, where necessary, to take in newer briefs and wider challenges. Yet many of them too remind us of the importance of nature, of the earth, of the fragile balance siting their architecture creates. Some may pre-empt the improbable architecture Paul Virilio speaks about: "given the interactive image and the interactive city, and if every image is destined for growth, in the epoch of non-separability this destiny is accomplished before our very eyes, thanks to the mutual development of the electronic urban environment and the architecture of systems, an improbable architecture whose efficiency none can deny." Others naturally retreat from such improbable architecture.

Despite the passionate call for a felt architecture with affinities towards nature and the environment, remote-controlled environments, spaces, walls of shadows and screens, operable by more-than-mobile phones, are all likely to configure architecture in the future as much as they configure electronic access.

In thinking about the way the 19th Century differed from the 18th century Michelet wrote in 1892: "Those who believe that the past contains the future, and that history is a stream forever flowing one and the same, forever impelling the same waters between its backs, must here reflect and see that very often a century is opposed to the preceding century, sometimes furnishing it a harsh denial."

There are as yet no real signs of any harsh denial, but despite the passionate call for a felt architecture with affinities towards nature and the environment, remote-controlled environments,

spaces, walls of shadows and screens operable by more-than-mobile phones are all likely to configure architecture in the future as much as they configure electronic access.

Today, in the new century, Finland looks likely to become once more the place to be. It is a society constantly open to change and novelty, whilst holding onto its proud existence as a young nation. This has immense advantages over wearier cultures. Yet we must balance the brave new technology and vision, the belief in siting nature within architecture, with an edgier, even radical, nostalgia. For the large urban projects continuing to fill the 'voids' in the Helsinki Centre are currently balanced in their eagerness for progress, spectacle and public space by the under forty-year old anarchists supporting the action to save the old buildings, once the Czar's stables. These railway warehouses, now a mesmeric labyrinth of flee markets, were about to be bulldozed by contractors until the Green Party put the immense Helsinki Music House project on hold. For how long no one can say.

Not for too long, one suspects!

Meanwhile the extension into electronic systems and the research into environmental controls in the Virtual Helsinki project look likely to transform the environment within which silence as communication can work. The obvious question to pose: how will architecture have to alter to allow control systems greater use and commerce? And, following on, how much control systems and commerce can alter to allow architecture its own response?

The strength of Finnish architecture in the last century emerged from a rare talent and solidarity within a profession.

Turned into a remarkable and flinty lyricism, we also recognise in this culture its reluctance to theorise, its ability to understand influence without over anxiety, and its talent to sample, synthesise, fuse and invent from within and elsewhere.

The strength of Finnish architecture in the last century emerged from a rare talent and solidarity within the profession. As it negotiated a relatively narrow band of 'modernism' it produced an inventive, pragmatic brilliance. This is still recognised all round the world for its 'finnishness'or, less generously, its 'Scandinavian references'. An architecture that was, and still is,

re-siting architecture

considered more natural, whether the Finnish Embassy in Washington or the Finnish Embassy in Berlin.

Turned into a remarkable and flinty lyricism, we also recognise in this culture its reluctance to theorise, its ability to understand influence without over anxiety, and its talent to sample, synthesise, fuse and invent from within and elsewhere. Perhaps it is now time to re-discover what has already been discovered.

In 1959, Stein Eiler Rasmussen wrote about Alvar Aalto in his modest but still remarkable book, Experiencing Architecture: "If we compare his Finland building at the New York World's Fair with its undulating interior wall, with Frank Lloyd Wright's glass shop, I am sure most people would find Aalto's work more natural. But he must be judged by his everyday architecture. His extraordinary employment of contrasting textural effects and the organic manner in which he builds up his structures are immediately apparent. But it is his firm grasp of the whole that makes his buildings so amazingly vital. They have something to say to us; he has brought about a union between architecture and life."

As with most critical sentences we are released by their accuracy and their claims. We pursue other trajectories of thought. We can move on. The *union between architecture and life* is difficult indeed. We must therefore honour

Aalto would have recognised, and no doubt smiled 'ironically' at the idea of deradicalism.

the intensity with which some of the younger architects – just as Aalto did – are able to stimulate and assimilate ideas within their new architecture. Aalto would have recognised, and no doubt smiled 'ironically' at the idea of *deradicalism*. Reading it positively, would he not have been in favour of younger architects wishing – metaphorically – for their architecture to stop (once and for all) the pretence of any avant garde? He would also surely have appreciated the modesty which is embedded in a strong, at times modest, or even inconspicuous, contribution to architecture. And would he not have seen this, too, an urgent antidote to the ill-founded, ambiguous ecstasy that still rules the too easy images of contemporary architecture?

To close we might be allowed some licence here. Within an inconspicuous architecture, a selfless architecture, is this a transition to a new architecture which might emerge from a horizontal activity? Like the improvisation in jazz, the fusion shown here in the architecture is both a new and ancient talent. It is also a comparative and generous talent that must perform in the provisional and restless present as

re-siting architecture

much as it acknowledges the past. Ultimately this might be a strategy for architects to resist the words and theories that architecture so likes to invent for itself.

Finland has certainly moved from the margins to the centre. Along with one or two other cities, Helsinki now leads the electronic revolution. If the contemporary moment does not hit a country like Finland in the way it hits and moves in, say, New York, Berlin, Vienna or London, it is certainly leading its own revolution. Finnish architecture performs best to an expected myth, some claim, and will go on presenting a near-perfect model for an architecture measuring up to the hopes and promises of the Twentieth Century. This too presents the challenge facing the talent of many younger architects and students who wish from their métier at least some contract with the contemporary world. The young architects seem to appreciate this dilemma. There are signs that they have stopped asking what the foreigner wants of their culture. From now on, heritage behind them, they are free to move on. Healthily 'de-radicalised' they also appear free to see architecture for themselves. Paradoxically this now looks as if it not only allows for quieter, more subtle change, but we might speak again – albeit carefully and gently – of a talented and simmering re-invention. Fused, architecture can be re-sited, the profession re-occupied!

Like the improvisation in jazz, this fusion shown here is both a new and ancient talent.

There are signs that they have stopped asking what the foreigner wants of their culture. From now on, heritage behind them, they are free to move on.

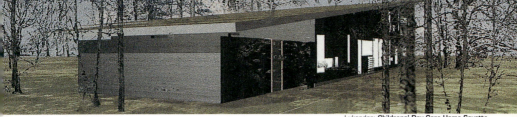

Lukander: **Childrens' Day Care Home Savotta**

biographies/hip

MINNA LUKANDER
(1965 Turku) M.Arch. Helsinki University of Technology 1994. **Professional experience:** 2000- Talli Architects: (Pia Ilonen, Karin Krokfors, Minna Lukander, Jukka Sulonen, interior architects Pasi Hämäläinen, Jari Häkkinen, Martti Lukander); 1995- Alli Architects (Pia Ilonen & Minna Lukander); 1995 The City of Helsinki, City Planning; 1992-93 B&M Architects; 1990-92 Harris-Kjisik Architects; 1988-90 Helsinki Studio Architects; 1988 Raili ja Reima Pietilä Architects; 1986 Architects Kauria & Turtola. **Projects:** (ALLI): 2000-Home and School for Disabled, Helsinki; 2000- Childrens Day Care Centre Savotta, Helsinki; 1999-2000 Elderly Home (renovation), Uusikaupunki; 1999- Finlandia Hall, Helsinki, development plan for extension and interior renovation; 1998- Apartments, Pihlajamäki, Helsinki; 1997-2001 Eliel Saarisen tie traffic tunnel; 1996-1998 Lasipalatsi (The Glass Palace), Helsinki (renovation & idea for Film and Media center and interior design). **Exhibitions:** 1996 Young Finnish Architects, MoFA, Helsinki; 1995 "Tilasiirtymiä", an architectural installation, Helsinki Festivals, MoFA. **Teaching:** 1994- Assistant, Helsinki University of Technology; **Jury Member:** 1998 Finnish Pavilion in Hannover, Expo 2000.

TUOMAS SILVENNOINEN
(1969 Helsinki) M.Sc. (Arch.) Helsinki University of Technology 2000. **Professional experience:** 1991 Koski-Lammi Architects, Helsinki; 1994 Architekturbüro Josef Paul Kleihues, Berlin; 1995-99 Pekka Salminen Architects, Helsinki; 1996- Partner of Group A.M; 1999- Partner of Tuula & Tuomas Silvennoinen Architects; 2002- Partner of Pekka Salminen Architects; 2002 Design instructor, HUT, Dep. of Architecture. **Projects:** 1992 New premises for the Dep. of Architecture Old Cable Factory, Helsinki (Narjus-Siikala-Silvennoinen-Tikka); 1995- Graphic and Exhibition Design TEK, Helsinki; Nordiska Metall, Stockholm; Pekka Salminen "Themes" exhibition and book (MOFA, Helsinki 1998, Technical University of Milan, 1999); 1996-1997 Fishing Centre, Nurmijärvi, preliminary design (with group A.M.); 1999 Märkiö Youth Centre, Nurmijärvi, Development Plan (with group A.M.); 1999-2001 Renovation, interior design and design of fixed furniture, FIM Group Ltd. Helsinki (with Tuula Silvennoinen); 1999- Centre for Orthodoxy and Nature, Ilomantsi. **Competitions:** 1992-96 prizes in various student competitions including three first prizes; 1988 Korso Church and Parish Premises, 1st purchase (with Tuomo Repo); 2002 Centre for Architecture, Building, Design and Information ARMI, 3rd prize (with Pekka Salminen). **Exhibitions:** Archiprix International – World's best graduation projects, Rotterdam. **Tuomas Silvennoinen** Hämeentie 6 A 2, 00530 Helsinki. tel./fax +358-9-7016517, mob. +358-40-5652745, e-mail tuomas @sgic.fi.

SOPANEN & SVÄRD
PIA SOPANEN (1960 Helsinki); M.Arch. Tampere University of Technology 1990; **ILKKA SVÄRD** (1959 Iisalmi); Tampere University of Technology 1980–; **Professional experience:** 1986- Sopanen-Svärd Architects; 1989-96 Trollius Architects (Sopanen, Svärd, Suominen, de la Chapelle). **Works:** 1993 Naantali Town Hall; 1994 Länsiväylä noise barriers and pedestrian bridges (Trollius Oy), 1999 Hotel Koli renovation; 2000 Heritage Centre Ukko, Koli National Park; 2002 Pajala area general plan. **Competitions:** 34 prizes, purchases and honorable mention in Finland and EU: e.g. 1987 Lappeenranta Lakeside Development, 1st prize; 1990 Naantali Town Hall, 1st prize; 1992 New Opera House Art Competition (Sopanen, Svärd, Nisunen), purchase;1993 New Royal Library, Copenhagen, purchase; 1997 Heritage Centre for Koli National Park, 1st. prize; 2001 Student House of Jyväskylä University, 2nd. prize. **Jury member** / Pia Sopanen: Meri-Matti School and Day Care Center, Espoo 2001. **Architects Sopanen-Svärd Oy** Myllykalliontie 2, 00200 Helsinki, tel. +358-9-27091360, fax +358-9-6822567, e-mail sopanen-svard@dlc.fi.

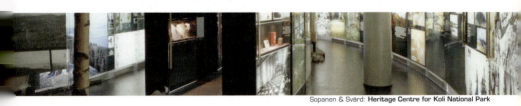

Sopanen & Svärd: **Heritage Centre for Koli National Park**

HANNUNKARI & MÄKIPAJA
VEIKKO MÄKIPAJA (1960) M.Arch. Helsinki University of Technology 1988. **KRISTIINA HANNUNKARI** (1958) M.Arch. Helsinki University of Technology 1991; tutor in various courses at HUT since 1990. Hannunkari & Mäkipaja, Architects since 1990–; **Urban design:** Lakefront Area general plan, Lahti; Vuosaari Centre (South), Helsinki; Kontula: rehabilitation of public space, Helsinki. **Selected Projects** (since 1997): Herttoniemi Apartment, Helsinki; Terraced Housing, Lahti; WM-Data IT-building, Lahti; Sammalparta Housing, Vuosaari, Helsinki; Seaside Apartment Housing, Aurinkolahti, Helsinki (2002) **Architects Hannunkari & Mäkipaja** Laivurinkatu 19 C, 00150 Helsinki, tel. +358-9-6844750, fax +358-9-68447510, e-mail arkkitehdit @hannunkari-makipaja.com.

biographies/hip

HKR

MARKKU HEDMAN (1966 Helsinki), Suvikummunrinne 4 K 26, 02120 Espoo, Finland, tel. +358-40-7024884, e-mail markku.hedman@hut.fi. M.Arch. Helsinki University of Technology 1996, Ph.D.-student, HUT, Dep. of Architecture since 1998. **Professional experience**: 1986-96 in several private architectural offices in Helsinki; 1997-98 part-time teacher in housing design, HUT; 1998-99 assistant in public building design, HUT; 1997- architectural office together with Timo Karhu and Mikko Reinikainen. **Projects**: Housing and urban design projects including ecological housing area of 129 apartments in Viikki, six houses to Tuusula housing exhibition 2000 and a summer cottage to Ähtäri summer housing exhibition 2000. **Scholarships and grants**: Several scholarships and grants including a grant from the Central Arts Council in 1995, a scholarship from the National Council for Architecture in 1998 and a four year scholarship from the Ministry of Education (1999-2002). **Competitions**: A prize in 6 national or international competitions for architectural students including first European regional prize for a new Bauhaus school in 1993 and a honorable nomination for a Cultural center to Thingvellir in Island in 1994. A prize in 5 open architectural competitions in Finland including first prize in a competition for an ecological housing area to Viikki and a second prize in "Vision 2025" – an international competition to Södermanland in Sweden. **TIMO KARHU** (1966 Karhula), Selkämerenkatu 12 D 77, 00180 Helsinki, Finland, tel. +358-40-7730868. M.Arch. Helsinki University of Technology 1995. **Professional experience**: 1987-2000 in several private architectural offices in Helsinki. **Projects**: Several housing and urban design projects including ecological housing area of 129 apartments in Viikki, six houses to Tuusula housing exhibition 2000 and a housing area of 49 apartments in Espoo (together with Kristina Karlsson). **Competitions**: A prize in 2 international competitions for architectural students including the European regional prize for a new Bauhaus school in 1993. A prize in 5 open architectural competitions in Finland (see Hedman) and a third prize in a national competition for a library building in Raisio. **MIKKO REINIKAINEN** (1966 Helsinki), Humalistonkatu 3B 28 00250 Helsinki, Finland, tel. +358-40-7162038, e-mail mikko.reinikainen@ksv.hel.fi. M.Arch. Helsinki University of Technology 1994. **Professional Experience**: 1988-95 in several private architectural offices in Helsinki;. 1997 Architect in the Helsinki City Planning Department. **Projects**: Housing and urban design projects including ecological housing area of 129 apartments in Viikki. Several urban design projects in the central city area of Helsinki. **Competitions**: First prize in 1 national competition for architectural students. A prize in 5 open architectural competitions in Finland including first prize in a competition for an ecological housing area to Viikki 1996. **HKR Architects H.K.R Cooperative** Jääkarinkatu 6, 00150 Helsinki, Finland, tel. +358-9-636391, fax +358-9-2609543, e-mail h.k.r@icon.fi, founded in 1996 (originally Hunga Hunga Architects Cooperative).

HKR: **Tuusula Housing**

JENNI REUTER

(1972) M.Sc. (Arch.) Helsinki University of Technology 2001, Ecole d'Architecture de Paris-Belleville 1994-95. **Professional experience:** 199x- in several private architectural offices; Museum of Finnish Architecture; The Finnish Association of Architects; own practice since 1999, architectural, exhibition and graphic design; Instructor,HUT: 2001- Wood construction, 2002- Basics of architecture. **Selected works:** 2002- Sattmark Pavilion, Paraisten; 2001-2002 5 Africas, exhibition design, Museum of Cultures, Helsinki; 2002 FINDESIGNNOW, exhibition design, Fiskars; 1995-2001 Women's Centre, Rufisque, Senegal (Saija Hollmén, Jenni Reuter and Helena Sandman); 1997-99 Straw bale and straw clay cabins, Parainen; 1995- graphic design for posters, books, magazines etc. for The Finnish Architectural Review, Museum of Finnish Architecture, Museum of Cultures, Helsinki University of Technology, Alvar Aalto Academy, YLE (Finnish Broadcasting Company), Ministry for Foreign Affairs of Finland, Elephant Films. **Competitions and grants:** 1994-1999 Prizes in various student competitions including two first prizes; several grants and scholarships; 2002 Pietilä Award (Saija Hollmén, Jenni Reuter and Helena Sandman). **Group exhibitions:** 2002 "Women's centre in Rufisque"; 8th International Architecture Exhibition; la Biennale di Venezia; 1998 "Straw bale houses", Parainen (solo); 1996-97 "Ruissalo – art in the landscape", Wäinö Aaltonen Art Museum, Turku and Valkoinen Sali, Helsinki; 1996 "Senegal-Mali" Helsinki University of Technology, Sibelius Academy, Academy of Fine Arts, Helsinki; 1995 "Painting and built space", Taidehalli, Helsinki. **Arkkitehtuuritoimisto Jenni Reuter**, Laivurinkatu 37 F 40, 00150 Helsinki, mob. +358-50-3055704, tel./fax +358-9-7535810, e-mail jennireu@welho.com.

Sopanen & Sarlin: **Knitting Mill Silmu apartment renovation**

SARLIN+SOPANEN

OLLI SARLIN (1966 Helsinki) M.Sc. (Arch.) Tampere University of Technology 2001; 1992- University of Art and Design in Helsinki, Interior Architecture and Furniture Design; 1995-96 Hochschule der Künste Berlin, School of Architecture. **Professional experience**: 1988-1991 Siren Architects, Sopanen-Svärd Architects, Martti Kukkonen Architects, Jokela & Kareoja Architects, Helsinki; 1995-96 RTW Architects, Abelmann+Vielain Architects, Berlin; 1997- Arrak Architects, Helsinki; 2001- Sarlin+Sopanen Architects Ltd. **Works**: 1994 Vegetarian Restaurant Tempura, Helsinki (with MS); 1995 Environmental Art Work, The PATH (with Cleo Bade, Arttu Hyttinen, Marjo Korolainen and MS); 1997 Knitting Mill Silmu, Helsinki (with MS). **Selected competitions**: 1999 Europan 5, Tallinn, Estonia, 1st prize (with Tuomas Hakala, Katariina Vuorio & MS); 2000 Tikkurila Area Development, tied 2nd prize (with Sari Lehtonen, Heikki Viiri & MS.); 2001 Europan 6, Jyväskylä, Finland, 1st prize (with Tuomas Hakala, Joakim Kettunen, Katariina Vuorio and MS). **Professional positions**: (OS & MS): 1999- Executive Committee of EKO-SAFA (Ecological Subsection in Finnish Association of Architects); 1999- boardmember, Wind Energy Company Lumituuli Oy and Energy Service Company Espa Oy. **MARJA SOPANEN** (1968 Lappeenranta) M.Sc. (Arch.) Tampere University of Technology 1998; University of Art and Design Helsinki (UIAH), Interior Architecture and Furniture Design 2000; Hochschule der Künste Berlin, School of Architecture 1995-96. **Professional experience**: 1987-88 Ark´idea Architects; City Building Department, Lappeenranta; 1989-90 Sopanen-Svärd Architects, Studio 5 Architects, Helsinki; 1992 Studio Cassatella Architects, Turin, Italy; 1995-96 RTW Architects, Abelmann+Vielain Architects, Berlin, Germany; 1996 Arrak Architects, Helsinki; 1997-2000 Sopanen-Svärd Architects, Helsinki; 2001 Virtual Apartment Service (Viraps) Research Group, UIAH; 2001-02 Helsinki City Planning Department; 2001- assistant, urban planning, HUT, Dep. of Architecture; 2001- Sarlin+Sopanen Architects Ltd. **Works, competitions, professional positions**: see above with Olli Sarlin. **Sarlin+Sopanen Architects Ltd**, Kulmakatu 5 B 18, 00170 Helsinki, tel. +358-9-2784204, mob. +358-40-8238251 (OS), mob. +358-40-5165316 (MS), e-mail olli.sarlin@arrak.com, marja.sopanen@luukku.com.

Saara & Janne Repo: **The Cycle Growing Housing Unit**

JARI TIRKKONEN

(1965 Savo) M.Sc. Architecture, Helsinki University of Technology 1999; **Professional Experience**: 1986-1989 Gullichsen-Kairamo-Vormala Architects; 1989-1992 Partner of Monark Architects; 1990- Partner of Group Architects; 1997-1999 Partner of Hunga Hunga; 1997-1999 Visiting Critic at the Faculty of Architecture, Helsinki; 1999-2001: building own house and studio with Saara Pyykkö. **Works**: 1992 Finnish Pavilion, Seville, Expo 92 (Monark); 1992 The Leisure Studio (Group); 1993-1998 Various awards for sustainable urban planning and housing (Hunga Hunga); 1997-1999 Ecological housing, Viikki, Helsinki; 1999 Interior of Skanno Design store, Helsinki; 2001 Own house, Kirkkonummi; **Art-related Projects:** 1987 Communication Cube (in collaboration with Ilkka Laine); 1994 Space is a State of Mind; a big, soft and wild spatial art-toy for children; 2000 Exhibition design, Olli Lyytikäinen's Retrospective, Kiasma, Helsinki; **Exhibitions**: 1992-2000 The Pavilion of Finland, (various international venues); 1995 The Leisure Studio, MoMA, New York, "Light Construction" (model in permanent collection); 1996 The Leisure Studio, Venice Biennale of Architecture; 1995-2000 The Leisure Studio at various exhibitions around the world.

SAARA & JANNE REPO

SAARA REPO (1971 Kuopio) M.Arch. University of Oulu, 2000; Erasmus exchange student in the Netherlands at TU-Delft Faculty of Architecture 1997. **Professional experience**: 1992 Architect Leena Nuutinen,Oulu; 1994 Architect Kari Virta Oy, Helsinki; 1997-2000 Nurmela-Raimoranta-Tasa, Helsinki; 2000- Riitta Korhonen Oy, Kuopio; **JANNE REPO** (1968 Pälkäne) M.Arch. University of Oulu 2002; Erasmus exchange student in the Netherlands, TU-Delft Faculty of Architecture 1997; **Professional experience**: 1990-91 Valkeakoski City, department of architecture; 1994 Architect Kari Virta, Helsinki; 1997-2000 Architects Nurmela-Raimoranta-Tasa, Helsinki; 2000- Riitta Korhonen, Architect, Kuopio; **Awards**: 1992 Rome-award, Villa Lante, University of Oulu; 1995 Award for building design, University of Oulu. **Works**: (Saara & Janne Repo): 1993 On/off University of

biographies/hip

Oulu, urban design competition for students (1st prize); 1994 Multum Flexible Housing Unit, (comp:1st prize); 1994 Sykli (3DThe Cycle) Growing Housing Unit, (hon. mention); 1999 Opas day-care Centre by Nature, (hon. mention) 1997; Avaruuden Ikkuna Future School-building (comp.); 1999 Project architects: 'Kombi', Housing Fair, Tuusula; 1999-2000 Urban design projects for Kuopio University & Tikkurila. **Saara and Janne Repo**, Kirkkokatu 19 A 20, 70100 Kuopio, tel. +358-17-2824483, fax +358-17-2882912, mob. +358-40-535323, e-mail jannerepo@raketti.net.

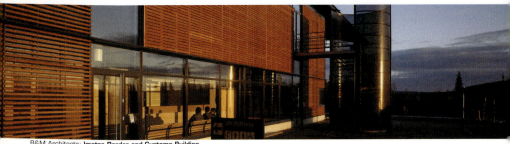

B&M Architects: **Imatra Border and Customs Building**

B&M ARCHITECTS

DANIEL BRUUN (1963 Espoo) M.Arch. Helsinki University of Technology 1999; 1990 Jean-Francois Bodin, Architects, Paris; 1991 Antoine Stinco, Paris; 1985-92 Helin & Siitonen, Architects, Helsinki; 1992- B&M Architects, Helsinki (Partner); 1997 Teaching at the Faculty of Architecture, HUT. **JUSSI MUROLE** (1962 Helsinki) 1994 M.Arch. Helsinki University of Technology; 1985-92 Gullichsen-Kairamo-Vormala, Helsinki; Studio GianCarlo De Carlo, Milano; 1983-84 CJN Architects, Espoo; 1992- B&M Architects, Partner; 1996-00 Tutor at the Faculty of Architecture. **Selected works:** 2000 Portaali Office Buildings, Helsinki; 2000 Kamppi City Center, Helsinki; 2000 Lintulahti Park, Sörnäinen, Helsinki; 1999 Kulosaari, Katajanokka Urban Plans, Helsinki; 1998 Border and Customs Stations, Imatra & Salla; 1996: Paavali Printshop loft, Helsinki; 2000 Klara Strand Housing, Stockholm (Urban plan); 1999 Sergels Torg, Stockholm (Public Square design); 1992-2000 Administrative Buildings, Congress Hall and Library, Al Jufrah, Libya; 1997-98 Masterplan, Jeddah, Saudi Arabia; 1995-97 Private Villa , Tripoli, Libya; 1996 Private Villa, Toompea, Tallinn; 1993 Mainsquare Public Buildings, Al Jufrah, Libya (Mosque, cultural centre, souk etc.). **Exhibitions:** 1998 Finnish Architecture 1992-1997 Museum of Finnish Architecture, Helsinki; 1996 Nordic Baltic Architectural Triennale, Tallinna, Estonia. **B&M Architects**, Melkonkatu 9, 00210 Helsinki, tel. +358-9-6821102, fax. +358-9-6927960, e-mail bm@bm-ark.fi, www.bm-ark.fi.

JKMM ARCHITECTS

ASMO JAAKSI (1966) M.Sc. (Arch.) Helsinki University of Technology1997. **TEEMU KURKELA** (1966) M.Sc. (Arch.) Helsinki University of Technology 1997, **SAMULI MIETTINEN** (1967) M.Arch. Helsinki University of Technology 1995. **JUHA MÄKI-JYLLILÄ** (1965) M.Arch. Helsinki University of Technology 1995. An architectural office with four partners was founded in 1998. The partners have received 29 prizes in architectural competitions. **Selected works:** 1998- Main Library of Turku; Joensuu University Extensions: 2000-2002 Aurora I, 2002- Aurora II; 2000-2002 Leipuri Day-care Center, Helsinki; 2001-2005 Viikki Center (Health center, Youth center, Church, Center for the Elderly); 2002-2005 Meri-Matti School, Espoo; 2002- ARMI Center. **JKMM Architects**, Salomonkatu 17 D, 00100 Helsinki, Finland, tel. +358-9-27093430, fax +358-9-68311610, e-mail ark@jkmm.fi or lastname.firstname@jkmm.fi

KESKIKASTARI & MUSTONEN

PAULA KESKIKASTARI (1960 Kaarina) M.Arch. University of Oulu 1995. **Professional experience:** 1980-1993 in various architectural offices; currently Keskikastari & Mustonen, Architects and the City of Turku. **TARMO MUSTONEN** (1961 Leppävirta) M.Arch. University of Oulu 1989. 1983-1988 in various architectural offices; currently Keskikastari & Mustonen, Architects. **Selected competitions and awards:** 1999 Åbo Akademin University, Österbottens Högskola, Vaasa, 3rd prize; 1996 Europan 4, Vaasa Mäkikaivo, 3rd prize; 1995 Raisio Kattelus housing exhibition area, purchase; 1989 Uusikaupunki, Vilissalo-Kasarminlahti area, 2nd prize; Paimio centre, 1st prize. The Architectural Prize of Oulu 1999. **Exhibitions:** 1985 "La Terza Mostra Internazionale di Architettura", Biennale di Venezia; 1987-88 "Exercises in Flight", Stockholm, Helsinki, Oulu, Berlin, Tromso, Punkaharju, Antwerp; 1993 "Architects from Turku"; 1996 "Young Finnish Architects", MoFA, Helsinki. **Publications:** Villa Verona, Finnish Architectural Review 7-8/1993, Architektur Aktuell, Austria 169/1994 **Keskikastari & Mustonen**, Peurankatu 6, 20810 Piispanristi, Finland, tel. +356-2-2424993, fax +358-2-2424964, mob. 040-5296700, e-mail ke.mu@kolumbus.fi.

Keskikastari & Mustonen: **Villa Verona**

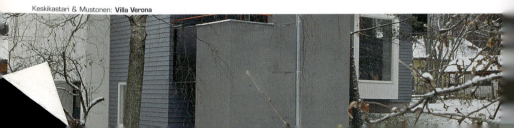

Petri Rouhiainen: **Poutamäentie 10 housing**

PETRI ROUHIAINEN
(1966 Ilmajoki) M.Arch. Helsinki University of Technology 1994; Architect Safa 1994. **Professional experience:** 1989-92 Group Monark/ Arkkitehtuuritoimisto; 1992 State Prize for architecture (Monark); 1995- Office for Architecture: Petri Rouhiainen Oy. **Teaching**: 1995-1997 Arkkitehtuuri 1 HUT Otaniemi; 1997-99 Urban Renewal of Built Enviroment HUT; 1997-98 'Rakennuttaja' Course HUT, Dipoli. **Competitions:** 1988 William van Alen Memorial Fellowship, 2. prize; 1989 Aleksandria Library (Special Merit): Monark; 1989 Sevilla Pavilion, 1st prize (Monark); 1996 Railway and Bus Terminal, Jyväskylä, 1st prize (Harris-Kjisik-Rouhiainen); 1999 "Tontinluovutuskilpailu Villasaaressa", Vuosaari, Helsinki 1st prize (Petri Rouhiainen). **Main works:** 1996-1999 Stockmann Extension, Tapiola, Espoo; 1996-1999 Poutamäentie: 10 housing blocks, Pajamäki, Helsinki; 1997-1999 Nuottaniemi Housing, Helsinki. **Works in progress**: 2000- Railway & Bus Terminal, Jyväskylä Travel Center", Jyväskylä; 1998- Leppävaara Housing, Espoo; 1999- Villasaari Housing, Vuosaari Helsinki; 1999- Lanterna Department Store, Helsinki. **Arkkitehtitoimisto Petri Rouhiainen Oy.**

APRT ARCHITECTS
AARO ARTTO (1964 Helsinki) M.Arch.Helsinki University of Technology 1993 (co-founder of APRT with Palo Rossi Tikka 1994). **Professional experience:** 1989-95 Arkkitehti (The Finnish Architectural Review); 1988-89 The Finnish Science Centre; 1985-88 The Museum of Finnish Architecture. **TEEMU PALO** (1962 Helsinki) M.Arch. Helsinki University of Technology 1993. **Professional Experience:** 1994 Pekka Salminen Architects, Helsinki; 1993 Reijo Lahtinen Architects, Helsinki; 1989-92 Harris-Kjisik Architects, Helsinki; 1988-89 Aarne von Boehm Architects, Helsinki; 1987-88 NRT Architects, Helsinki; 1986-1987 Raili and Reima Pietilä Architects, Helsinki;1984 -86 Kosti Kuronen Architects. **YRJÖ ROSSI** (1961 Eno) M.Arch.Helsinki University of Technology 1993. **Professional practice:** 1992-94 Pekka Salminen Architects; 1989-92 Mauri Tommila Architects, Helsinki; 1988-89 Huhtiniemi-Söderholm Architects, Helsinki; 1987-88 Laiho-Pulkkinen-Raunio Architects, Helsinki; 1986-87 Benito Casagrande Architects, Turku. **HANNU TIKKA** (1960 Helsinki) M.Arch. Helsinki University of Technology 1993. **Professional experience:** 1994-95 Pekka Salminen Architects, Helsinki; 1993 Studio Daniel Libeskind, Berlin; 1990- 92 Harris-Kjisik Architects, Helsinki; 1986-90 Aarne von Boehm Architects, Helsinki; 1982-86 NRT Architects, Helsinki. **KIMMO LINTULA** (1970 Helsinki) M.Sc.(Arch.) Helsinki University of Technology 2001. **Professional experience:** 1990-96 HLS Architects; 1996-97, 1999- Helsinki University of Technology, Faculty of Architecture; 1996- Artto Palo Rossi Tikka Oy (Sibelius Hall and Töölönlahti Parks). **Selected Projects**: 1994- Urban planning and infrastructure design for Ørestad, Copenhagen; I996-99 Raisio Library Auditorium Raisio, Finland; I997-2000 Lappeenrana University of Technology, 5th building phase, Finland; I998-2000 Töölönlahti Parks Helsinki; I998-2000 Helsinki-Gardenia Environmental Information Centre, Viikki, Helsinki; I998-2000 Sibelius Congress and Concert Hall, Lahti; I999- 2004 Joutsa Cultural Centre, Finland; 1999- Trivium, Turku, Finland; 2002- Railway Station Hotel, Helsinki, Finland. **APRT Architects** Uudenmaankatu 2 K, 00120 Helsinki, tel. +358-9-27091470, fax +358-9-27091476, e-mail aprt@aprt.fi (Aprt architects c/o ARKKI ApS, Teknikerbyen 7, DK-2830 Virum, Denmark, tel. +45-45-854433, fax +45-45-831660, email yro@khras.fi).

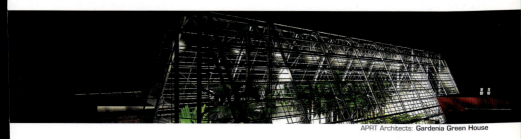

APRT Architects: **Gardenia Green House**

MIKKO MANNBERG
(1960) M.Arch. (1990) and L.Tech. (1999) Department of Architecture, University of Oulu; **Professional experience:** 1983-1991 NVV / NVØ architects, Oulu; 1988-89 Town Planning Office, Varkaus; 1990 Keskikastari-Mustonen architects, Turku; 1991-92 Jouni Koiso-Kanttila, Oulu; 1991-94 Anttila-Mannberg-Meinilä-West architectural studio, Oulu; 1997-99 Jukka Laurila, Oulu; 1997-98 Ulla and Lasse Vahtera architects, Oulu; 1999-2000 Helena Hirviniemi, Oulu. **Works**: 1993 Student Clubhouse, Oulu (collaborators, Kyösti Meinilä, Jaakko West); 1999 Villa Laine, Ruka, Kuusamo (Jukka Laurila Architects). **Exhibitions:** 1985 La Terza Mostra di Architettura Biennale di Venezia; 1985-86 Palladio I Dag, Stockholm, Helsinki MFA; 1987-88 Exercises in Flight, Stockholm, Helsinki, Oulu, Berlin, Tromsø, Punkaharju, Antwerp; 1992 FinlandiDa '92, Stockholm; 1992-94 Caught between the Wood and the Bark, Kemi, Oulu, Helsinki MFA, Stockholm, Copenhagen. **Teaching/Research**: 1993-95 Coord. & asst., Modern Nordic Architecture (Erasmus /Socrates) Programme, Oulu Department of Architecture; 1995-97 Researcher in the National Doctoral Programme in Architecture; 1996-97 Visiting Researcher at the Istituto Universitario di Architettura di Venezia; 1998-99 research assistant at Oulu Department of Architecture; 1999-2004 assistant and lecturer at Oulu Department of Architecture. **Other activities**: include exhibition and graphic design work (with Anna-Leena Jokitalo, Kyösti Meinilä). Mikko Mannberg, Toivoniementie 10 As. 27, 90500 Oulu, tel. +358-50-3706830, e-mail mikko.mannberg@oulu.fi. **Lassila Mannberg Architects (Ltd)**, Pakkahuoneenkatu 12 A, 90100 Oulu, tel. +358-8-370750, mob. +358-50-3706830.

biographies/hip

ANNI VARTOLA

(1965 Helsinki) M.Arch. Helsinki University of Technology 1994; 1997 Licentiate in Science (Technology) Helsinki University of Technology. **Teaching:** 1999- Lecturer, Theory of Architecture Studio, HUT, Dept. of Architecture; 2002 Visiting lecturer, Theatre Academy Finland. **Professional practice:** 2002 Project manager, European Forum for Architectural Polices, Ministry of Education; 1998-2000 Studies and research co-ordinator, HUT, Dep. of Architecture; 1991- Arkkitehtitoimisto Vartola & Viljamaa. **Publications**: 2002: Time of Music – Time of Art – Art in Time, Ptah (in print); 2000: From Contradiction to Complementarity – Six Views on Research, arq 3/2000; 1999 Practice Ptah 1-2/1999; 1999 Arkkitehtuurin teoria – utopia vai mahdollisuus? Synteesi 2/1999; 1999 Fact, Knowledge, Applicability and Other Goodies for the Science of Architecture. Nordisk Arkitekturforskning 3/1999; 1999 From Schools of Thought to Schools of Thinking. EAAE Conference Proceedings 1999; 1997 The Fiction of Order. Research Publications, Vol 13/1997. Helsinki University of Technology, Dep. of Architecture; Arkkitehtuurin tieteenfilosofisia ongelmia. Ark4/1996. **Vartola & Viljamaa Architects**: Lauttasaarenmäki 4, 00200 Helsinki, tel. +358-09-68411270, fax +358-09-68411277, e-mail arkvv@saunalahti.fi; http://www.saunalahti.fi/arkvv.

MARCO STEINBERG

(1967 Jyväskylä) M.Arch. Harvard University 1996; BFA, B.Arch., Rhode Island School of Design 1990. 1996- own architectural practice. **Professional experience**: Raili and Reima Pietilä Architects; 1992 Koll, Italy; 1994-1996 preparator for the Peggy Guggenheim Collection & the Venice Biennale (Art and Architecture). Worked with Bill Viola, Robert Wilson. Ongoing Collaborations with digital artist Riverbed; Installation design include: "Hand Drawn Spaces", "Theater of Drawings", "Ghostcatching", "Flicker-track & Verge", "Verge" and "Pedestrian". **Teaching**: 1999- Assistant Professor of Architecture, Harvard University, Graduate School of Design; 1989-99 Visiting Critic Rhode Island School of Design; Co-organizer "New Technologies in Architecture: Digital Design and Manufacturing Techniques" conference series, Harvard University; Lectured widely on the subject of materials, prototyping and design; Research on materials and manufacturing processes. **Selected publications**: "Prototype for a Plywood Wheelchair" (Harvard Design School, 1999), "Material Legacies: Bamboo" (RISD, 2000), "Immaterial/Ultramaterial"(ed. T. Mori, G. Braziller Publisher, 2002), co-editor of "New Technologies in Architecture" (HDS, 2001). Exhibition design for the Museum of Contemporary Art Chicago, Fogg Art Museum, The Kitchen NYC, Harvard Design School. **Current projects**: Stage set design "Alphabet" (based on a script by John Cage) premiering at the Edinburgh Festival (2001); Reconstituted Materials section "Immaterial/Ultramaterial" exhibition, Harvard (2001); development of new street light prototypes for iGuzzini, Italy. Continued research and development of new computer-based manufacturing processes for complexly moulded, smart, plywood; continued work in new applications for off-the-shelf industrial materials. **Marco Steinberg** 1666 Washington Street #3, Boston, MA 02118 USA, tel. (617) 8522415, fax (617) 4958916; Tallberginkatu 9, Helsinki 00180, Finland, tel. +358-9-3441900, fax +358-9-3441701, e-mail steinber@gsd.harvard.edu.

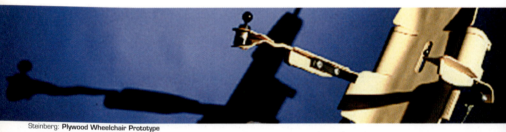

Steinberg: **Plywood Wheelchair Prototype**

RIA RUOKONEN

(1963 Turku) M.Arch. (Landscape Architect) Helsinki University of Technology 1992. **Professional Practice**: 1992- Byman & Ruokonen Landscape Architects; 1986-92 Maisemasuunnittelu Iisakkila & Byman Oy; 1987-89 Insinööri-toimisto LTT Oy. **Selected works**: 1994-96 Vuosaari Coal Reserve: Landscape Plan (with Eeva Byman); 1998-99 Housing Fair, Kanavansuu, Lappenranta, (with Eeva Byman); 1998- Kellomäki Parks Planning: City-Historical Path (with Byman, Karin Krokfors & Heli Virkamäki); 1999 Expo 99 Horticultural Exhibiton, Kunming, China, (Golden Prize for Permanent Outdoor Garden Design); 2000- State Prison, Plan for Surroundings. **Exhibitions**: 2001 Young Finnish Architects 1996, Finnish Landscape Architecture. **Teaching**: 1991-96, 1999 Landscape Architecture, HUT, Dep. of Architecture. 1998- Chairman of the Finnish Association of Landscape Architects. **Byman & Ruokonen Landscape Architects**, Tikkurilantie 44 P, 01300 Vantaa, tel. +358-9-8571761, fax +358-9-8571776, e-mail byman.ruokonen@maisema/ark.inet.fi.

ANDERS ADLERCREUTZ

(1970) M.Sc. (Arch.) Helsinki University of Technology 1999: ETSA Barcelona 1994-95. **Professional experience:** 1997-2000 SARC architects; 2001- A-konsultit architects. **Workshops**: 1993 KTH, Stockholm; 1996 Royal Danish School of Architecture, Copenhagen. **Exhibitions**: 1995 Paris, in 'Painting and Built space', Taidehalli, Helsinki; 1996 'Built in Museum of Finnish Architecture; 1996 Dokumenta (Architecture) Copenhagen. **Competitions:** 1996 New Housing, Vuosaari, Helsinki, purchase (with Eric Adlercreutz); 1997 "Trekamp I Trä", Finnish Wood Innovation, Uusimaa, 3rd prize; 1998 Nordic Wood Innovation 2nd prize ; 2000 School and Day-Care Centre, Leskenlehti, invited competition, 1st prize (with Eric Adlercreutz, Hasse Hägerström and Matti Ollila); 1997 Stocksund, Sweden, Housing, purchase (with Eric Adlercreutz). **Projects:**

biographies/hop

Adlercreutz: **House for Conductor Jorma Panula**

1996 House Livman, extension, Helsinki; 1998-2000 House Panula, Kirkkonummi; 1999 Cottage Flander (Extension to 18th century house, Inkoo); 2001 Cottage GELP, Hiittinen; 2001 Pre-fabricated house; 2001 House in Tenala, Kalby, (Restoration and re-modelling). **Graphic Design:** Renzo Piano – Spirit of Nature Wood Award. The Building Information Ltd, Helsinki. Has run his own office since 1996. **Anders Adlercreutz,** Ödesängsvägen 86, 02420 Jorvas, tel. +358-9-2981221, e-mail adlercreutz @mac.com.

M3 ARCHITECTS
JUKKA MÄKINEN (1970) M.Sc. (Arch.) University of Oulu 1998. **Professional experience:** 1995- in various offices; 1998 Steel Building of the Year Award (University of Oulu). **KARI NYKÄNEN** (1970) M.Sc. (Arch.) University of Oulu 1997; Foreign studies: Fachbereich Architektur, Hannover, Germany, 1994-95. **Professional experience:** in various offices since 1992. **HENRIKA OJALA** (1971) M.Sc. (Arc.) University of Oulu 1999; 1999- preparing Doctoral Thesis in University of Oulu; 1993-1994 foreign studies: Duncan of Jordanstone School of Art, Dundee, UK. **Professional experience:** Since 1996-. **JANNE PIHLAJANIEMI** (1970) M.Sc. (Arch.) University of Oulu 1998; foreign studies: Arkitektskolen i Aarhus, Denmark, 1994. **Professional Experience:** 1995- in various offices; currently teaching Modern Architecture, Univ. of Oulu; 1998 Wooden Building of the Year Award (University of Oulu); . **JYRKI RIHU** (1970) M.Sc. (Arch.) University of Oulu 1998; Foreign studies: School of Architecture and Urban Design, Kansas, USA, 1994-95. **Professional Experience:** since 1993; 2000- Helin & Co. Architects; Thesis of the Year Award 1998 (Univ. of Oulu). **Competitions:** (respective authors referred to by their last name initials.) 1992 Graveyard and Funeral Chapel, Oulujoki Church. Oulu, Finland, Student Competition, 1st prize (Univ. of Oulu: MNPR); 1994 Common Room, Apartment Block, Alberga, Espoo, Finland, Finnish Student Ideas Competition,1st prize (MNR); Koskikara Area in Kajaani, Finland; 1995 Aittaluoto Area in Pori, Finland, Student Competition, 1st prize (Univ. of Oulu: MNP); 1996 Sanginsuu Parish Building, Oulu, Finland, 1st prize (MNRP with Jussi Tervaoja); 1995-96 Bucurest 2000, Romania; 1996 Hallantalo, Multipurpose Building, Ukkohalla, Hyrynsalmi, Finland, Student Competition, 1st prize (Univ. of Oulu: MP); 2000 Varjakka Residential Area in Oulunsalo, Finland, 1st prize (MNP); 2000 Hollihaka Area, Oulu, Finland, 1st prize (MNP); 2000 Kaakkuri Parish Centre in Oulu, Finland, 1st prize (MNP); 2000 Harviala Area in Janakkala, Finland, 1st prize (N). **Exhibitions and Publications:** ARK (Finnish Architectural Review) 3/1997, Sanginsuu Parish Building PUU(Wood) 2/ 1998, Sanginsuu Parish Building, Suomi Rakentaa Exhibition, 1998, Sanginsuu Parish Building. **m3 Architects,** Kansankatu 47, 4. krs, 90100 Oulu, tel. +358-8-5573036; fax +358-8-5573039, e-mail toimisto@ arkkitehdit-m3.fi.

m3 Architects: **Hiidenkivi (Glacial Boulder) Jyväskylä Music and Art Centre**

POOK ARCHITECTS
KATARIINA RAUTIALA (1972); M.Sc. (Arch.) Helsinki University of Technology 2000; Escuela Tecnica Superior de Architectura de San Sebastian 1995-96; 1er Curso International de Urbanismo, Las Formas del Crecimiento Urban, Vic Spain 1996. **Professional experience:** 1998-99 Helamaa & Pulkkinen; 1998 Ingervo Consulting; 1997 Architects 6B; 1997 Architecture Workshop, Coast Wise Europe-Finland; 1996-2001 Member of The Building Board of Espoo. **Exhibitions:** (with Pentti Raiski): 2000 2nd International Design Biennal Festival, Saint-Etienne, France; YF2000-Arlon, Belgium; 2000 Time of Wood, Fiskars, Finland; YF2000-Glasgow School of Art, Scotland; 1999 Design Forum, Sanomatalo Helsinki, Finland; 1999 Docomomo, Otaniemi, Finland. **PENTTI RAISKI** (1971) M.Sc.(Arch.) Helsinki University of Technology 2000; Escuela Tecnica Superior de Architectura de San Sebastian 1995-96;-1er Curso International de Urbanismo, Las Formas del Crecimiento Urban, Vic Spain 1996; Spinno-business Development Centre Otaniemi 1999- ; St. Paul's College, Australia 1989-90. **Professional experience:** 2001- Wood Focus-Large scale wooden structures and buildings, Project Manager; 1997-98 Parviainen Architects; 1997- POOK Architects. **Competition:** (with Katariina Rautiala) Academy of Visual Arts, Leipzig Germany 2001, 2nd prize. **Pook Arkkitehtitoimisto** Kasarmikatu 14 B 13 00130 Helsinki Finland, tel. +358-9-41147347, fax +358-9-68133101, e-mail info@pook.fi, http: www.pook.fi.

POOK Architects: **Convertible Wooden Hall Construction**

Viiri: **Solarhouse**

HEIKKI VIIRI

(1962 Rovaniemi) M.Arch. University of Oulu 1993. **Professional Experience**: 1990-1992, 1999-2000 Olli-Pekka Jokela - Pentti Kareoja Architects, Helsinki; 1992 Atelier Wilhelm Holzbauer, Wien; 1993-95 Mecanoo architekten b.v., Delft; 1996 Ulla ja Lasse Vahtera, Architects, Oulu; 1996-99 NOON Architects, Oulu (partner); 1999- Heikki Viiri, Architect, Helsinki; 2000- Lahdelma & Mahlamäki Architects, Helsinki. **Teaching**: 1997-1999 University of Oulu, Assistant, Contemporary Architecture (housing). **Exhibitions**: 1997 "Puun Aika" Finland; 1998 "Taloja", Oulu; 2000 "Labyrinth" Helsinki 2000 Cultural Capital, Helsinki. **Competitions**: 2000 Tikkurila centre, Vantaa, shared 2. prize (Lehtonen, Sopanen, Sarlin, Viiri,); 2000 Home for Elderly People, Loviisa, purchase (Heikkinen, Jauhiainen, Viiri); 1996 International compettiion of Södertörn University area, Stockholm, Sweden, shared 2. prize (Jokela, Kivistö, Lehtonen, Sahi, Sforn, Viiri); 1996 Europan 4 Tampere, hon. mention (Lehtonen, Sahi, Viiri); 1996 Egological Housing area of Ristinummi, Vaasa, purchase (Aitoaho, Tahvanainen, Viiri, Viljanen); 1992 International competition of the centre of Storuman, Sweden, shared 2. prize (Kurkela, Viiri); 2001 Europan 6, Jyväskylä hon. mention (Lehtonen, Repo, Viiri). **Heikki Viiri Architect**, Kulmakatu 5 B, 00170 Helsinki, tel. +358-40-5033008, e-mail heikkiviiri@yahoo.co.uk.

MESKANEN & PURSIAINEN

PIHLA MESKANEN (1970 Helsinki) M.Sc. (Arch.) Helsinki University of Technology 2001; Degree in Pedagogy, Lahti Polytechnic Institute of Design 2001. **Professional experience**: 1996- architectural office together with Olli Pursiainen; 1993- Arkki, School of Architecture for Children (with architects Tuuli Tiitola-Meskanen and Miina Vuorinen). **Teaching**: architecture to children at Arkki since 1994 and lecturing and teaching to children and adults (schools, adult institutes, Tampere Polytehnic School of Art and Media). **Works**: on curriculums for architecture; curriculum for the basic education of architecture 1995-2000, Curriculum of architecture in Comprehensive Schools 1999 (Finnish Cultural Foundation), curriculum for the basic education of architecture 2002 in the National board of Education; exhibitions for children on the tactile qualities of architecture 1995-1996 Helsinki and Espoo (with Olli Pursiainen). **OLLI PURSIAINEN** (1970) Helsinki University of Technology, Dept. Of Architecture, 1992-, (major subjects: Building Construction); University of Art and Design, Helsinki; studies in furniture design, 2000-. Architectural office together with Pihla Meskanen since 1996. **Furniture design and exhibitions**: 2000 Painting and built Space, Taidehalli, Helsinki, Furniture exhibition, Köln, Germany, Art exhibition, Hämeenlinna, Easy Living – furniture exhibition. Architects Meskanen & Pursiainen. **Projects**: 1996-2002 Single-family houses, holiday homes, attic apartments, interior design, exhibition design; 1996 Architectural day care center Arkki, Vantaa; 1997 Arkki school of Architecture for Children and Youth, Helsinki; 1998 Jokisali Consert Hall, Vantaa; 1996 Extension of a maternity Ward in Tiadiaye, Senegal; 1995 Public Sauna in Zamosc, Poland. **Competitions**: 1999 High Quality Environment Award (Association of Interior Designers, SIO, Finland); Landscape Gallery competition, prize and realization (with Pook Architects). **Meskanen & Pursiainen Architects** Kasarmikatu 14 b 13, 00130 Helsinki, tel. +358-9-41104120, fax +358-9-6813 3101, e-mail ark.mp@co.inet.fi, www.arkkitehdit.org.

KAROLA SAHI

(1965 Rautalampi) The University of Industrial Arts, Department of Interior and furniture Design, Helsinki 1996; M.Sc.(Arch) University of Technology, Tampere 1993. **Professional experience**: 1997-2000 ARX Architects (partner); 1998 Heikkinen-Komonen, Helsinki; 1993-95 Interior Design Studio Simo Heikkilä, Helsinki; 1991-92 Jokela-Kareoja, Helsinki; 1990 GWSK Architects, Stockholm; 1989 Erholz-Iivonen, Helsinki; 1996- own practice, Studio AKSA Helsinki. **Works**: 2001 Apartment Sahi-Pajunen, Renovation, Knitting factory Silmu, Helsinki; 2000 Virkkunen Apt. Interior design, Helsinki; 1998 Unique-designoffice/interiordesign, Helsinki (with T.Antikainen); 1998 House Pipa, Kuopio; 1998 Vuotalo, furniture design, Helsinki (Heikkinen-Komonen). **Teaching**: 2000- Woodstudio, University of Industrial Arts, Helsinki; 1996-99 Assistant, Helsinki University of Technology, Dept. of Architecture. **Exhibitions**: 2001 'Young designer of the year' exhibition, Design Forum, Helsinki; 2001 Hima in Bo 01, Malmö; 2000 Labyrinth, Helsinki; 2000 HIMA-exhibition, Into-gallery, Helsinki; 1998 HIMA-exhibition, Bau-gallery, Helsinki. **Competitions**: 1996 Europan 4, Hon. Men. (with S. Lehtonen and H. Viiri); 1993 Future Bauhaus, Dessau, 1st prize. **Karola Sahi**, Architect Safa, Kulmakatu 5 A 14, 00170 Helsinki, Finland, mob. +358-50-5556142, e-mail karola.sahi@iki.fi.

Sahi: **Light Surfaces**

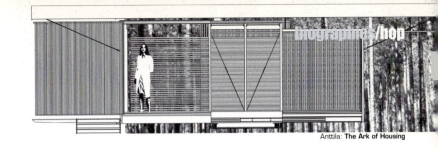

Anttila: **The Ark of Housing**

JESSE ANTTILA
(1973) M.Sc. (Arc.) Helsinki University of Technology 1999. **Professional experience:** 1996 Ellerbe Becket, Minneapolis, USA; 1997 Architects Tarki Liede, Helsinki; 1998 Architects Helamaa ja Pulkkinen, Helsinki; 1999 COLABS, Baltimore-Helsinki; 2000- QUAD Architects, Helsinki; 2000- Jesse Anttila, Helsinki; works on the field of urban infrastructure and industry, exhibitions and graphic design. **Related activities:** 2000 Healthy Buildings Conference, Helsinki, Scientific Secretary; 2000 Arts and Handicrafts Educational Institution in Halikko – AutoCAD teacher; 1998 Finnish Embassy, Kathmandu, Nepal (Intern). Office: Lönnrotinkatu 30 D, 00180 Helsinki; web www.kolumbus.fi/jesant.

EEVA-LIISA PELKONEN
(1962) Ph.D. candidate, Columbia University 1996-; M.E.D. Yale University, School of Architecture 1994; M.Arch. Tampere University of Technology 1990. **Teaching:** 1994-98 Critic of Architectural Design, Yale School of Architecture, New Haven; 1998- Assistant Professor (Adjunct), Yale School of Architecture; Guest critic: Barnard College, Columbia University, Harvard University, Helsinki University of Technology, Pratt-Institute, Rhode Island School of Design, Tampere Technical University, University of Virginia, Wesleyan University. **Selected publications:** Achtung Architecture, (MIT Press, 1996); "The Glaze," "The Veil" in The Light Construction Reader (ed. Kipnis & Riley, Monacelli Press, 2001); "Constructed Grounds. New Strategies in Contemporary European Architecture" in The Built Surface (ed. Anderson & Koehler, Ashgate Press, 2001; "Aalto's Unfolding Imagination" Daidalos, #71/1999. **Professional Practice:** 1987-1988 Reima and Raili Pietilä Architects; 1987 A-Consultants, Helsinki Finland; 1988-92 Robert Obrist and Partner, St.Moritz, Switzerland; Volker Giencke, Graz; 1994- Collaboration with Turner Brooks Architects, New Haven, Connecticut. **Projects:** 2000 Brooks/Pelkonen Residence, New Haven; 1998-2000 Yale University, Boathouse, Derby, CT; 1995-98 Stonington Historical Society, Library-Archive; 1990-present: Eeva-Liisa Pelkonen Architect: Hietaranta house, Kirkkonummi, Finland, completed 1998; Paavolainen residence, Helsinki, 1995. **Eeva-Liisa Pelkonen**, 9 Reservoir Street, New Haven CT 06511, tel. 203-7872234, fax 203-4537175, Liisankatu 19 I 47, 00170 Helsinki, Finland, tel. +358-9-1351180, e-mail pelkonen@ yale.edu.

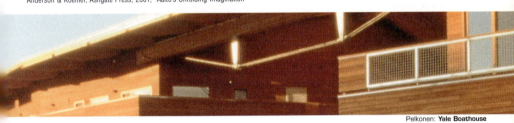

Pelkonen: **Yale Boathouse**

SANAKSENAHO ARCHITECTS
MATTI SANAKSENAHO (1966 Helsinki) M.Arch. Helsinki University of Technology 1993; **Professional experience:** 1990-92 Partner: Monark; 1991- Sanaksenaho Architects, Helsinki. **Teaching:** 1993-95 HUT; 1996 Guest Professor: Århus School of Architecture, Denmark. **Competitions:** 1996 Library in Alexandria, Special Merit. (Monark);1989 Finnish Pavilion, Sevilla Expo 1992, 1st prize,(Monark); 1996 Ecumenical Chapel,Turku, Finland, 1st prize; 1999 Helsinki Music Centre, 1st phase, prize. **Works:** 1989-92 The Finnish Pavilion, Seville (Monark); 1992-93 The Chapel, "Empty Space", Tapper-Foundation, Saarijärvi, Finland; 1993-99 Student Centre, Vaasa, Finland, (with Pirjo Sanaksenaho); 1996- Ecumenical Art Chapel, Turku, Finland (with PS); 1996 Sculptor's House. Sysmä, Finland (unrealised); 1997- 1998 Kasarmikatu 25, Helsinki (renovation, with PS); 1997-1998 Santapark, Rovaniemi, Finland; 1999 Hackman Designor -Shop interiors, Stockholm, Helsinki; 1999- Tammimäki, single family house, Espoo (with PS). **PIRJO SANAKSENAHO** (1966 Turku), M.Arch. Helsinki University of Technology 1993. **Professional experience:** 1988-1993: Raili & Reima Pietilä Architects, Severi & Petri Blomstedt Architects, Kari Järvinen & Timo Airas Architects; 1997- Partner in Sanaksenaho Architects. **Teaching:** 2000- HUT, Dep. of Architecture (Housing). **Sanaksenaho Architects**, Tehtaankatu 13 C 52, 00140 Helsinki, tel. +358-9-177341, fax +358-9-630636, e-mail arch@sanaks.pp.fi.

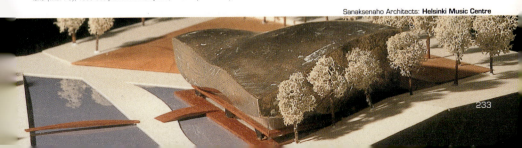

Sanaksenaho Architects: **Helsinki Music Centre**

biographies/house

QUAD ARCHITECTS
(est.1997) **JUHA HUUHTANEN** (1960 Hämeenlinna) M.Sc. (Arch.) Tampere University of Technology 1990. **Private practise**: private houses, summer houses and interior design. **ILKKA LAITINEN** (1966 Nilsiä) M.Sc. (Arch.) Tampere University of Technology 1995. **Private practise**: private houses, etc. **MIKKO METSÄHONKALA** (1966 Ylöjärvi) M.Sc. (Arch.) Tampere University of Technology 1996. **Activities**: in the fields of the visual arts and aesthetics, published "Valta ja vallattomuus (Power and Unruliness), 1995. **JARI VIHERKOSKI** (1966 Anjalankoski) M.Sc. (Arch.) Tampere University of Technology 1994. **Private practise**: private houses, summer houses and interior design. **Works**: (Quad) 2002 Sustainable Development Daycare Centre, Helsinki (Viikki experimental building area); 2001 Baltic Art Centre Björkanderska Magasinet, Visby, Gotland (Sweden)1st phase; 1998 Project planning for the Ruuti City Block community facilities, Helsinki; 1998 Project planning for Viikinmäki Primary School, Helsinki; 2001 The Pori Ruskaranta Housing Company Senior Citizens Centre, Pori; 2003 Åbo Akademi University, Unit of Ostrobothnia Österbottens Högskola, Vasa; 2001 Aurinkopuisto Housing Company, Helsinki; 2002 Ilta-Aurinko Housing Company, Helsinki; 2002 Aurinko, Housing Company, Helsinki. **QUAD Architects**: Kalevankatu 14 C 7, 00100 Helsinki Finland, tel. +358-9-612 6670, fax +358-9-612 66720, e-mail quad@quad-arkkitehdit.fi.

SARLOTTA NARJUS ANTTI-MATTI SIIKALA
SARLOTTA NARJUS (1966 Turku) M.Arch. Helsinki University of Technology 1996. **Professional experience**: 1989-98 Heikkinen-Komonen Architects; 1990-95 Narjus-Siikala Architects; 1998- SARC. **Teaching**: 1995-2000, HUT, Dep. of Architecture; **ANTTI-MATTI SIIKALA** (1964 Turku) M. Arch. Helsinki University of Technology 1993. **Professional experience**: 1987-93 Finnish Museum of Architecture, Juhani Pallasmaa, Heikkinen-Komonen Architects; 1990-95 Narjus-Siikala Architects; 1995- SARC. **Teaching**: 1993-99 HUT, Dep. of Architecture; 2001 University of Arts and Crafts(UIAH), Helsinki, workshop. **Awards**: Young Finland State Prize 1996. **Selected works**: 1900/2002 Katajanokan Amiraali Housing Company, Renovation of an Old Russian Quartering; 2003 University of Oulu, Faculty of Medicine, Main Building; 2001 Kone Building; 2000 Expo 2000 Finnish Pavilion; 2000 Sonera House; 1999 Sanoma House; 1992 Kuopio Market Place. **SARC**: www.sarc.fi; sarc@sarc.fi.

Siikala & Narjus: **Expo 2000 Finnish Pavillion in Hannover**

BERGER+PARKKINEN
TIINA PARKKINEN (1965 Vienna, Austria) 1965–84 lived in Helsinki; 1994 Akademie der bildenden Künste in Vienna Architektin, Mag.Arch., staatlich befugte und beeidete Ziviltechnikerin, Arkkitehti SAFA. **ALFRED BERGER** (1961 Schwarzach/Pongau, Austria) 1989 Akademie der bildenden Künste in Vienna Architekt, Mag.Arch., staatlich befugter und beeideter Ziviltechniker. **Works**: (Berger+Parkkinen) 2001 House Pennanen, Vienna; 2000 Kunsthalle, Vienna, Exhibition design: NORDEN Contemporary Art from Northern Europe; 1995-1999 The Embassies of the Nordic Countries in Berlin (Internationale competition, 1st prize); 1997-98 Akademie der bildenden Künste, Vienna (reconstruction); 1990-94 Ice-sport-stadium Donaustadt, Vienna (1st prize); Selected projects: 2000 Ponte Parodi, Genua, Italy (invited competition); 2000 The Altona Station, Hamburg, Germany (invited competition, 1. Prize); 2000 Biomedical Research Center, Vienna, Austria (invited competition, 1st prize); 1998 MUMUT Graz (2 stage competion, prize-winner); **Exhibitions:** 2000 Ringturm, Vienna, Architektur des 20. Jahrhunderts: Finnland"; 2000 Pavillon de l'Arsenal, Paris: Panorama des capitales européennes; 2000 Palais d'Iéna, Paris, 100 ans d'architecture finlandaise; 2000 Max Muller Bhavan, New Dehli, "Contemporary architecture in Berlin"; 1997 Aedes Berlin, Berger+Parkkinen "Landschaft und Raum". **Publications**: (selected): 40 architects under 40: 2000 Jessica Cargill-Thompson, Taschen, München; Berger+Parkkinen, 2000; Die Botschaften der Nordischen Länder Berlin, Axel Menges, Stuttgart; Architektur des 20. Jahrhunderts: Finnland, 2000 Prestel Verlag; Topos, European landscape magazine, 9/2000; l'architecture d'ajourd'hui 7+8/2000; Wallpaper, 1+2/1999, 12/1999; and others. **Berger+Parkkinen Architects**, Wien, A-1060, Fillgrader-gasse 16, tel. +43-1-581-49-35, fax 581-49-37, Helsinki 00180, Tallberginkatu 1/101, tel. +358-9-6854643, fax +358-9-68552066, e-mail www.berger-parkkinen.com, berger.parkkinen @aon.at.

Berger+Parkkinen: **The Embassies of the Nordic Countries in Berlin**

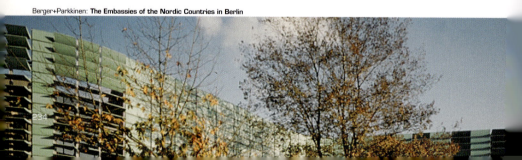

biographies/house

KIRSTI RANTANEN MAURI KORKKA

KIRSTI RANTANEN (1967 Helsinki) M.Arch. Tampere University of Technology 1996. **Professional experience:** 1988- in several architectural offices in Finland; 1998- own architectural office in Helsinki with Mauri Korkka. **Teaching:** tutor, HUT, Dep. of Architecture: urban design 1997-99; urban renewal 1999-. **MAURI KORKKA** (1958 Lahti) M.Arch. Tampere University of Technology 1990; **Professional experience:** 1982- several architectural offices in Finland. **Teaching:** 1991-97 Senior Architectural Design tutor, Tampere; 1996 teacher, the International Forum of Young Architects, Paris Val de Marne School of Architecture; 1998- teacher, HUT, Dep. of Architecture: 1998 art and architecture, 1999- future cities. **Competitions:** several prizes in competitions, stipends. Many entries in national and international competitions, among others Berlin Central District Spreeinseln / both phases 1994 (Korkka-Rantanen-Lehtonen). **Works:** (Mauri Korkka Kirsti Rantanen Architects) 1999-2000 City Centre Urban Design, Raisio; , 2000-2001 Plan for Savio area, Kerava; , 2001 Studies to extend Volvo-Auto Building, Helsinki; 2001 Sketch for River Valley Sports and Leisure Park, Kerava; 2001- Koskela Housing Project, Helsinki; 2001- Myllypuro landscape art project (1st prize in a competition/Korkka, 2000). **Mauri Korkka Kirsti Rantanen Architects**, Pormestarinrinne 6, 00160 Helsinki, tel +358-9-6221241 e-mail ark.mkkr@pp.htv.fi.

A.MEN

a.men architects was founded in 1993 by five partners, Tommi Grönlund, Turo Halme, Iiro Mikkola, Petteri Nisunen and Jaakob Solla. All partners have studied at Tampere University of Technology, Department of Architecture and some also in University of Industrial Arts in Helsinki. Their projects include architectural design, urban planning, interior design, furniture design and graphic design. Besides these normal office routines the partners have been teaching and lecturing in various institutions and participated many exhibitions. In addition to the partners a.men architects currently employees three qualified workers.

HARRI HAUTAJÄRVI

(1962 Rovaniemi) M.Arch. University of Oulu, Department of Architecture 1991; ICCROM ARC International Architectural Course, Rome 1995. Worked in several architect's offices, with his own office since 1995. **Works:** interiors and renovations (e.g. new exhibition rooms of the Arktikum building 1998 etc.); several exhibition designs for museums (e.g. The Finnish National Gallery); leisure dwellings, restoration etc. Solo exhibitions: (e.g. hexagonal plastic hell, Museum of Art and Design, Helsinki 1994-95; versus, Galleria Jangva, Helsinki 1998) and participation in several other exhibitions; working between art and architecture. **Professional positions:** 2000- Editor-in-chief: ark – Arkkitehti – The Finnish Architectural Review. A strong critic of some present-day phenomena, he has written widely on architecture for Finnish magazines and newspapers. **Harri Hautajärvi** (Arkkitehtitoimisto), Minna Canthin katu 1 A 9, 00250 Helsinki, Finland, tel./fax +358 9 7538138, e-mail hautajarvi@nic.fi.

PÄIVI JÄÄSKELÄINEN

(1961 Kivijärvi) M.Arch. University of Oulu 1989; "NoHo, Artists' Center, N.Y.C." 1989 (Diploma of the year 1990), University of Industrial Arts, Helsinki: Furniture Design Studio: prototypes in wood and metal;1999 UIAH: Future Home Graduate School: "Forms and Spaces of Living, case study: "Attics, lofts" (Doctoral studies). **Professional Experience**: 1983 Raili & Reima Pietilä, Helsinki; 1984 Villa Jääskeläinen, Pyhäsalmi; 1984 NVV Architects, Oulu (Toholampi Town Hall); 1985 Lowrie & Jansen Architects, New York; 1986 Tapiola Studio Architects, Espoo; 1986-87 Zaha Hadid London; 1988 Karen Bausman & Leslie Gill Architects, New York, Resigno Residence; 1989 Helin & Siitonen Architects, Helsinki. Since 1997 Studio Mezzo, own architectural firm & exhibition space, showroom: renovations, exhibitions. **Teaching:** 1986 University of Oulu, Dep. of Architecture: assistant teacher; 1994-95 Helsinki University of Technology, Public Buildings 1, ARK III. **Exhibitions**: 1986 "North Winds" -exhibition, Kiiruna, Sweden; 1990 Diploma Work, Moscow; 1993 Urban Design & Project, Cable Factory, Helsinki; 1997 Studio Mezzo: Sketches; "Forms 1". **Competitions:** 1997 Embassy of Finland, Canberra, hon. mention. **Päivi Jääskeläinen,** Punavuorenkatu 18 A 6, 00150 Helsinki, tel. +358-9-637307, +358-40-771 7034, e-mail pj@studiomezzo.com.

Soini: **Keltainen Yksityiskohta (Yellow Detail)**, 220x300cm, pigment.

KAISA SOINI

(1966) M.Arch. Cranbrook Academy of Art, Michigan U.S.A. 1994, M.Sc. Architecture, Tampere University of Technology 1994. **Professional experience:** 1994- Artist full-time; Design Instructor Faculty of Architecture at Helsinki University of Technology, Espoo Finland 1997-98 & Tampere University of Technology 1998-2001. **Solo Exibitions:** 1996- Art Center Mältinranta Tampere: 'Varjo' / 'The Shadow'; 1997 Studio Mezzo Helsinki: 'Suhteet' / 'The Proportions'; 1997 Imatra Culture Centre Imatra: 'Shadows'; 1996-98 'Paintings of Architecture" series; 1997 Gallery Titanik Turku: 'Rihma' / 'The Thred'; 1997 Gallery Valööri Helsinki: Kartassa ja rajoilla' / 'In Maps'; 1998 Gallery Otso, Tapiola: 'Pinnassa' / 'In the surface" (with Kirsi Leiman and Mikko Metsähonkala); 1999 Gallery Paula Väänänen, Turku: 'Tila 1' / 'Space 1'; 1999 Studio Mezzo, Helsinki: Tila 2 / 'Space 2'; 2000 Suomi-Gallery Stockholm, Sweden: 'Identity'; 2001 Lönnström Art Museum, Rauma: 'Sasi & Soini' (with Marjo-Riitta Sasi); 2001 Gallery Duetto, Helsinki: 'Strange Fruit'. **Group Exhibitions**: 1994 Cranbrook Art Museum Michigan U.S.A.: 'The Individual Thesis show" and 'The Thesis Group Show, work by Cranbrook Academy of Art Graduates'; 1996 Museum of Finnish Architecture Helsinki, Finland and MUOVA Vaasa, Finland, 'The Young Architects' Group Show'. **Collections**: The Lutherian Parish of Turku, The VVO-Concern Helsinki, The Tampere University of Technology, The LM-Ericsson Concern, Stockholm. **Kaisa Soini**, Papinkatu 21 E 61, 33200 Tampere, mob. +358-44-5137269.

biographies/house

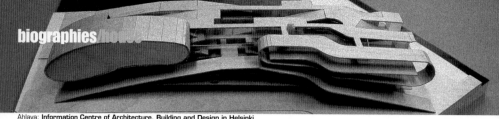

Ahlava: Information Centre of Architecture, Building and Design in Helsinki

ANTTI AHLAVA

(1967 Tampere) M.O.D. Architects, Helsinki, founder and partner. Doctoral Candidate, University of Art And Design Helsinki (UIAH, Program of Urban Interventions), Edinburgh University, Department of Architecture (postgraduate) 1997-8; M.Arch. (SAFA) Helsinki University of Technology (with distinction) 1996. **Professional experience**: 1989-1998 Kai Wartiainen Architects, Helsinki. **Teaching**: 2000- Senior/Tutoring Lecturer, Urban Design, Helsinki Univ. of Technology, Department of Architecture; 1997-99 Guest Critic, University of Art & Design Helsinki. **Publications**: on architecture and other art forms, specialised in British culture, in Arkkitehti, Helsingin Sanomat, Image, Kanava etc. **Works**: 2001 Digital Café office renovation; 2000- FinnMarin textile factory renovation; scenography (University of Theatre, Helsinki); one-family houses; international workshops. **Competitions**: (recent) 2001 Information Centre for Architecture, Building and Design (ARMI), Helsinki; 1999 Shikenchiku International Architectural Competition, Tokyo (with Sebastien Tison); 1999 Habitare Furniture Competition, Helsinki; 1999 Kierikkikeskus Archeological Centre, Yli-Ii; 1999 Aurinkolahti School, Helsinki; 1995 Viikki Ecological Residential Area (Special Prize). **M.O.D. Architects Ltd** Kalevankatu 9 B 19; 00100 Helsinki; architecture, urban planning, design, scenography, graphic & web design, web site: www.arkmod.fi, tel. +358-9-611660, mob. +358-50-3241179, fax +358-9-61240660, e-mail antti.ahlava@arkmod.fi.

REFLEX DESIGN

Reflex Design runs a wide range of design activities, research and experimentation focusing on ecology, innovation and processes. **SARI ANTTONEN** (1966 Helsinki) M.A. University of Art and Design Helsinki UIAH, Dep. of Interior Architecture and Furniture Design 1999; cabinet maker Vihti Art and Craft College 1988: **Research**: 1999-2002 Leader on innovative use of recycled plastics in furniture design, Future Home program, Univ. of Art and Design. **Teaching**: 1999- Part-time Furniture Design Teacher, UIAH, Dep. of Interior Architecture and Furniture Design; 1997-1998 University of Lapland, Dep. of Industrial Design. **Awards**: Several awards; 1996 "Finnish National Award for Art", Finnish Ministry of Culture; 2001"Pro Finnish Design" Special Mention; 2001 "Furniture Design Award" Finnish Association for Interior Architects; 1999 "GOOD DESIGN" Award of the Chicago Atheneum,; 1997, 1999 "Habitare Top Ten" Award, Design Forum. **NICOLAS FAVET** (1971 Dijon, France) M.Arch. National School of Arts and Industries of Strasbourg (E.N.S.A.I.S.) 1994; Post-Graduated in City Planning (Urban Institute of Paris (IUP); Exchange student at the Helsinki University of Technology (HUT) – Dep. of Architecture; ERASMUS scholarship. Worked as a free lance architect in Helsinki and Paris since 1994; Nicolas Favet Architects, Paris since 1996. **Teaching**: 1996-2002 La Villette School of Architecture in Paris. **Research**: 1998-1999 Virtual Apartment Selling research project, University of Art and Design Helsinki. **Publications**: Author and correspondant for various European publishers and magazines (D'Architectures, Archi Créé…); co-author of «Sustainable Architecture and Urbanism» (Birkhäuser). **Exhibition and interiors designs**: include the inaugural exhibition of Kiasma Museum of Contemporary Art in Helsinki, interiors of the French Cultural centre in Helsinki, Showroom for the furniture manufacturer Piiroinen in Helsinki, boutiques for Marimekko (in association with Animal Design) in Helsinki, set for the play by B.-M. Koltès (Dans la Solitude des Champs de Coton). **Product and furniture design**: "Kiss" chair (produced by Piiroinen); "Prêt-à-porter" sofa and armchair: "Kiasma" drinking glass designed for Kiasma Museum of Contemporary Art Helsinki (produced by Reflex Design): "Tubab Serie" manufactured in Senegal out of recycled metal (produced by Arctikk). **Competitions**: 1996 Manifesto Eco-House *Eco-Logis* in Paris, first prize (with Kai Wartiainen); 1998 Plan for Munkkisaari, hon. mention; 1997 Plan for Luneville, first prize; 2001 Plan for 50 town houses in Tourcoing; 2002 Plan for Junot district in Dijon; 2002 85 apartments in Dijon. **Recently exhibited**: e.g. 2001 "Workspheres", MoMa New York; 2000 "Aperto Vetro 2000", Venice Glass Biennial; 2000 "The Generation X", Scandinavia House, New York; 2000 "Pursuit Of Excellence", Haifa Museum of Art, Israel. **Reflex Design Oy** Eurantie 2-6 00550 Helsinki tel/fax+358-9-726170321, Rue Championnet F-75018 Paris tel./fax +33-1-42265880; e-mail contact@reflexdesign.net.

LIVADY

Livady Architects is a Helsinki-based practice sounding out the creative margins of the profession. Its partners, Mikko Bonsdorff (1967), Marko Huttunen (1966), Pekka Lehtinen (1967), Panu Lehtovuori (1968), Mikko Mälkki (1966), Janne Prokkola (1966) and Lauri Saarinen (1968), pursue individual careers. Unifying interests include a critical, research-oriented overall attitude, the dynamics of contemporary urbanism and new uses of existing spaces and environments. Livady Architects has developed a considerable expertise in traditional structures and construction methods. Selected projects: 1994 "Pihlajiston Valot", a pilot project on suburban renewal, Helsinki; 1995 lighting plan for the Helsinki city centre (project); reuse of the Pasila railway depot, Helsinki; 1998-1999 study on the future of the State Railway warehouses, Helsinki 2000; 2000-2001 inventory of the built history of the Alko industrial complex in Salmisaari, Helsinki. **Livady Architects:** Hämeentie 4 C 11, 00530 Helsinki, tel.+358-9-34870501, fax +358-9-34870502, e-mail Livady@livady.inet.fi.

VALVOMO

Valvomo Architecture Studio: Designers/partners: Ilkka Terho (1968), Teppo Asikainen (1968), Vesa Hinkola (1970), Markus Nevalainen (1970), Kari Sivonen (1969), Jan Tromp (1969) , Rane Vaskivuori (1967), Timo Vierros (1967). **Studies**: Helsinki University of Technology 1989- (Vierros and

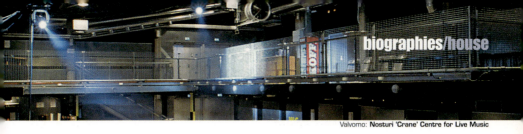

Valvomo: **Nosturi 'Crane' Centre for Live Music**

Hinkola gratuated '99). **Objects in production**: 1995 Netsurfer-computer divan (Snow-crash Ab); 1996 Chip-divan (Snowcrash Ab); 1996-98 Globlow-lamp, 4 models (Snowcrash Ab); 1998 Dress chair (Snowcrash Ab); 1999 Kromosom chair (Snowcrash Ab); 2000 Soundwave-panel (Snowcrash Ab.; **Exhibition architecture**: -96 Japan Today, International exhibition, Turku, Finland; 1991-97 Finnish Architects SAFA, 10 exhibitions; 1993-97 Finnis Architecture, FMA, Helsinki; 1996 95 Shivering Timber, Museum of Applied Arts, Helsinki; 2000 Alien Intelligence, Kiasma Museum of Contemporary Art, Helsinki. **Architecture & interior design**: 1996 Nylon night club, Helsinki; 1996-97 Proidea Filmstudios, Helsinki; 1996 Stockholm comics library; 1997 Enso Fine Papers -photo gallery, Finland; Marimekko clothing and textile company, fair stands; 1998 Soup Restaurant Helsinki; 1998 Stora Enso fair stand, Birmingham; 1999 Kaisaniemen Dynamo advertisement company, Helsinki; 1999 Artek shop and showroom, Helsinki; 1999 Artek fair stand, Helsinki; 1998-99 Cable Factory museums, Helsinki; 1999 Ogilvy & Mather advertisement company, Helsinki; 1999-2000 Razorfish (new media company) Helsinki; 2000 Pravda Restaurant, Helsinki; 2000 Nosturi (music center and concert hall) Helsinki; 2000 Point hair design studio, Helsinki; 2000 Lowe Lintas Partners, adv. agency, Helsinki; 2000-01 Base, new media and film company, Helsinki. **Exhibitions**: 1997 Snowcrash -design furniture exhibition, Milan and Helsinki; 1997 The Aesthetics of Everyday, Nagoya and Tokyo; 1998 Artek, Milan; 1998 Designers Block, London; 1998 Orgatec, Köln; 1998-2000 Köln international furniture fair; 1998 Köln Design Museum, Scandinavian Design; 1996-2000 Milan international furniture fair; Living rooms, Museum of Applied Arts, Helsinki; 100 exhibition, Helsinki 2000; 1999 Finnish Design, Design Forum 2000. **Valvomo Ltd**, Uudenmaankatu 33 E, 00120 Helsinki, Finland, tel. +358-9-6122310, fax +358-9-61223150, web site www.valvomo.com, e-mail info@valvomo.com.

OCEAN NORTH

Ocean North was formed in 1998 by Tuuli & Kivi Sotamaa, Michael Hensel and Birger Sevaldson and has its main production office in Helsinki, Finland. **Helsinki KIVI SOTAMAA** (1971 Helsinki) M.A. University of Art and Design, Helsinki UIAH; also studied at Helsinki University Technology, Department of Architecture and the Royal College of Art, Department of Architecture, London. Lectures and teaches widely. Currently Doctoral Candidate at UIAH. **TUULI SOTAMAA** (1974) Helsinki; MA. University of Art and Design Helsinki UIAH. Studied ceramic and glass design at UIAH, and Industrial Design at Central St. Martins College of Art and Design, London. Currently working on Diploma for UIAH. Worked as a researcher of ceramic materials at UIAH and as a trainee at Alessi SPA. **London MICHAEL HENSEL** (1965) Cologne; Dipl.Ing. Cologne Polytechnic School of Architecture and Grad Dipl Des. Architectural Association School of Architecture. Teaches and lectures widely. Currently he is the Unit master of Diploma Unit 4 – Urban Studio and Academic Coordinator of the Emergent Technologies graduate programme at the Architectural Association School of Architecture. **Oslo BIRGER SEVALDSON** (1953) Oslo; MA. National College of Art and Design in Oslo. Sevaldson is an associate professor at the Institute of Industrial Design at the Oslo School of Architecture. He currently pursues a Ph.D. in the field of Digital Design research. **Selected projects**: 2001 Urban Design: Evolving Narva – pre master plan study for Narva city; Building design: 2002 The New World Trade Center for Max Protetch Gallery, New York; 2001 Landscraper Ring Bridge, commissioned design for the Living bridges exhibition, Dusseldorf; 2001 Urban Amplifiers, FEIAD International Design Competition Finalist Entry, Taipei. Interior design: 2002 Suunto Interiors, design commission in process, Helsinki; 2002 Trussardi Lounge, design commission in process, Milan. Exhibition design: 2002 Greyscale + CMYK, Tramway Gallery, Glasgow; 2001 ARS 01, Kiasma Museum of Contemporary Art, Helsinki. Installations: 2002 Formations, Fondazione Nicola Trussardi, Milan; 2000 Intencities, Art Genda Biennial, Helsinki. Product and Furniture design: 1999 a_drift, New york Times Millenium Capsule – competition finalist entry. Web design: 2002 Ionic.nifca.org – virtual gallery for Nordic Institute of Contemporary Art NIFCA. **Selected exhibitions**: 2002 Formations, Fondazione Nicola Trussardi, Milan; 2002 Mood River, Wexner Center of the Arts, Columbus, Ohio; 2002 The New World Trade Center, Max Protetch Gallery, New York; 2001 ARS01, Kiasma - Museum of Contemporary Art, Helsinki.

Ocean North: **New York Times Capsule**

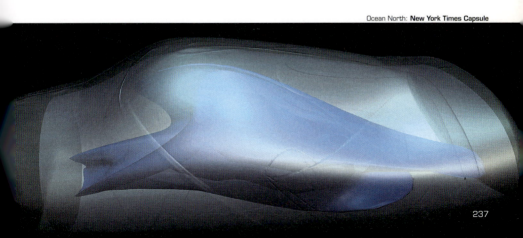

biographies: p.225 Sopanen & Svärd: Heritage Centre (Arno de la Chapelle); p.226 HKR Architects: Tuusula Housing (copyright Martti Lintunen); p.227 Sopanen & Sanlin: Knitting Mill Siirnu (photo Arno de la Chapelle), Saara & Janne Repo: The Cycle Growing Housing Unit (photo Pentti Vänskä); p.228 B&M Architects Imatra Border and Customs Building (photo Jussi Tiainen), Keskikastari & Mustonen: Villa Verona (photo Pauno Narjus); p.232 Heikki Virri: Solarhouse (photo Studio Ilpo Okkonen oy), Karola Sahi Light Surfaces (photo Charlotta Boucht); p.233 Sanaksenaho Architects Helsinki Music Centre (photo Jussi Tiainen); p.235 Kaisa Soini 'Keltainen yksityiskohta' ('Yellow Detail', photo Jussi Tiainen).

acknowledgments and thanks, first, go to all the forty practices for their willingness to submit material for this collection and for their enthusiasm for the project from the very beginning. It might be unfair to identify some young architects at the expense of others but this is hardly the case. The strength of an architectural culture lies in the way ideas and 'difference' allow development and exchange. Whether these forty practices agree with their position within the tripartite structure – *hip, hop, house* – matters less, I feel, than their willingness to open themselves to ideas, debate and the 'sampling' which could, of course, see some of their works appear 'hop', and not 'hip', 'house' and not 'hop'. This nicely echoes the fluidity of architecture and critical thinking at present and, at the moment of publication, many of these young architects will doubtless be designing new works with possibly quite another contemporary talent.

It is, of course, not always easy to predict the type of architecture that will result from such talent. Is this not as it should be? Like Herzon and de Meuron, recent winners of the Pritzker Prize, much of their passion comes from not knowing each Monday what their architecture will be. The debates in architecture today are so wide, changing so rapidly as to appear to have no consistency only constant movement. If this offers a kind of stasis, incertitude, we must advise ourselves not to get too far outside the dilemma that holds architects so carefully, so attentively, so reductively – box or blob, frame or net!

There is cautious excitement for the future and it echoes the contemporary fusion and collaboration all around. With this in mind, my sincere thanks go to the designer Antti Ahlava for his undertaking and design innovation. His interest and continued suggestions for relevance in both text and image made it a true collaboration. Thanks also go to Tiina Heloma, the publishing manager at the Building Information Ltd who, as it says in one of John Ashbery's poem, started in the middle. But she instantly recognized with passion the unusual nature of this book, and the necessity to widen the brief to include architecture from the new generation(s). Thanks also go to Kristiina Lehtimäki for once again getting everything in order so smoothly, and to Heimo Salo, Gunnel Adlercreutz and Markku Salmi for their continual support for these ideas. Appreciation to Esa Piironen, Vesa Peltonen, Mikko Metsähonkala, Kati Blom and Jyrki Tasa for valuable suggestions and finally to Building Information Foundation RTS (Christer Finne) for the important, preliminary grant to enable the collection of material and the writing of texts to begin. Perhaps we should remember what Ezra Pound wrote in 'Kulchur': "There is no ownership in most of my statements and I cannot interrupt every sentence or paragraph to attribute authorship to each pair of words, especially as there is seldom an a priori claim even to the phrase or the half-phrase."

roger connah, spring 2002, arlington architecture, texas.

ROGER CONNAH lives in Stockholm & Ruthin, North Wales where he runs The Hotel Architecture. Previous publications include: WRITING ARCHITECTURE 1989, K/K: A couple of Finns and Some Donald Ducks 1991; WELCOME TO THE HOTEL ARCHITECTURE 1998, GRACE & ARCHITECTURE (1999), SA(l)VAGED MODERNISM (2000), ZAHOOR ul AKHLAQ (2000), AALTOMANIA (2001), HOW ARCHITECTURE GOT ITS HUMP (2001). Currently editing the Collected Works & Words of Zahoor ul Akhlaq and Visiting Professor (Graduate Studio) at the University of Texas, Arlington (Spring 2001, 2002).

photo credits:

Image copyrights belong to the authors (architects and their offices in question) unless otherwise stated here:

cover: Ocean Intercities Installation, B&M Architects At Jufrah Administrative Buildings (photo Jussi Tainen), SARC Expo 2000 Finnish Pavilion (photo Jussi Tainen), Petri Rouhiainen: Poutamäentie housing blocks (photo Jari Jetsonen).

inner covers: photos Juha Nenonen.

title pages (p. 1-2): p.2 Heikki Viiri Solarhouse (photo Studio Ilpo Okkonen oy), p.3 B&M Architects Salla Customs and Border Office (photo Jussi Tainen).

project pages: *(referring to the picture numbering)*
Tuomas Silvennoinen: 1 Kuvasuomi ky, photo Matti Kallio.
Sopanen & Svärd: 2 copyright METLA / Erkki Oksanen, 3-4 photos Arno de la Chapelle.
HKR Architects: 1 copyright Martti Lintunen, 2 photo Jukka Ahola.
Jenni Reuter: 1 photo Jenni Reuter, 2, 3-4 photos Juha Ilonen.
Sarlin Sopanen: all photos Arno de la Chapelle.
Saara & Janne Repo: 1-7 photos Pentti Vänskä.
B&M Architects: 1-4 photos Jussi Tiainen.
JKMM Architects: 1-2 photos Arno de la Chapelle.
Petri Rouhiainen: 1,3-4 photos Jari Jetsonen.
Marco Steinberg: 2 copyright Paul Warhol 2001.
m3 Architects: 1 computer rendering Henrika Ojala.
PODK: 5 photo Anja Lampinen.
Heikki Viiri: 1 photo Juha Sarkkinen, 3-7 photos Studio Ilpo Okkonen oy.
Meskanen & Pursiainen: 1 photo Olli Pursiainen, 2 photo Peter Försgård, 4-6 photos Samuli Woolston.
Karola Sahi: 1 photo Marko Huttunen, 3-4 photos Charlotta Boucht.
Sanaksenaho Architects: 2a&b photos Jari Jetsonen.
Narjus Siikala: 1-3, 6 photos Jussi Tiainen.
a.men: 1 photo Magnus Selander, 3-6 photos Arno de la Chapelle, 7 photo Iiro Mikkola, 8 photo Antti Viitala, 9 photo Studio Sempre, 10 photo Studio Sebastian.
Kaisa Soini: all photos Jussi Tiainen.
Reflex Design: 1 photo Vesa Heino, 2a-2c photos Teemu Töyrylä, 3-4 copyright Christophe Demonfaucon photographe, 5 photo Lasse Keltto Studio, 6 photo Samuli Rantanen, 7 photo Marco Melander, 8 photo Kiasma Store (modified by AA).
Livady: 3 photo Mikko Mälkki
Ocean North: 2 modified by Antti Ahlava